THE SAINT MAKERS

CONTEMPORARY SANTERAS Y SANTEROS

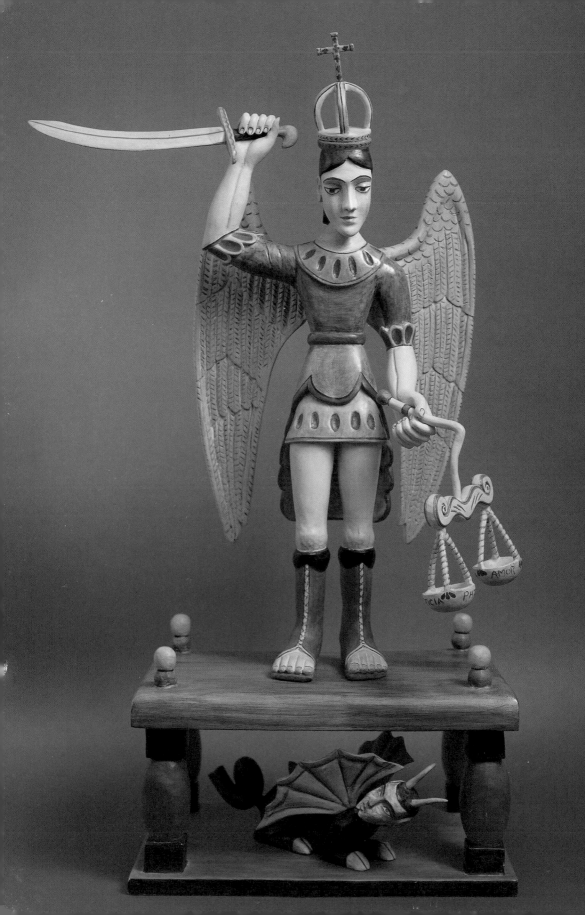

THE Saint MAKERS

CONTEMPORARY SANTERAS Y SANTEROS

CHUCK & JAN ROSENAK

NORTHLAND PUBLISHING

To the santeras and santeros in this book, and to those who came before: GEORGE LÓPEZ, ENRIQUE RENDON, *and* HORACIO VALDEZ—*it was our privilege to witness the renaissance of the living tradition of religious art in Northern New Mexico and Southern Colorado.*

Throughout this book, the use of accents in proper names conforms to the artists' own practices.

COVER: *Marie Romero Cash,* NUESTRA SEÑORA DE LA SOLEDAD/OUR LADY OF SOLITUDE, *1997, wood, gesso, fabric, paint, tin, silver beads, artificial flowers, 35½ x 13 x 6 inches. Chuck and Jan Rosenak.*

FRONTICEPIECE: *Félix López,* SAN MIGUEL ARCÁNGEL/SAINT MICHAEL THE ARCHANGEL, *c. 1995, aspen, cottonwood, natural pigments, homemade gesso, 38 x 25 x 12 inches. Margot and Robert Linton.*

BACK COVER AND TITLE PAGE: *Krissa López,* LAS VISPERAS DE LA FIESTA DEL PUEBLO DE POJOAQUE/ VESPERS AT THE FEAST OF POJOAQUE PUEBLO, *1997, pinewood, mineral pigments, gold leaf, varnish, 16½ x 11 inches. Courtesy of Félix López.*

The text type was set in Sabon
The display type was set in Manson
Composed in the United States of America
Designed by Nancy Rice
Art direction by Jennifer Schaber
Edited by Heath Lynn Silberfeld / Enough Said
Production supervised by Lisa Brownfield

Printed in Hong Kong by Global Interprint

Copyright © 1998 by Chuck and Jan Rosenak
All rights reserved.

This book may not be reproduced in whole or in part, by any means (with the exception of short quotes for the purpose of review), without permission of the publisher. For information, address Northland Publishing Company, P.O. Box 1389, Flagstaff, AZ 86002-1389.

All portraits of santeras and santeros by Chuck Rosenak. All photographs of art objects by Peter Vitale, with the following exceptions: Ron Berhmann [page 26, courtesy LPD Press, from Charlie Carrillo: Tradition and Soul]; Jill Caven [pages 14 and 44]; Peter López [page 66]; Raymond López [page 74]; Lynn Lown [pages 23, 24, 32, 46, 50, 68, 70, 71, 72, 78, 80, 82, 83, 92 (both), 97, 98, 117, 121, 122, 123, 131, 132, 134, and 135 (right)]; Dan Morse [page 129]; National Museum of Art, Smithsonian Institution [page 47]; St. Francis Cathedral [page 10]; William Sutton [page 119]; Taylor Museum for Southwestern Studies of the Colorado Springs Fine Arts Center [page 77]; UNM Maxwell Museum [pages 43, 52, and 58]; and Bob Wartel [page 125]. These photographs are copyrighted to the individual photographers or institutions.

FIRST IMPRESSION
ISBN 0-87358-718-9

Library of Congress Catalog Card Number 98-24958

Rosenak, Chuck
 The saint makers : contemporary santeras y santeros / Chuck & Jan
Rosenak.
 p. cm.
 Includes bibliographical references and index.
 ISBN 0-87358-743-X
 1. Santeros—New Mexico—Biography. 2. Santeros—Colorado—
Biography. I. Rosenak, Jan. II. Title.
N7910.N6R67 1998
704.9'482'09789—dc21 98-24958

697/7.5M/8-98

Contents

Santeras y Santeros

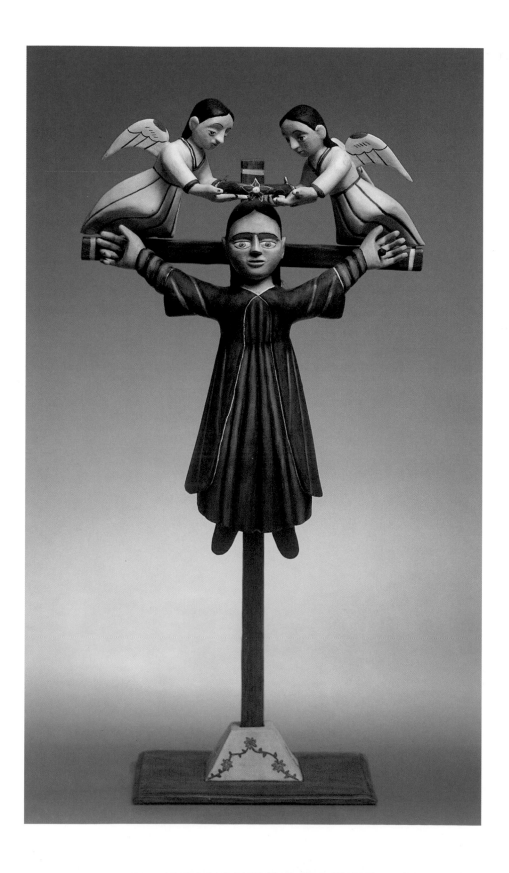

Introduction

RENAISSANCE OF RELIGIOUS ART

Although there was a flowering of religious art in Northern New Mexico and Southern Colorado—right under our noses—we, who pride ourselves on being astute collectors and writers on contemporary folk art, did not smell the excitement in the air until July of 1997. We were too busy traveling in the South while planning to update our *Contemporary American Folk Art: A Collector's Guide* and traveling the Navajo Reservation gathering information for the reprinting of our *Navajo Folk Art: The People Speak*. The art we were writing about was suddenly a hot commodity in New York and other commercial art centers of the United States, and we sought new adventures to keep us revved up.

Then, on the eve of Spanish Market in late July of 1997, Dave Jenney, Northland Publishing's savvy publisher, took us to dinner at the atmospheric El Nido restaurant in Tesuque (where we live) and said, "Slow down, you two. Look around you—great art is happening right under your noses on the Plaza in Santa Fe." And boy, was he right!

Jan and I have visited, photographed, and written about approximately 450 artists since 1988. Most of these artists have made their way into important galleries and museum collections—from avant-garde to au courant. The historical significance of their work is now assured. We realized we could retravel the entire country and *maybe* find some new artists worthy of inclusion in future publications or we could take Dave Jenney's advice and drive ten miles south to the Plaza and Spanish Market. We followed Jenney's advice—had breakfast at the La Fonda Hotel, at the end of the historic Santa Fe Trail, and—in pursuit of great art—joined the throng of curators, folk art collectors, and sightseers.

By 1997, we had collected the work of some of the modern master New Mexico carvers or santeros, including Horacio Valdez, Enrique Rendon, George López, José Mondragon, Frank Brito, Eulogio Ortega, and Nicholas Herrera. Through gift and museum purchase, the Smithsonian's National Museum of American Art in Washington, D.C., had already acquired most of the early pieces we owned by these artists, and the works were under consideration for inclusion in national touring exhibitions in the year 2000. Their absence had left a hole in our hearts. We were ready for new contemporary images and acquisitions.

OPPOSITE:
Jerome Lujan, SANTA LIBRADA/ SAINT LIBERATA, *1997, wood, gesso, natural pigments, 21¼ x 10⅜ x 6⅛ inches. Courtesy of the Spanish Colonial Arts Society, Inc. Collection on loan to the Museum of New Mexico, Museum of International Folk Art.*

But we were not prepared for the excitement of Spanish Market. Our adventure of discovery led us to not a few new discoveries (as anticipated) but rather the forty artists in this book. We believe these santeras and santeros rank among the top artists working in the United States today. With the exception of Frank Brito Sr. (page 22), Félix López (page 54), and Luis Tapia (page 127), who were included in the *Museum of American Folk Art Encyclopedia of Twentieth Century American Folk Art and Artists,* and Nicholas Herrera (page 45), who was included in *Contemporary American Folk Art: A Collector's Guide,* none of these artists was represented in our previous publications.

A TIME FOR INTROSPECTION

There is a national trend in art to pull into ourselves and look for inner values. Reliance on the European avant-garde and academically inspired trends of the moment no longer satisfies the hunger of Americans in their search for something wonderful. When we look inside ourselves, either as individuals or collectively, we find that there is much lacking. We then ask for divine intercession.

If we cannot lead saintly lives, why not admire those who devote their lives to that attempt? If abstract ideas lose their meaning or are repeated too often, why not return to simple truths and virtues that are universal? If life appears threatening, why not look to angels for protection? As a nation, we do all of the above. So why shouldn't our art reflect our spiritual hunger?

The fact is that in Northern New Mexico and Southern Colorado the mostly Hispanic population has, since the 1600s, done all of the above. The people of this region, surrounded by temptation and a harsh and sometimes hostile environment, are united by their inner devotional strength. The santeros—and more recently, the santeras—have helped the faithful; attempted to lead saintly lives; expressed simple truths and virtues in their art; looked to saints and angels for intercession and protection. They have stepped into the breach and have given us opportunity for joy in introspection and an art of universal importance in our daily lives—not just abstract ideas. They are leading us toward a renaissance of religious art in America.

THE EMERGENCE OF A NORTHERN NEW MEXICO AND SOUTHERN COLORADO ART FORM[1]

The first Spanish colony in New Mexico was established in 1598 by Don Juan Oñate, just a bit north of Santa Fe along the Rio Grande River. Christian images accompanied this band of soldiers, Franciscan friars, and settlers into "New Spain" ("Nueva España"). Through the study of European, especially Spanish, art of that time, we can guess at the early images brought to Northern New Mexico (the Blessed Virgin, often as Nuestra Señora del Rosario, Christ Crucified, and perhaps such popular saints as Santiago and San Antonio), but the originals were mostly lost when in 1680 the Pueblo Indians rose in revolt and destroyed most of the European homes and early churches. The Europeans then fled south to what is now Mexico.

Twelve years later, in 1692, Don Diego de Vargas returned with an army of Spanish soldiers and Mexican Indians to reestablish Spanish rule. Under Spanish rule, the population of the area expanded rapidly. The settlers needed saints, and the first santeros, believed to be friars and artisans from Mexico, appeared. The earliest indigenous religious paintings were created on buffalo hides (an art that is not practiced at present, but see Ramón José López, page 69).

In the 1700s, the tradition of the santero began to emerge in the small villages of Northern New Mexico and Southern Colorado. Two of the mid- to late eighteenth-century santeros were Captain Bernardo Miera y Pacheco (a Spaniard) and Fray Andrés García (a Mexican). Their art was influenced by European baroque styles, but they also helped initiate what was to become an indigenous art form.

As the demand for santos increased, the art was no longer the art of Spain and Mexico—it took on a life of its own. The santeros created a New Mexico style, unique to the Southwest. When the Hispanic population pushed north into what is now called the San Luis Valley of Colorado, they took their saints with them.

[1] The information in the history section of this Introduction is based primarily on the following sources: E. Boyd, *Popular Arts of Spanish New Mexico* (1974); Charles L. Briggs, *The Wood Carvers of Córdova, New Mexico* (1980); Larry Frank, *New Kingdom of the Saints* (1992); Myra Ellen Jenkins and Albert H. Schroeder, *A Brief History of New Mexico* (1974); Thomas J. Steele, S.J., *Santos and Saints* (1974); Marta Weigle, *Brothers of Light, Brothers of Blood* (1976); William Wroth, *Christian Images in Hispanic New Mexico* (1982) and *Images of Penance, Images of Mercy* (1991). We refer the reader to these books for additional information on New Mexico, the early santeros, and the Penitentes. See Selected Reading (page 146) for full publication information.

For the most part, the santeros led holy lives; it was thought that the more religious the santero, the more powerful his saints. There simply were not enough priests to minister to the devoted in this large geographic area. To fill the void, the Brotherhood of Our Father Jesus the Nazarene (Los Hermanos Penitentes, or the Penitentes) increased in strength. This Brotherhood was, from the beginning, surrounded by a veil of mystery and awe. The Penitentes were associated with the Catholic Church, and rules were issued by the Bishop of Santa Fe (later Archbishop), Jean Baptiste Lamy, as early as 1856. At first, the Brotherhood met in local churches. Later, however, local chapters established their own independent places of worship, called moradas.

Moradas began to appear at about the time the Civil War ended. Unlike the churches that were in the centers of the villages, the moradas were hidden away in arroyos and valleys outside of the towns. The Hermanos engaged in secret practices, like self-flagellation during Holy Week ceremonies. Many of these practices, which appear cruel and excessive today, were never officially authorized by the Catholic Church. The Penitentes, however, did fulfill a spiritual need and acted much as welfare agencies act today. They took care of the needs of widows and orphans, helped the poor, and were disciplinarians and educators of the young.

There is an additional historical fact to consider in regard to the Penitentes. Much of the art of the early santeros was made for the moradas and preserved in these places of worship. Some of these sacred objects have found their way into museums, and others have served as inspiration for the sacred art of today. Félix López (page 54), for instance, became a santero after seeing the santos in a morada surrounding the coffin of his father.

THE HISTORIC SANTEROS

Many of the early santeros cannot be identified by name; many of the objects they created have been lost, but short descriptions of a few who influenced the artists in this book follow:

1. PEDRO ANTONIO FRESQUIS OF TRUCHAS (1749–1831) is known today for his high-quality retablos, delicate crucifixes, and reredos. He worked in various churches at Trampas, Truchas, Santa Cruz, Nambé, and the Rosario Chapel in Santa Fe. Fresquis may have been the first well-known santero born in New Mexico.

2. THE LAGUNA SANTERO (worked c. 1796–1808) is best known for his altarpiece at the San José Mission church at

the Laguna Pueblo. The Laguna santero and his followers also made gesso reliefs. He painted with tempera, and his innovative style influenced those who came later.

3. ANTONIO MOLLENO worked in the first half of the nineteenth century and was formerly identified as the "Chile Painter" because he incorporated designs that suggested the hot New Mexico pepper in some of his retablos. He executed several altarpieces, including one centered around his large crucifix of "Our Lord of Esquípulas" at the Santuario de Chimayó.

4. JOSÉ ARAGÓN is thought to be a Spaniard who came to New Mexico around 1820. He was very successful and may have operated a workshop with help from assistants. The many bultos he made are of exceptionally high quality.

5. JOSÉ RAFAEL ARAGÓN (c. 1796–1862) worked during the period referred to as the "Golden Age" of New Mexico santos (1790–1863). Aragón is the artist most often mentioned by the artists in this book as an influence on their art. His central altarpiece for the Church of San Antonio de Padua in Quemodo (now Córdova) is considered one of the finest in New Mexico. The artist was extremely prolific, and virtually all the altarpieces made in New Mexico between 1825 and 1862 (the time of his death) were created by Aragón. His last altarpiece is on display at the Taylor Museum for Southwestern Studies of the Colorado Springs Fine Arts Center.

6. THE ARROYO HONDO SANTERO (who worked between 1830 and 1850) used distinctive space-filling dots and dashes that make his style easily recognizable. He worked north of Taos and left a small body of beautiful bultos.

7. JUAN MIGUEL HERRERA, also of Arroyo Hondo, worked between 1870 and 1890. He was one of the santeros who filled the needs of the Penitentes for ceremonial bultos in their moradas. Known for his large bultos of Christ and El Ángel de La Muerte (The Angel of Death; see Nicholas Herrera, page 45), his large figures contained movable limbs so that they could be arranged in different configurations when carried.

8. JOSÉ BENITO ORTEGA (born 1858, worked until about 1907) used bright colors and stylized flat shapes. He was very prolific and supplied many households, as well as moradas, with santos.

The work of these master santeros and their many followers is readily accessible for study today in the churches of Northern New Mexico and at a number of public institutions: the

Hispanic Heritage Wing of the Museum of International Folk Art in Santa Fe, the "Sacred Land" permanent exhibition at the Taylor Museum for Southwestern Studies of the Colorado Springs Fine Arts Center, the New World Department of the Denver Art Museum, and the Father Thomas Steele Collection at Regis University in Denver. There are also illustrations of their work in several books (many of which are listed in Selected Reading).

The santeras and santeros in this book have studied the masters and are familiar with their work and the materials they used. In fact, Charlie Carrillo, a santero and teacher has said, "The formal art school is a thing of the past for New Mexico carvers. The historic santeros are the art school of the present."

THE MODERN ERA

When José Benito Ortega moved to Raton, New Mexico, and stopped working, it probably marked the end of the classic tradition of santo making (although it lingered for a while in Southern Colorado). The Atchison, Topeka & Santa Fe Railway reached Las Vegas, New Mexico, in 1879 and Albuquerque in 1880. Before the arrival of the railroad, about the only mass-produced religious images available in New Mexico were lithographs; after the railroad's arrival, plaster of Paris statues and other commercial products representing the popular culture became available in quantity.

Had it not been for the Penitentes, the santo-making tradition might have died altogether. Since the moradas still required Passion figures for Holy Week, the tradition survived, although it went into a slow decline.

Córdova (see Sabinita López Ortiz, page 103, and Gloria Lopez Cordova, page 32), the small isolated village north of Santa Fe and south of Taos, was one of the places where santeros continued to work in the early twentieth century. When José Dolores López, a carpenter living in Córdova, heard that his son Nicodemus was to be drafted during World War I, López, fearful that he would not return and often unable to sleep, began to chip-carve small unpainted figures from aspen and cedar. By the time of his son's return, López had become an extraordinarily inventive santero.

New Mexico achieved statehood in 1912, and by the 1920s Santa Fe and Taos were becoming important art centers. Anglo artists from the East, who gravitated to these cities, were interested in discovering, preserving, and promoting Indian and Hispanic art and culture. They began to visit

Córdova, especially during Holy Week, and "discovered" José Dolores López. Two artists who admired López were Mary Austin (a writer) and Frank Applegate (an artist). These two were among the founders of the Spanish Colonial Arts Society in 1925.

Austin, Applegate, and their friends helped to revive and expand the market for Spanish Colonial arts and crafts. At the same time, they had a substantial impact on the direction the art forms would take. They suggested to López, for example, that he concentrate on chip-carving and leave his work unpainted (previously the artist sometimes used house paints and bright colors). Whatever the merits of their artistic views, these patrons did assist in revival of an art form that appeared to be dying.

Sabinita López Ortiz,
Our Lady of Fatima,
1997, aspen, cedar, 27 x 15¼ x 9 inches.

THE SPANISH COLONIAL ARTS SOCIETY

The Spanish Colonial Arts Society, founded in 1925 for the purpose of encouraging and promoting Spanish Colonial arts and crafts, included the work of santeras and santeros but also colcha (a form of embroidery), weaving, furniture making, tin work, and straw inlay. The Society has had periods of inactivity, but since the 1950s it has grown steadily in vitality. At present, it has a staff, under the directorship of Bud Redding, and is housed in a charming building near Santa Fe's historic Plaza. The Society maintains a library, publishes the yearly *Spanish Market* magazine, and sets guidelines deemed necessary to maintain the standards and traditions of the Spanish Colonial arts.

The Spanish Colonial Arts Society also has a large collection (over 2,500 pieces) of traditional and contemporary Hispanic art from New Mexico, Mexico, and other countries, most of which is presently housed in the Museum of International Folk Art in Santa Fe. Other pieces are on loan to El Rancho de las Golondrinas.

The Spanish Colonial Arts Society has done more than any other institution to preserve, revitalize, and lead the way to the current renaissance in religious art in the Southwest.

SPANISH MARKET

The most important function of the Spanish Colonial Arts Society is its sponsorship of Spanish Market; admission is free

to the public. Since 1972, Spanish Market has been held on the Plaza in Santa Fe on the last weekend in July. Spanish Market, and associated events, which include an auction, a gala preview party, and other social activities, is a festive weekend of Hispanic music (mariachi bands) and dancing, Hispanic food, and artists' demonstrations. Colorful booths are set up for participants in the Plaza and in front of the Palace of the Governors; tents are set up for demonstrations; and there is a bandstand for music and dancing. The event has grown yearly. In 1965, there were 18 exhibitors—in 1997, 200. The attendance has grown from a very few to an estimated 40,000 in 1997.

The Spanish Colonial Arts Society also holds a Winter Market in December. In 1997, Winter Market was held in the Sweeney Center in Santa Fe. Winter Market is also well attended and a must for collectors. However, unlike the annual Spanish Market, prizes are not awarded, and some artists do not participate or save their best work for summer.

Entry into Spanish Market is a hard-won privilege. The potential exhibitor must submit work to a panel of judges and must be selected. Many artists are unable to gain admission. Some of the artists in this book, for instance, failed in their initial attempts. On the other hand, many of the artists in this book have won best of show (including Charlie Carrillo, Gustavo Victor Goler, Anita Romero Jones, Ramón José López, David Nabor Lucero, Alcario Otero) and numerous special awards, purchase prizes, poster awards, and first-place ribbons.

Spanish Market includes a separate Contemporary Market, sponsored by the Santa Fe Council for the Arts in conjunction with the Spanish Colonial Arts Society. Since 1981, the Market has also included a Youth Exhibitors Division, intended to encourage young people in the arts. The work is often of high quality and of interest to collectors who feel it is a way to obtain work by the masters of tomorrow.

THE PENITENTE INFLUENCE TODAY

The style of the Penitentes includes realistic depictions of crucifixions (Cristo Crucificado) that are large and usually have movable limbs so that the object can be dressed and carried in processions. The Penitente style has influenced the contemporary santos in this book.

Ten years ago we thought that the Brotherhood was dying out, but we were wrong. Its membership has, in fact,

increased in recent years. The Penitente mystique, shrouded in secrecy, produces imagery that is of interest to our readers, but we have been asked not to identify individual members.

Master santeros that we have known and written about, such as George López (when he was a young man), Enrique Rendon, and Horacio Valdez, were all Penitentes. Enrique Rendon, in fact, was the Hermano Mayor (elder brother or leader) of the Penitentes in Lyden, New Mexico. Because of his desire for secrecy, we promised that we would not write about his position with the Penitentes during his lifetime, and we did not.

Several of the artists in this book are Penitentes, but it is considered bad form for them to use their membership in the Brotherhood in connection with the sale of their work. For this reason, we have not mentioned the fact in their biographies, even though it may be relevant to their art.

TRADITIONS CHANGE—THE ART CHANGES

In this book, we talk about contemporary artists and their art. As previously indicated, the style of Northern New Mexico and Southern Colorado religious art was initially folk art (few of the early santeros were trained artists). The images of saints come from a long folk tradition that arises out of communal needs and communal education. Folk traditions often incorporate illustrations from the popular culture, as well as from fine art, and that is what happened in the Southwest. The Spaniards brought with them memories of European art and assimilated the local color and popular culture of the region and Mexico.

In fact, when the Whitney Museum of American Art in New York City celebrated its fiftieth anniversary in 1980 with the seminal exhibition "American Folk Painters of Three Centuries," it included the work of José Rafael Aragón. For the purpose of this book, however, we have not made any attempt to distinguish folk art from fine art. This also seems to be a national trend in scholarship. The untrained in art are increasingly becoming recognized as part of art history and the art-museum–contemporary-art establishment.

The artists in this book (both trained and untrained in art) are all living, and their art reflects the age in which they live. The traditional bulto (a sculptural form) and retablo

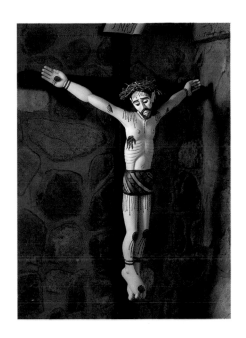

José Benjamín López, CRISTO CRUCIFICADO/ CHRIST CRUCIFIED, *c. 1993, aspen, Russian olive, cottonwood, oil paint, 60 inches. Courtesy of José Benjamín and Irene López.*

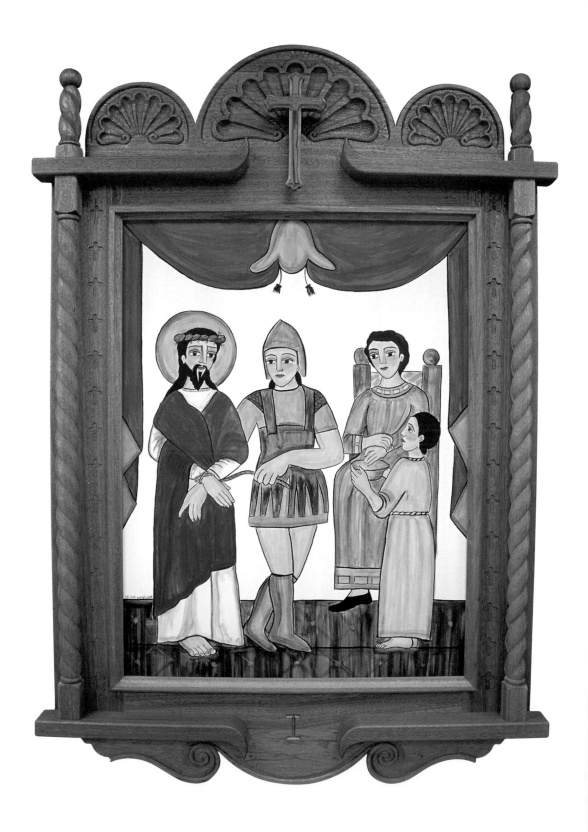

(a flat form) were made out of local wood, covered with gesso, painted with homemade pigments, and varnished with a mixture of piñon sap and alcohol.

Today, there are art supply stores in every community, and the convenience of obtaining materials has led some artists to use oil-based paints, acrylics, and store-bought gesso and varnish (see, for instance, Luis Tapia's statement on page 127). We see no problem with the use of these commercial products. Some conformists may mourn the disappearance of corsets, rant against current hairstyles, and resist changes in new models of cars, but in art there must be change. Repetition or mass production destroys the heart and soul of what we call art.

Picasso did not paint like Goya or Zurbarán. Miró did not paint like Picasso, and those who came later in the 1960s and 1970s (Millares, Tapies, and Saura) did not paint like Picasso and Miró. But all achieved greatness, and their art is recognizably Spanish.

Great art comes from the soul of the artist and reflects his or her idiosyncratic and personal vision. That is what we are looking for in our selection of contemporary images. All of the art in this book reflects the heart and soul of the Hispanic culture of Northern New Mexico and Southern Colorado, even though some may say it breaks tradition.

With changing times, certain saints have taken on new meaning in the lives of the population. For instance, Saint Liberata has come to stand for women's liberation to some, and Saint Anthony will help not only with the finding of lost objects but also with the finding of "good husbands." The region is no longer as dependent on the isolated small farm as it once was, so the people tend to rely less on San Ysidro, although he is still a popular New Mexico saint. Now that New Mexico has gambling casinos, San Cayetano (patron of gamblers) is appearing more frequently. Our Lady of Guadalupe remains an oft-carved and painted figure.

There is one further tradition-breaking phenomenon that has taken place in recent years: the emergence of the santera. The role of women in Hispanic society has not been one of bread winning, and women have let men take most of the credit for achievements outside of the home. Even the Hispanics we talk to admit to "a bit of the macho" in their culture. But women have always helped with santo making, and we have documented the fact that women, over the years, have played a crucial role in the art signed by their husbands and fathers (see Sabinita Ortiz, page 103; Gloria Lopez Cordova, page 32; and Marie Romero Cash, page 28).

OPPOSITE:
Marie Romero Cash,
STATION OF THE CROSS I,
1997, gesso-covered birchwood,
watercolor, 48 x 32 inches.
Courtesy of St. Francis
Cathedral.

Today, there is no gender distinction in judging eligibility for Spanish Market. It was a santera, Marie Romero Cash, who was commissioned by the Archdiocese of Santa Fe to paint the fourteen Stations of the Cross for Saint Francis Cathedral in Santa Fe. The santeras in this book have all left their marks on the religious art of the region.

The emergence of women in the religious art of the Southwest in recent years has paralleled societal changes in the United States. Nevertheless, the important historical role of women—while, unfortunately, not as well documented as we would like—should not be forgotten.

WHO BUYS SANTOS?

Santeras and santeros depend on a market for their product. Who buys their work? Well, almost every church-going Christian has been surrounded by images of saints, God, and angels since birth. Illustrated Bibles, books, churches, home altars—even TV and movie images of angels and Biblical characters—are omnipresent in the United States. People rely on powers beyond themselves for salvation and for lesser favors, such as finding lost key chains. So the devoted buy images of saints. In the Hispanic culture of the Southwest, most traditional homes contain altars or pictures of saints.

There is a personal relationship between people and their saints. When we visited Marie Romero Cash and admired a display of saints she had created, Cash noticed that one of her children had turned Saint Anthony toward the wall. "Why?" she exclaimed to the saint. "You haven't been naughty!" And then she turned Saint Anthony around so he faced into the room again. Frank Brito's wife, Corinne, told us of an even harsher punishment for a saint who didn't perform satisfactorily—the santo was put away in a drawer for a period of time. A story often told (perhaps apocryphal) is of the villagers who prayed to Jesus for rain and got such a great rainstorm that the fields were flooded! The next morning, they were seen carrying a statue of the Blessed Virgin to the fields. The priest commented that he was glad to see their faith. The villagers replied, "We are taking the Blessed Virgin out to show her the damage caused by her son."

The people need their saints and so do the churches. The santeras and santeros in this book have been commissioned to work in churches in California, Oregon, and Washington, as well as New Mexico and Colorado. More importantly, the Catholic Church in New Mexico is replacing plaster images with real carvings. Santa Maria de La Paz Catholic Community, El Rancho de las Golondrinas, and Archbishop Sheehan's

private chapel all presently have contemporary santos on display. In addition, as detailed throughout this book, a number of the artists have participated in restoration and rebuilding of reredos and other objects in historic New Mexico churches in Taos, Ojo Caliente, and elsewhere. They were also responsible for rebuilding the morada at Abiquiu after its destruction by vandals in 1992. Church commissions have always played a major role in the creation of religious art, and the Catholic Church in New Mexico is rediscovering the importance of art in the religious life of its parishioners.

The people need their saints; the churches need their saints; and we are very fortunate that especially in New Mexico and Colorado our museums and public institutions realize the importance and uniqueness of the religious art of the Southwest. These institutions are buying, studying, displaying, and conserving the art forms of the region. (For a partial listing of public institutions where religious art may be seen and studied, see the Museum, Gallery, and Santero Guide in the back of this book).

We enjoy standing back a bit at Spanish Market and watching the spectacle of museum curators, the Spanish Colonial Arts Society (which gives purchase awards), and collectors pushing to the front of the line in the early Saturday-morning rush and competition. They are all buying santos (retablos, bultos, and reredos). All of this competition is good for the santeras and santeros in this book—they are usually sold out by noon of the first day and taking orders for commissions to keep them going for the rest of the year.

Astute collectors of contemporary art are always looking for the new in art. They know that *The New York Times*, the *Dallas Morning News, Art in America*, and many other newspapers and periodicals have increased their coverage of folk art events; they know that the art market turned away from European and academically inspired art and turned to American self-taught artists in the 1990s. Collectors know that the work of Bill Traylor, for instance, a folk artist whose work we bought and about whom we wrote in the 1980s, was sold at auction in New York in 1997 in the mid-five-figure range. Collectors know that there was a New York auction of historic bultos and Spanish Colonial furniture in 1998, and it brought record prices.

Yes, there is a renaissance of religious art in New Mexico and Southern Colorado—right under our noses. New forms of expression are appearing almost daily, and old forms are being explored and revived.

FOLLOWING PAGE:
Gustavo Victor Goler,
EL ÁNGEL DE NUESTRA
GUARDIA/GUARDIAN ANGEL,
*1996, wood, watercolor,
gesso, 12 x 6 x 5 inches.
Private collection. Courtesy
of the artist.*

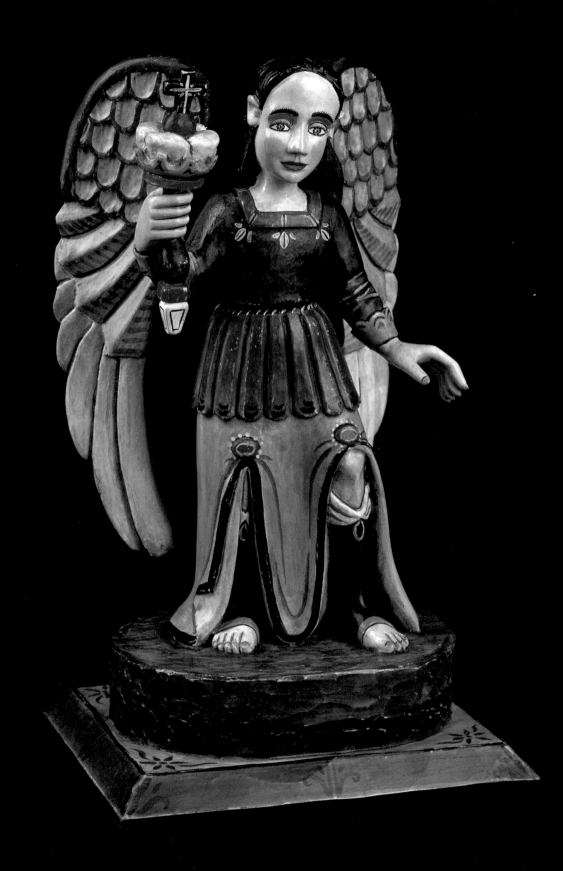

Santeras
y
Santeros

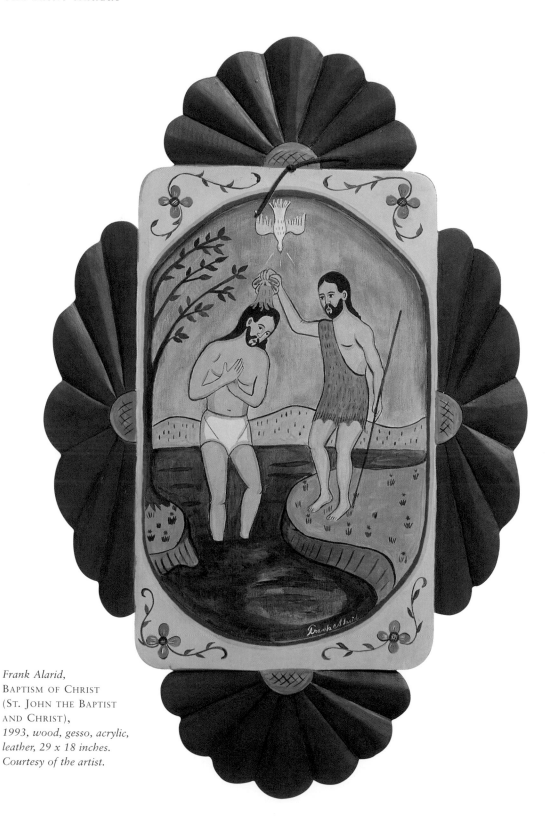

Frank Alarid,
BAPTISM OF CHRIST
(ST. JOHN THE BAPTIST
AND CHRIST),
*1993, wood, gesso, acrylic,
leather, 29 x 18 inches.
Courtesy of the artist.*

FRANK ALARID

Frank (Pancho) Alarid is a master colorist. The subject matter of his bultos and retablos is traditional, occasionally even romantic; the iconography and materials are also traditional, but the finishing touches of color (such as blue eyes, bright red robes, contrasting orange and yellow carved decorative elements) are his trademark style. At first, Alarid used natural pigments, but he soon learned that he did not have the time to grind them and that only acrylics could produce the bright colors he was looking for. "Color is an inner thing," Alarid explains, "perhaps from my heart."

> "I DREAMT ABOUT A BANQUET OF ANGELS:
> SAINT MICHAEL, SAINT RAPHAEL, SAINT GABRIEL,
> AND OTHERS. THEY WORE ROBES OF BRIGHT COLORS—
> I USE THE COLORS AS THEY APPEAR TO ME."

BORN
August 12, 1950,
Santa Fe, New Mexico

RESIDES
Santa Fe, New Mexico

EDUCATION
Graduate,
Santa Fe High School

It is no accident that Alarid is a colorist—he was tutored by one of the great painters of the Southwest, Randall Davey, a highly successful portrait painter who was also well-known for his colorful racetrack scenes. When Alarid was growing up, his family compound was near the Davey estate (this historic property belongs to the Audubon Society today). Alarid's great-grandfather owned a ranch along the Santa Fe River on what is now Upper Canyon Road in Santa Fe (today an area largely composed of galleries and expensive homes). Alarid's father, Octaviano Alarid, was a caretaker for the nearby Davey estate. Starting in about 1961, for several years, after school and during vacations, the young Alarid worked alongside Davey in his studio and was taught as a disciple of the master.

Alarid learned to paint and use color from Davey, but he became a santero through the fortuitous perception of another Upper Canyon Road neighbor, E. Boyd. A recognized authority in the field, Boyd was an artist, writer, anthropologist, and curator of Spanish Colonial arts for the Museum of New Mexico and the Spanish Colonial Arts Society. E. Boyd showed Alarid some historic bultos and retablos in the collection of the museum. Alarid recalls his reaction to the historic material as follows: "It was like lightning had struck me: I can carve and I can paint—I can make a bulto!"

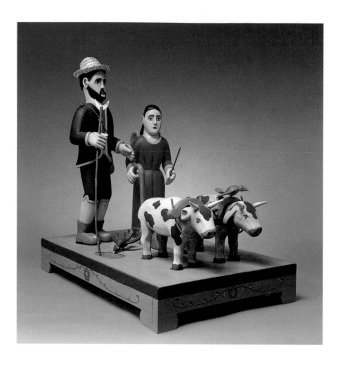

Frank Alarid,
SAN YSIDRO/SAINT ISIDORE,
1997, wood, gesso, acrylic,
leather, tin, straw, 24 x 25
x 15 inches. Courtesy of the
artist.

"Life put obstacles in my path [the army from 1970 to 1972, a divorce, a period of unemployment with a daughter to support], but this was meant to be," the santero told us. Presently Alarid is on the road to success in his chosen vocation. He lives in an adobe house he helped to construct near his old family compound on Upper Canyon Road. While there is a lot more traffic than in Alarid's childhood days, the area still has a rural feeling that inspires him to work. In addition to his work as a santero, Alarid is employed by the Museum of New Mexico Maintenance Department.

Alarid is proud of his traveling saint, "Our Lady of Guadalupe." She has been to Poland (1989) and is presently in another traveling exhibition, "La Guadalupana: Images of Faith and Devotion," organized by the Museum of International Folk Art (1996). "She's had a nice vacation," according to the artist.

Alarid has pieces in the permanent collections of the Museum of International Folk Art, the Spanish Colonial Arts Society in Santa Fe, and the Taylor Museum for Southwestern Studies of the Colorado Springs Fine Arts Center.

Frank Alarid has been exhibiting at Spanish Market since 1988 and has won many awards, including the coveted Poster Award (1989), First Prize/Retablos (1990), and the Spanish Colonial Arts Society Purchase Award/Bultos (1995). He has been featured twice on the cover of *Spanish Market* magazine (1989, 1995). "I find it unfair to people to sell my work through galleries because they double the price, so I sell from my home and at Market," declares the santero.

FERNANDO BIMONTE

Fernando Bimonte paints good-sized retablos that he calls "murals." His subjects range from the saints of his native land, Uruguay, to landscapes of his chosen home in New Mexico, dominated by religious figures. Bimonte has painted a contemporary version of the Last Supper with female participants. The themes are often religious, yet everything is open for exploration; nothing is totally dictated by history or conventional belief. Bimonte is part of the melting-pot tradition that shakes up the U.S. establishment art scene from time to time. The history of this type of contemporary art is that, given time, it tends to have a great influence on younger painters. "My work," says the artist, "is a process—a little carpentry, a little design, plus flat painting."

"THE OBLIGATION OF AN ARTIST IS TO COMMUNE WITH THE PEOPLE."

Of his present home, Bimonte relates, "When I came to New Mexico and saw the art, I said, 'Wow!'" But his journey to the Land of Enchantment took many years. He left Uruguay on an odyssey of discovery in the late 1970s, "because I could see no future for me in my country," he says.

The creation of art was in Bimonte's blood, a driving ambition. His grandfather had been, in Bimonte's words, "a monumental sculptor," working with Carrara marble from northern Italy; his brother is a painter in Uruguay. "I first went to Italy and then to Spain. In Spain, I traded my artwork for tuition to go to cooking school. Later I went to Mexico." About 1980, he arrived in New York City where he worked as a chef. By 1982, offered employment as a chef for a private oil company, Bimonte arrived in New Mexico where he married Barbara Jaramillo, a distant relative of Santa Fe's mayor.

The artist is a workaholic, spending as many as twenty hours a day in his studio preparing retablos, mixing paint, making frames, and painting. His motto is "People want to see something fresh." With that in mind, he covers his wooden surfaces with chicken wire and applies stucco, instead of the traditional gesso, adding texture and interest to the work. Employed at one time for a furniture maker, the artist is a highly skilled carpenter. "The frame," says Bimonte, "is an important part of the picture." He makes his own elaborate and painted frames that may also contain sculptural elements—

BORN
*August 12, 1955,
Montevideo, Uruguay*

RESIDES
*La Cienega (near Santa Fe),
New Mexico*

EDUCATION
About ten years of school

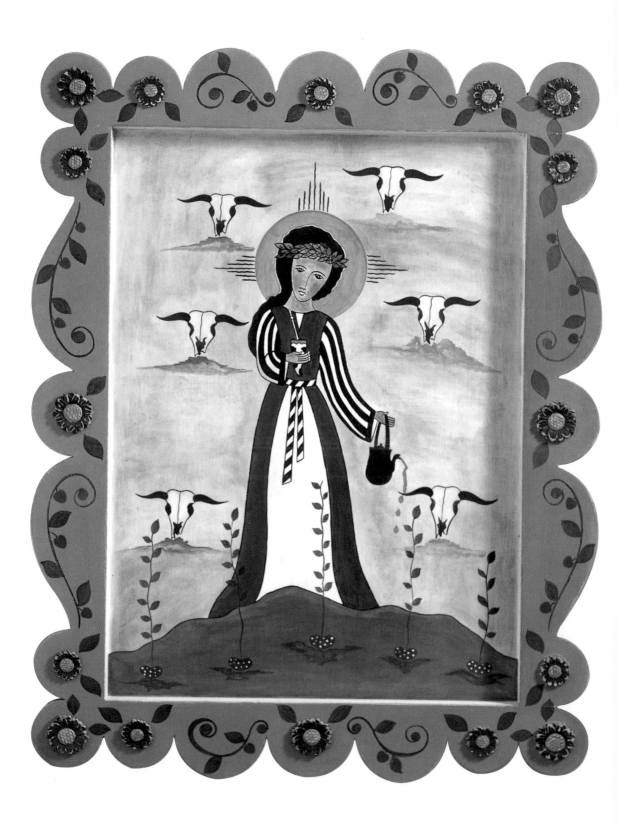

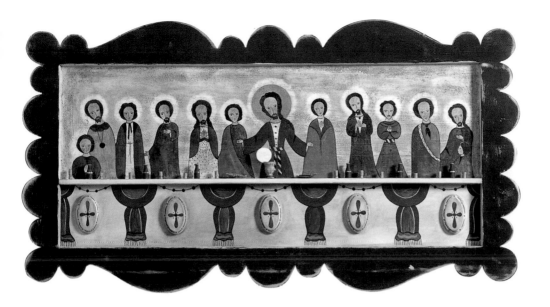

each one intended to augment the subject matter of the finished retablo. While his work is contemporary, his subjects are timeless, so the frames are antiqued with a wire brush and the retablo is finished with a coat of floor wax instead of the traditional beeswax coating used on retablos in Northern New Mexico.

Bimonte has a retablo in the church at Truchas, New Mexico. Recently, in the fall of 1997, he lectured at the Eiteljorg Museum of American Indians and Western Art in Indianapolis, Indiana, in connection with the traveling exhibition organized by the Maxwell Museum of Anthropology of the University of New Mexico and entitled "Cuando Hablan Los Santos: Contemporary Santero Traditions from Northern New Mexico." Bimonte's murals were for sale at the White River Trader, the Eiteljorg Museum store.

Bimonte is modern in his approach to selling his work. In addition to representation by several major galleries (Móntez in Santa Fe and Adalante at El Pedregal, Scottsdale, Arizona), the artist also has a website on the Internet. Sometimes his smaller pieces are available at the Museum Shop at El Rancho de las Golondrinas in La Cienega. Bimonte opens his studio to collectors each November for the La Cienega Studio Tour.

Bimonte's retablos appeal to folk art collectors in general, as well as collectors of Spanish Colonial art. While he would like to exhibit at Spanish Market, his work may be too contemporary for some of the judges.

Fernando Bimonte,
THE LAST SUPPER,
1997, wood, house paint, stucco, 36 x 65 inches. Chuck and Jan Rosenak.

OPPOSITE:
Fernando Bimonte,
VIRGEN DEL CAMPO/
VIRGIN OF THE COUNTRY,
1997, wood, paint, stucco, 45 x 35 inches. Chuck and Jan Rosenak.

FRANK BRITO SR.

Frank Brito Sr. is the heart and the soul of the living tradition of the santero in Northern New Mexico and one of the last surviving carvers of the World War I and Depression years generation. In those years cash was a rare commodity in Santa Fe. His santos became popular with those who had little cash and were not satisfied with lithographs, photographs, or plastic reproductions yet wanted images of saints. Affluent collectors of santos did not come on the scene until much later. Many of the most innovative artists of today proudly display his bultos in nichos in their homes. The younger generation is influenced by his folk art forms, which are reverent and, at the same time, contain the imaginative self-taught mastery of a man who looks at the world with gentle humor.

"CARVING SANTOS IS SOMETHING I HAVE TO DO."

BORN
January 10, 1922,
Albuquerque, New Mexico

RESIDES
Santa Fe, New Mexico

EDUCATION
Through fifth grade

Frank Brito Sr.,
OUR LADY OF THE
IMMACULATE CONCEPTION,
c. 1976, carved wood, water-colors, cloth, 18½ x 13 x 7 inches. Laurel Seth Gallery.

It wasn't easy for Brito to make his way—he quit school to help his family—cutting grass, selling papers, and doing yard work. When he grew older, he worked as a laborer and plasterer and finally for a plumbing company from 1950 until he retired in 1970. Brito now receives social security and works as a santero. "Today," says Brito, "I'm into myself—I do what I want to."

Unlike many of the young people of today, Brito did not set out to become a santero. However, the demand for saints was built into the culture and someone had to make them. "When I was thirteen, I liked to make faces," the artist remembers. "When I was twenty, I started to sell bultos door to door to the faithful for ten or fifteen dollars." And it wasn't easy to learn how to make a bulto, either. For instance, the young Brito had a serious problem: He could not afford store-bought paintbrushes. But this impediment to his trade was soon solved by an older santero. One day, while riding his bicycle on Canyon Road in Santa Fe, peddling santos to the shops that were springing up along what was then a rural unpaved thoroughfare (presently Santa Fe's bustling gallery row), the fledgling artist encountered the santero Lorenzo López Sr. (grandfather of santero Ramón José López), driving his carreta (a wooden-sided wagon pulled by mules). López had the solution to Brito's problem: He taught him to make brushes from the eyelashes of a pig or a horse, easily available at the time.

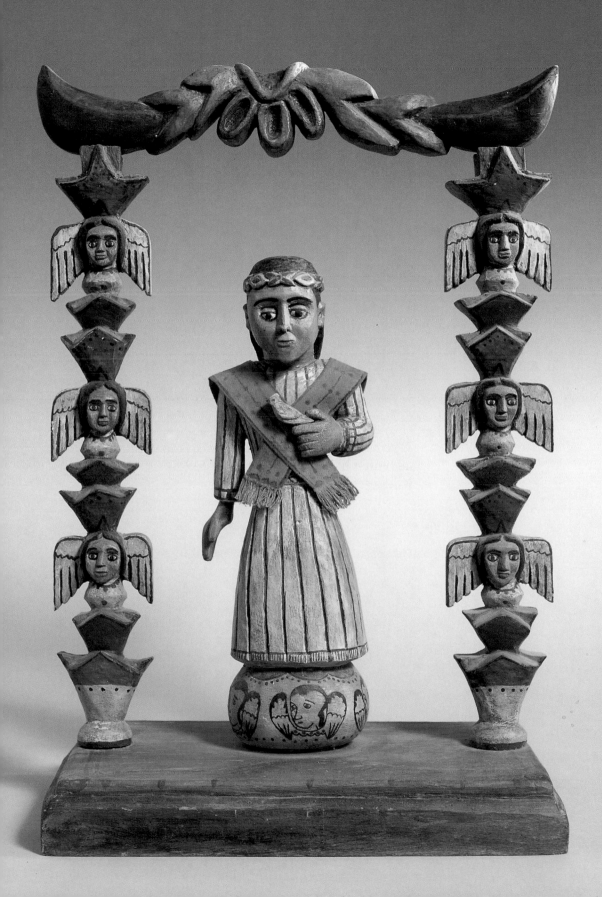

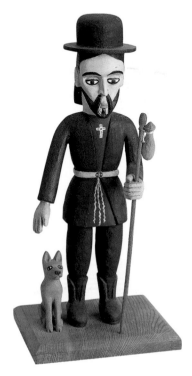

"In the 1940s and 1950s," Brito recollects, "people bought saints for devotional purposes, to have them blessed and leave them on an altar or to keep them at home and pray to them. Now this is mostly gone. Bultos cost a thousand dollars or more—galleries and rich collectors buy most of them."

For a short time during the middle 1980s, Brito made folk art animals—coyotes, rabbits, roosters, and cats—which were in great demand by tourist-oriented shops in Santa Fe. Many of these animals found their way into national folk art exhibitions and even into museums, but these animals are not considered Brito's best work.

The earliest pieces that the artist made were painted with homemade pigments, but he also used water-based paints on many of his signature works, now considered masterpieces. "I soon learned," Brito recently said, "that if you so much as sneeze on water-based paint, it may run, so I have turned to acrylic paints."

Over the years, Frank Brito sold his bultos through several upscale galleries, such as the Laurel Seth Gallery in Santa Fe. He also exhibits at Spanish Market (but irregularly since 1985), where he has won many ribbons and awards, including the Master's Award for Lifetime Achievement (1996). "Today, I have no problem selling my work," he explains. "People come to the house; they write; they call; and I don't even try to keep up with the demand."

Brito's work may be seen in many museums, including the Museum of American Folk Art in New York City, the Smithsonian's National Museum of American Art in Washington, D.C., the Albuquerque Museum, and the Museum of International Folk Art in Santa Fe. One of his bultos, a San Ysidro, was presented to Pope John Paul II when the Pope visited California in 1987.

Brito's son, Frank Brito Jr. (born December 28, 1943), also now retired, has taken up carving, working out of his father's home/studio. His work displays a lot of humor and may even be considered irreverent by some, although this is not the artist's intent. He carves saints such as San Pascual, the kitchen saint, in humorous renditions, including one version on roller skates. "Some galleries want humor," Frank Brito Jr. explains, "and I enjoy doing this kind of art." His work is very popular with tourists and others seeking objects that are less expensive than his father's. Carvings by Frank Brito Jr. may be found in many galleries and museum shops throughout the region. Brito's grandson, Gilbert Montoya Jr. is also a santero; his work can be seen at Spanish Market.

CHARLIE CARRILLO

Charlie Carrillo states that he is an "academician"—the link between the Hispanic popular culture and the santero. "My aim is, first, to educate the world and, second, to be a santero." Carrillo is a teacher first and a santero/artist second. His expertise lies in Colonial New Mexico Hispanic traditions. As a contract archaeologist for the University of New Mexico in 1977, Carrillo directed work at a site near Abiquiu, the first Spanish settlement in the area. This dig led to a lifetime of commitment: He married Debbie Barbara Eliza Trujillo, a traditional Hispanic potter from Abiquiu; discovered his own cultural ties to historic New Mexico; and became a dedicated santero.

> "I REALIZED IN THE 1970S THAT NO ONE WAS LOOKING AT HISPANIC MATERIAL CULTURE. I LEARNED THE TRADITION AND I STICK TO THE RULES, AND WHAT BRINGS IT ALL TOGETHER IS THE CATHOLIC CULTURE."

BORN
January 1, 1956,
Albuquerque, New Mexico

RESIDES
Santa Fe, New Mexico

EDUCATION
Ph.D., Anthropology,
University of New Mexico
(1996)

As an artist/teacher, Carrillo has researched the methodology of the historic santeros. He also has observed the few practitioners, such as Malcolm Withers, who were still working in the 1970s. He has mastered and revived all of their techniques—the carving of bultos and painting of retablos, the making of gesso reliefs and hollow-frame sculptures; he has studied and learned the iconography of the saints; he has found the natural pigments necessary to make paint; and he has produced, by his count, "over six thousand religious objects since 1977."

In the area of technical versatility, none has surpassed this master. But historically the santero worked within a folk art tradition. Carrillo's work, while technically and historically correct, lacks (to date) the recognizable individuality and idiosyncratic nature of folk art. As Father Thomas J. Steele, S.J. (who called Carrillo "among the best of the contemporary santeros" in his book *The Regis Santos*), explains, "An educated and sophisticated individual has a choice of style—a folk artist does not. The folk artist's style comes from a self-motivated inner compulsion that he probably can't explain and can't control." Carrillo has this choice of styles, and he has mastered many of them—his work ranges from pure folk

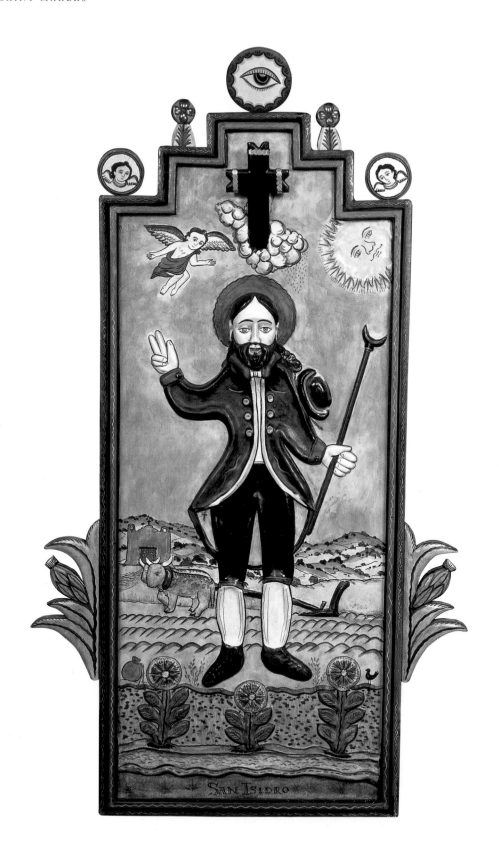

in feeling, to copies of old masters, to highly sophisticated renderings of contemporary religious subject matter. And that is okay with Carrillo—he considers the art of the santero "sacred art," not just folk art.

As a teacher, Carrillo is a crusading missionary for Hispanic culture. He states, "The formal art school is a thing of the past for this type of work. The historic santeros are the art school of the present. I have conducted more than a hundred workshops during the past fifteen years, teaching the fundamentals." Many of these workshops have been held under the auspices of the Spanish Colonial Arts Society at museums and community colleges throughout Northern New Mexico and Southern Colorado. According to Carrillo, "The renaissance in Spanish Colonial art forms is not a phenomenon that is going to come and go. It is an honest tradition with history. The people find comfort in a personal relationship with saints."

Carrillo has done more than teach; he has created exemplary work for the churches and moradas of the region. When vandals burned and destroyed the morada at Abiquiu (including a reredos made by Carrillo), for instance, he was one of the santeros who organized the morada's rebuilding. His work also appears in such churches as the church at Ojo Caliente (north of Santa Fe) and the Mount Angel Abbey and Seminary, Saint Benedict, Oregon.

Carrillo's work was included in the exhibitions "¡Chispas! Cultural Warriors of New Mexico" at The Heard Museum, Phoenix (1992), and "Cuando Hablan Los Santos: Contemporary Santero Traditions from Northern New Mexico" at the Maxwell Museum of Anthropology, Albuquerque (1995); and his work currently appears in the traveling exhibition "Our Saints Among Us: 400 Years of New Mexican Devotional Art" (1997). His santos are on display in the permanent collection of Regis University, Denver, Colorado, and they are in the Museum of International Folk Art in Santa Fe, the Albuquerque Museum, the Denver Art Museum, The Heard Museum in Phoenix, the Millicent Rogers Museum in Taos, and the Taylor Museum for Southwestern Studies of the Colorado Springs Fine Arts Center. He is the subject of a book by Barbe Awalt and Paul Rhetts, *Charlie Carrillo: Tradition & Soul/Tradición y Alma* (1995).

Charlie Carrillo, CRISTO CRUCIFADO/ CHRIST CRUCIFIED, *1992, wood, gesso, nails, leather, ribbons, 23¾ x 18 x ½ inches. Museum of International Folk Art.*

OPPOSITE:
Charlie Carrillo, SAN ISIDRO/SAINT ISIDORE, *1994, wood, gesso, natural pigments, silver, 20 x 49½ inches. JoAnn and Robert Balzer.*

His work has been presented to many dignitaries, among them King Juan Carlos of Spain and President Bill Clinton (upon his meeting with Pope John Paul II at Regis University in 1993).

Since 1980, Charlie Carrillo has been an annual participant in Spanish Market, where he won Grand Prize/Best of Show in 1990, First Place/Retablos in 1992 and 1993, the E. Boyd Memorial Award in 1994, and the Hispanic Heritage Award in 1995. In point of fact, he has won an award almost every year.

BORN
January 1, 1942,
Santa Fe, New Mexico

RESIDES
Santa Fe, New Mexico

EDUCATION
Graduate, Santa Fe
High School;
college and graduate courses;
Ph.D. candidate

OPPOSITE:
Marie Romero Cash,
LA SANTISIMA TRINIDAD/
THE HOLY TRINITY,
1997, wood, gesso, gessoed
fabric, paint, varnish, 23½ x
15 x 9½ inches. Chuck and
Jan Rosenak.

MARIE ROMERO CASH

Marie Romero Cash wears two hats: She is a modern-day santera commissioned on several occasions by Catholic churches to replace plaster of Paris saints in the churches of Northern New Mexico with contemporary images more meaningful to the community and she is a folk artist extraordinaire, creating bultos and retablos, mostly based on religious themes, for the collector and the devout alike. "I run the border between santera and folk artist," Cash says. "I am here now, and I do not intend to be conventional."

> "HISTORICALLY, YOU CAN FIND A LOT OF MATERIAL ON NATIVE AMERICAN WOMEN GOING BACK TO THE EIGHTEENTH AND NINETEENTH CENTURIES, BUT IF SPANISH WOMEN ARE MENTIONED, IT IS USUALLY DEROGATORY."

Cash has a style that is instantly recognizable—from across the vast rotunda of a cathedral or in a museum showcase. She uses bright modern colors (a lot of reds, yellows, and blues) and her figures have sharp, slim, almost abstract contours, with big hands. "Big hands are my trademark," she explains. "Except at the very beginning, I've always done big hands."

"I grew up in Santa Fe, but I don't like to be called Hispanic—I am one-hundred percent Spanish back to the 1600s. I was baptized and confirmed in Saint Francis Cathedral," Cash says. "We attended Mass in churches filled with plaster of Paris saints and marble altars. The churches with carved

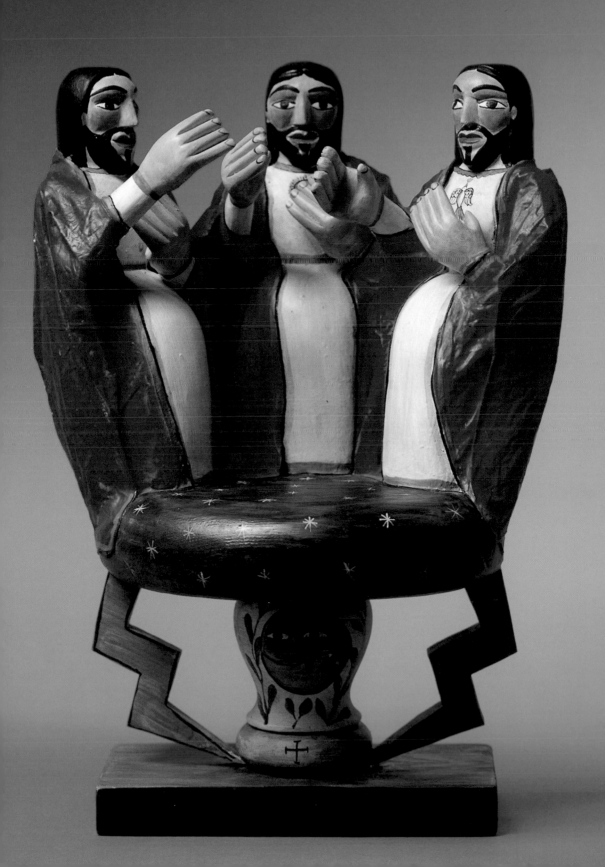

wooden santos that represented my culture were all in the villages to the north. I had to learn about my culture, the hard way, later in life." And Cash had to find herself in other

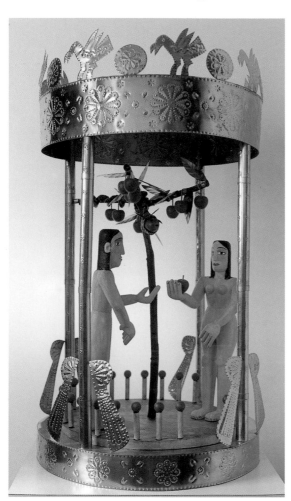

Marie Romero Cash,
ADAM AND EVE,
c. 1994, carved wood, acrylic paint, cloth, tin (Don Cash). 40 x 24 inches. Margot and Robert Linton.

ways, as well. Everyone who has attended Spanish Market is familiar with the Romero family artists and their meticulous and delicate work as tinsmiths. Her parents, Emilio and Senaida Romero, are masters of the craft, but working in tin was not for Cash.

"I was brought up to marry and be a tinsmith. I married and marriage took me away from home [places like Miami and Phoenix]," Cash says." She later worked as a legal secretary, but when she returned to Santa Fe for good in 1974, she had three children, and "art was in the air."

In 1974, she accompanied her mother to Spanish Market and sold a retablo. By 1978, Cash was carving prize-winning bultos, as well as retablos, for Spanish Market. Little by little, she visited village churches, studied, and learned about the history of Spanish Catholicism in Northern New Mexico.

Her artistic skills and knowledge of Spanish Colonial religious art led to a commission in 1984 to construct a reredos for the church at El Rito (near Abiquiu), New Mexico. This magnificent reredos, in turn, led to work on other altar screens for churches at Arroyo Hondo, Española, San Luis, the Archdiocese Chapel in Albuquerque, and a church in Pueblo, Colorado. In 1987, she received funding from the National Endowment for the Arts and the New Mexico Arts Division to document religious carvings and paintings in Northern New Mexico churches.

In 1995, Archbishop Michael J. Sheehan held a competition, which Cash won, to create new Stations of the Cross for Santa Fe's Saint Francis Cathedral (they were blessed by Archbishop Sheehan on Ash Wednesday, February 12, 1997). In the history of New Mexico, no santera has ever received so many high honors.

Cash has completed an impressive body of work, but she is also working on two books, one on Northern New Mexico village churches, to be published by the University Press of Colorado, the other on devotional spaces in Northern New Mexico *(Los Altares de la Gente),* to be published by the Museum of New Mexico Press.

Museums, as well as churches, have acquired Cash's work. These include the Smithsonian Institution's National Museum of American Art in Washington, D.C., the Museum of International Folk Art in Santa Fe, the Museum of American Folk Art in New York City, the Albuquerque Museum, the Autry Museum of Western Heritage in Los Angeles, the Taylor Museum for Southwestern Studies of the Colorado Springs Fine Arts Center.

Cash's first bulto, "Nuestra Señora del Cielo," was included in the seminal exhibition "One Space/Three Visions" at the Albuquerque Museum (1979). She was also included in an important early exhibition at the Taylor Museum, "Hispanic Crafts of the Southwest" (1977), as well as a number of later shows, such as "¡Chispas! Cultural Warriors of New Mexico" at The Heard Museum in Phoenix (1992).

Marie Romero Cash has been exhibiting at Spanish Market since 1978 and has won many honors, including the Masters Award for Lifetime Achievement (1992) and the Nathaniel Owings Folk Art Award, which was created just for her in 1995.

Cash states that she loves her work but must sell. She will take commissions and usually has pieces for sale at her home, often including small works that are ideal for gifts or for devotional purposes if a client cannot afford major pieces. The gallery shop at the Maxwell Museum of Anthropology in Albuquerque sometimes carries Cash's pieces, as does the La Bodega gallery in Santa Fe.

GLORIA LOPEZ CORDOVA

BORN
October 6, 1942,
Córdova, New Mexico

RESIDES
Córdova, New Mexico

EDUCATION
Graduate, McCurdy Mission
High School, Española,
New Mexico

Gloria Lopez Cordova,
SAN JOSÉ/SAINT JOSEPH,
1997, aspen, cedar, 19¼ x
7 x 8¼ inches. Courtesy of
the artist.

Gloria Lopez Cordova is a member, and perhaps the most famous, of the living carvers presently known as "The School of Córdova" (see also Sabinita Ortiz, page 103). She was the first santera in the picturesque mountain village of Córdova to sign her own name to her work. "My mother would sit and do the chip-carving, sanding, and detail work on the saints my father signed," she says, "and then turn to me and say, 'carving santos is a man's work.'"

"BE HAPPY WITH WHAT YOU MAKE. IF YOU MAKE
A DOLLAR, YOU DIDN'T HAVE IT BEFORE."

As the years have gone by and Lopez's style has matured and developed, her bultos have become the most decorative, exacting, and technically proficient produced by the School of Córdova. "I'll never be a saint," she is fond of saying, "but I'm not afraid of men, and when I look at the old carvings, they were beautiful and bring me inspiration and joy, but mine are more detailed and more decorative."

Cordova has known little in her life outside of the village of her birth and the vocation of santera. Her great-grandfather, Nasario Guadalupe López (1821–1891) was a santero, but it was her grandfather, José Dolores López (1868–1937), who created important innovations in the religious art forms of northern New Mexico, developing the chip-carving technique on unpainted aspen wood that has become the trademark of the School of Córdova. Cordova worked with her father and mother, Rafael and Precide López, and with her uncle, George López, from the time she was about five years old. "I did the 'woman's work,'" she explains. "The Lord must be on my side because he eventually made me an artist, too."

Cordova is known for her ability to sand and finish aspen wood to such a degree that it has been mistaken for polished ivory (like ivory it will also yellow a bit in time). "You have to be very careful with your knife," she says, "or aspen will crack." Like the other members of the School of Córdova,

the only color that she imparts to a bulto is her occasional use of unpainted cedar to highlight an object or add decorative elements to a piece. Her years as an apprentice to her father and George López show in her work—her chip-carving is exemplary. The santera has taught her children to carve, and presently several of her grandchildren are also helping, starting as she did with sanding. The art of this village is in good hands and continues into succeeding generations.

The highway leading into the picturesque mountain village of Córdova has been paved for about fifteen years now and is definitely on the map. Gloria Lopez Cordova has posted hand-lettered signs along the roadway, leading tourists and collectors to the shop that she opened in 1978. In the shop are display tables of wares for sale—hers and those of family members. Cordova makes small animals, saints, and trees of life for tourists, but she usually has a few major pieces on hand for collectors, as well.

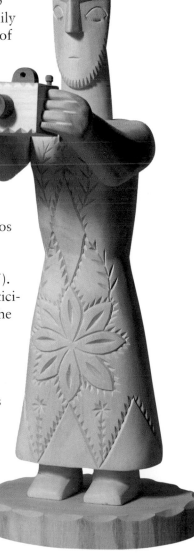

Gloria Lopez Cordova, FIGURE WITH CAMERA, *1982, aspen, cedar, 16¾ x 6½ x 5¾ inches. Museum of International Folk Art.*

Gloria Lopez Cordova's large and highly decorated pieces, especially the unique ones, have made their way into such collections as the Museum of International Folk Art and the Spanish Colonial Arts Society in Santa Fe, the Millicent Rogers Museum in Taos, and the Library of Congress in Washington, D.C. Her work was included in such shows as "One Space/Three Visions" at the Albuquerque Museum (1979) and "Cuando Hablan Los Santos: Contemporary Santero Traditions from Northern New Mexico," a traveling exhibition organized by the Maxwell Museum of Anthropology in Albuquerque (1995). Cordova was also one of the twenty-six santeras who participated in the Museum of International Folk Art's "Art of the Santera" (1993).

Cordova has been participating in Santa Fe's Spanish Market since 1976 and has won many awards over the years. She says that she "always tries to make something unique for Market—something that no one in Córdova has made before."

JAMES CORDOVA

OPPOSITE:
James Cordova,
HOLY FAMILY,
gesso relief, 1994, wood,
gesso, pigments, 29½ x 17 x 2
inches. Courtesy of the artist.

James Cordova is a young artist and scholar who has been given the opportunity to see and study the global significance of his artistic and cultural Hispanic heritage. "I am learning," he states, "to put my Hispanic culture and the religious art of Northern New Mexico into the context of the global community. I can see our art being absorbed and accepted by the big city art world—mainstreamed into the twenty-first century. I can use our traditional forms of expression to communicate contemporary ideas."

"IT'S NOT ABOUT BEAUTY. IT'S ABOUT THE STARK REALITY OF LIFE."

Cordova states, "Having lived so close to New York [he attends school in New Jersey], I see that Luis Tapia and Nicholas Herrera, in particular, are positioning themselves with politically charged work that is making an impression on the contemporary art scene." Cordova's bultos and retablos are more conservative in feeling than Tapia's or Herrera's, but he has had an opportunity to speak and demonstrate at several museums on the East Coast, such as the Museum of American Folk Art in New York City. For an artist of his age, he has already acquired quite a large following among collectors in New York.

Cordova says that sometimes, in a state somewhere between wakefulness and sleep, he sees images of the saints and forces himself to get up and sketch his dream/vision. From these sketches, he later chooses the subjects for his bultos and retablos. Cordova is experimenting with complicated tableaus, containing a number of saints or figures. He also crafts time-consuming gesso reliefs that have a contemporary feeling.

James Cordova started entering Spanish Market in 1989 as a Youth Exhibitor. In 1992, he was juried in as an adult and received the Bienvenidos Award (for a first-time exhibitor showing exceptional promise). In 1993, Cordova was the winner of the Hispanic Heritage Award, and in 1996 he won a Spanish Colonial Arts Society Purchase Award.

When Cordova has work to sell, you can sometimes find pieces at the El Potrero Trading Post in Chimayó, New Mexico, and at Móntez Gallery in Santa Fe.

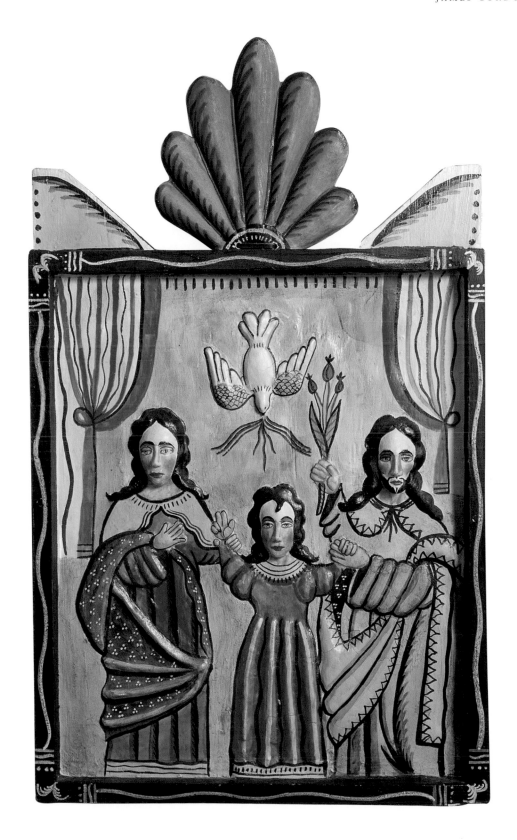

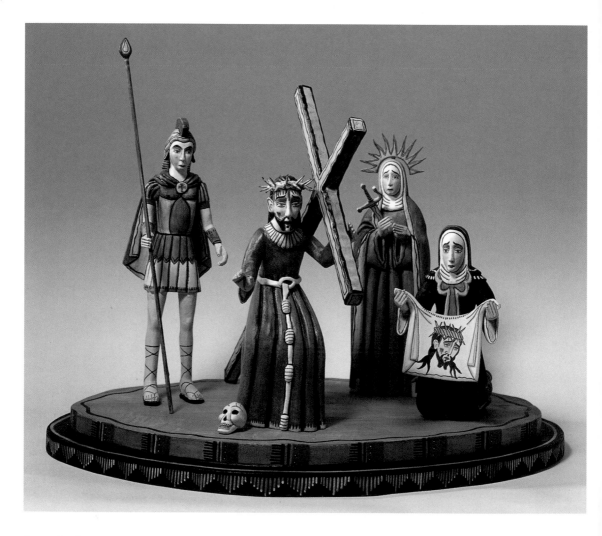

James Cordova,
CAMINO Y CALVARIO/
ROAD TO CALVARY,
1997, wood, gesso, leather,
paint, 17½ x 27½ x 18 inches.
Courtesy of the artist.

JOSÉ RAUL ESQUIBEL

José Raul Esquibel is an exemplary practitioner of what has been called the "Colorado Style" (see also Carlos Santistevan, page 118). He carves deep into the wood, often leaving portions of his bultos and retablos unpainted. His retablos contain elements of bas-relief and are intended as teaching tools for a mostly Hispanic audience. "People," he says, "are hungry for two things: food and spirituality. I cannot give them food, but I can help them find their roots so that they can return to their culture."

"EVERY BIRTH SHOULD BE CELEBRATED, EVERY DEATH MOURNED. IT IS THE SANTERO'S MISSION TO RESENSITIZE."

Because he is talking to a young Hispanic audience, Esquibel presents the saints in a contemporary mode. Instead of swords, he may include an image of a nine-millimeter gun in a portrait of Our Lady of Sorrows since the use of a gun, rather than sword or spear, is more readily understood on the streets of Denver. Esquibel goes into the high schools with his message; he also speaks regularly to clubs and groups throughout the region. In addition, he takes his message to a local prison, where, since 1984, he has carried on a ministry through the Kairos group, an interdenominational lay prison ministry.

Before taking up the vocation of santero, Esquibel was a high-level law enforcement agent. In the army, he worked in

BORN
March 21, 1944,
Littleton (outside Denver),
Colorado

RESIDES
Littleton, Colorado

EDUCATION
B.A., Regis College; M.A.,
Latin American Studies,
Georgetown University,
Washington, D.C.

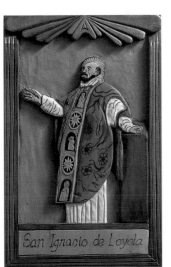

the Office of the Inspector General and later, as a civilian, for the Equal Employment Opportunity Commission (EEOC) in Washington, D.C. When he learned that his father was ill in 1982, Esquibel transferred to Denver as a senior-level manager for the local office of the EEOC (retiring in 1995). It was his boss in Denver who suggested, "Go back to your roots, Joe." And that is what Esquibel has done through his carving.

José Raul Esquibel,
SAN IGNACIO DE LOYOLA/
SAINT IGNATIUS OF LOYOLA,
1997, wood, natural pigments,
19 x 11¼ x 1¼ inches. Chuck
and Jan Rosenak.

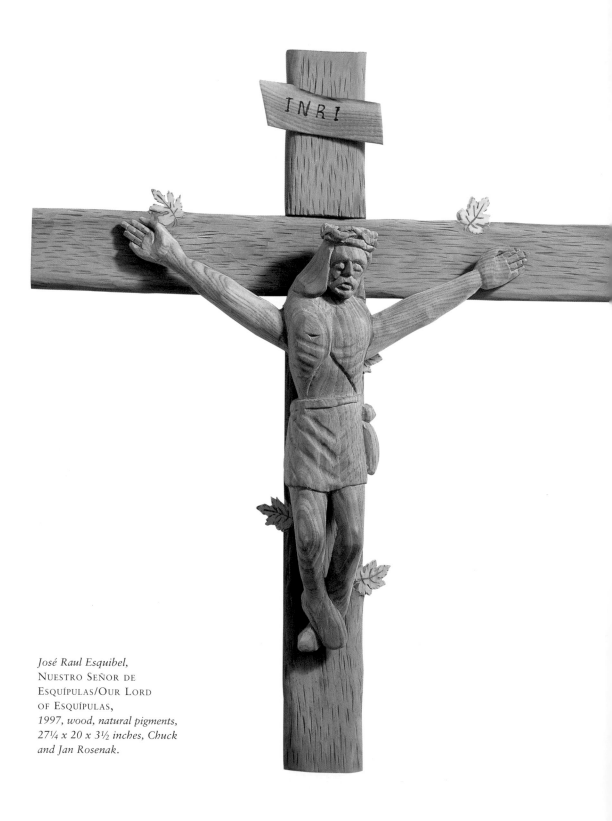

José Raul Esquibel,
NUESTRO SEÑOR DE
ESQUÍPULAS/OUR LORD
OF ESQUÍPULAS,
1997, wood, natural pigments,
27¼ x 20 x 3½ inches, Chuck
and Jan Rosenak.

"I have a charismatic gift that is unlearned," Esquibel asserts. "I have to use it!"

José Raul Esquibel was one of two santeros to be exhibited at the inaugural art exhibition for the Denver International Airport in 1997 (see also Malcolm Withers, page 130). In that year, his work was also included in "Santos: Sacred Art of Colorado" at Regis University in Denver. His bultos and retablos may be found in the Regis Collection, Denver; the Archdiocese Collection, Paris, France; and at the Penitente morada in Abiquiu, New Mexico (north of Santa Fe). Esquibel is particularly proud of an altar screen he made for the church in his father's New Mexico village of Rociada. In 1997, he won the Heritage Grant of the Colorado Council on the Arts.

To date, Esquibel has not participated in Spanish Market as an exhibitor. However, in 1996 he was asked to be a judge. When a high-level official of the Spanish Colonial Arts Society asked him how he sold his work, if not at Market, he replied, "The Penitentes and other santeros buy everything I make."

Cruzito (Cruz) Flores

Cruzito (Cruz) Flores carves bultos and paints retablos "very much in the tradition of our ancestors," intended primarily for devotional and teaching purposes. His work, however, does address contemporary concerns. "The need for the santero in day-to-day village life is still with us," he explains. "It takes the whole village to raise a child. It used to be that the Penitentes helped the village to become an extended family. Now, people come to me and say, 'My school-age daughter is pregnant; I have to have a saint.' 'My son is on drugs; I need a saint.' 'My daughter is about to have a difficult birth; can you carve a San Ramón [Nonato]?'"

BORN
May 3, 1942,
Las Vegas, New Mexico

RESIDES
Las Vegas, New Mexico

EDUCATION
Some college courses

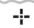

> "HISPANIC KIDS TODAY ARE NOT ANCHORED
> TO THEIR CULTURE. THE SANTERO CAN HELP
> BY FILLING THIS VOID."

Flores is presently director of staff development at the Las Vegas Medical Center, a state-run institution. He did not deliberately set forth on his second career as santero until about 1988. "Oh," he postulates, "the art was always there.

As a kid, I helped my dad, Guillermo Esperanzo Flores, make traditional furniture [some of which the family was forced to burn during an unusually cruel winter]. My father was very devout, and the family was sustained in hard times by his faith. When I was in my forties, I read a book by Father Thomas Steele [a Jesuit priest who studies, collects, and has written on the saints of the region for thirty years]. I just grabbed for it—got an old beat-up board and painted a retablo of Saint Joseph. My wife took it to a local festival and sold it for ten dollars. The purchaser said, 'Shouldn't there be some more zeros on the price?'" Thus, encouraged, Flores began to work seriously at his art.

Cruz Flores took a weekend course run by Charlie Carrillo at Highlands University and is now a teacher himself Las Vegas's Luna Vocational Technical Institute, offering classes dealing with the history and technique of designing and making retablos. Flores received a grant for this purpose from the Spanish Colonial Arts Society, the organization that sponsors Spanish Market.

"My dream," he states, "is to form our own escuelita [small school] in Las Vegas. We have people right here who could teach all of the traditional Hispanic arts—retablos, bultos, colcha [a form of embroidery], tin work, furniture, straw inlay, et cetera. I would like to see us buy one of the old historic buildings on the Plaza and set up our school there—our focus would be to bridge the past with the present, so we can have a future."

For now, Flores's immediate goal is to teach traditional Hispanic arts to his daughter and granddaughter. In fact, his granddaughter Jessica, now fourteen, has won three prizes in the Youth Exhibitors Division of Spanish Market, and, in 1994, one of her pieces was selected for the Winter Market poster.

A large statue of Jesus the Nazarene by Flores is in a local morada and another is on display at the headquarters of the Saint Joseph Society in downtown Las Vegas.

Cruz Flores sells his work at Spanish Market, at Tito's (a local Las Vegas gallery), and to people who come to his home.

OPPOSITE:
Cruzito (Cruz) Flores, SANTO NIÑO DE ATOCHA/ THE HOLY CHILD OF ATOCHA (EN NICHO), *1997, carved and painted wood, gesso relief, 19 x 14 x 7½ inches. Chuck and Jan Rosenak.*

GUSTAVO VICTOR GOLER

BORN
March 12, 1963,
Buenos Aires, Argentina

RESIDES
Taos, New Mexico

EDUCATION
A.A., Colorado Institute
of Art; conservation
apprenticeship in California

OPPOSITE:
Gustavo Victor Goler,
LA SANTA FAMILIA/
THE HOLY FAMILY,
1994, pine, gesso, watercolor,
piñon sap varnish, wax, 23¾
x 16½ x 6⅜ inches. UNM
Maxwell Museum and Penny
and Armin Rembe.

Gustavo Victor Goler gives new meaning to Biblical figures; the saints of old speak anew in contemporary terms. He has mastered his craft but he's "constantly," as he puts it, "playing around with the intricacies of color, line, and configuration." He has been working with wood since he was a teenager. He started out by helping his uncles in their restoration business in Santa Fe, calling it "playing with wood." He has interned, through his work as a conservator, with the masters, restoring pieces by such masters as José Aragón and the Laguna Santero, and on his own has created a bright new world of artistic endeavor. Goler explains himself as follows: "I call myself a santero because I study the life and iconography of the saints, but I am making the transition to artist" (others have followed the same path; see Louis Tapia, page 127, for instance).

> "I CONTINUE WITH SOME CONSERVATION WORK
> BECAUSE IT KEEPS ME IN TOUCH WITH
> THE MASTERS."

Goler is a perfectionist, constantly striving to evolve multifigured themes, the perfectly configured face, folds of brightly hued cloth that hang regally, ever more detail. But he is also a realist: "I can make no more than twelve major bultos in a year," he explains, "so I make some retablos and smaller bultos for Spanish Market. Also, I want the community to be able to afford something of mine."

After college, for a short time, Goler operated his own conservation and restoration business in Santa Fe, moving his studio to Taos in 1988. Soon he was making his signature santos. In 1989, he received a big break when he was commissioned to do the fourteen Stations of the Cross for one of the oldest and most historic churches in New Mexico, the Holy Cross Church in Santa Cruz (north of Santa Fe). Later (1995–1997), he supervised restoration of the altar screen that dates back to 1795. This historic screen had been painted, probably by the Laguna Santero, and overpainted by a master, Rafael Aragón.

The work of this young santero has been included in many major exhibitions, including "Crafting Devotions: Tradition in Contemporary New Mexico Santos" at the Autry Museum of Western Heritage in Los Angeles (1994); "Cuando Hablan Los Santos: Contemporary Santero Traditions

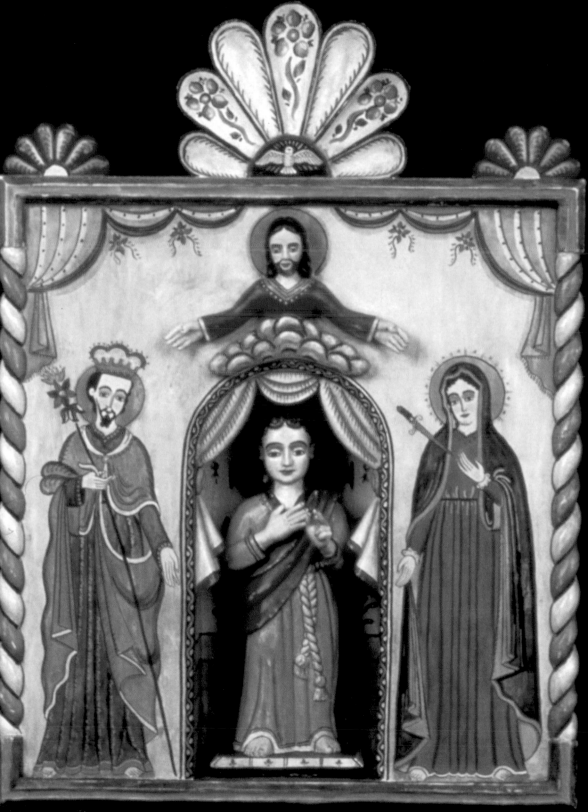

from Northern New Mexico," a traveling exhibition organized by the Maxwell Museum of Anthropology, University of New Mexico, Albuquerque (1995); and "La Guadalupana: Images of the Virgin of Guadalupe" (1997) and "Living the Tradition: Contemporary Hispanic Crafts from the Taylor Museum Collection" (1997), the Taylor Museum for Southwestern Studies of the Colorado Springs Fine Arts Center (1997).

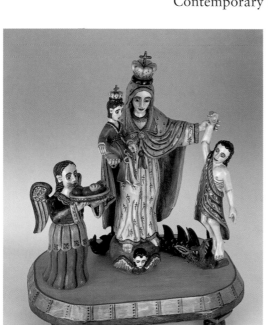

Gustavo Victor Goler, Nuestra Señora de la Luz/Our Lady of Light, *1994, wood, watercolor, gesso, 20 x 16 x 12 inches. Alfred J. Walker and the artist.*

Gustavo Victor Goler's work may be found in the permanent collections of the Autry Museum of Western Heritage in Los Angeles, the Museum of International Folk Art in Santa Fe, the Maxwell Museum of Anthropology in Albuquerque, the Taylor Museum for Southwestern Studies of the Colorado Springs Fine Arts Center, and the Regis Collection of Santos (a teaching collection assembled by Thomas J. Steele, S.J.), Regis University, Denver.

Goler had a bit of trouble getting juried into Spanish Market because he was born in Argentina, not New Mexico. However, his family moved to New Mexico when he was six years old, and Goler grew up in Santa Fe. He was accepted into Market in 1988 and immediately began winning ribbons. Among Goler's many awards are the following: the Hispanic Heritage Award (1990); Best of Show and First Place, Bultos (1992); Alan and Ann Vedder Award (1993); Best of Show (1994); and First Place in both Retablos and Bultos en Nicho (1997).

Goler sells his work at Spanish Market and at Winter Market, but when the doors open you have to proceed directly to his booth and take a number—he'll sell out within the first hour. In 1998, he participated in a gallery show at the prestigious Gallery 10 in Scottsdale, Arizona, along with Charlie Carrillo, David Nabor Lucero, and Arlene Cisneros Sena. "I really like it, though, when people come to my studio," he explains. "That way they can see what I'm about."

Nicholas Herrera

Nicholas Herrera, the "El Rito Santero," is a contemporary follower of the true folk tradition of the Northern New Mexico santero. His art celebrates the harsh and sometimes cruel reality of life in the small, mostly Hispanic farming village of El Rito. His neighbors have abandoned a horse-based economy for the pickup truck, but the village church and the nearby morada are still the cultural center of town where holy days and fiestas are celebrated. Rural life, especially for the young, has picked up some of the wild side of big cities, but this Hispanic community is still dependent upon faith and hard work for survival.

> "I DON'T HOLD BACK IN MY WORK BECAUSE OF TRADITION. I MAKE THAT WHICH HAS NEVER BEEN MADE BEFORE."

Herrera's art tells it as it is in El Rito and most of Northern New Mexico. If Christ were to return to earth, he might be arrested by the police; the figure of La Muerte (death) rides in a low-rider (an Hispanic version of a hot rod) and carries an automatic weapon (instead of the traditional bow and arrow); death in the form of nuclear waste travels the highway leading from the Los Alamos National Laboratory.

Because of his subject matter and his lack of concern for some of the traditional materials employed by the historic santeros, Herrera is considered controversial. Herrera, however, explains his lack of concern by countering, "The santeros have always used available materials. I make some of my own pigments, cover my wood with gesso, and carve traditional saints, but I will also use whatever is appropriate to make a point." Herrera's work is idiosyncratic, but so was the work of such Spaniards as Picasso and Miró and the great American artists of this century. In this sense, he is leading the way into new traditions of modern art that are yet to come (see also Luis Tapia, page 127).

Herrera tells the story of his youth as follows: "Man, it was all rock and roll—drunk-driving arrests, drugs, and girls." And then he had a profound lifestyle-changing religious experience in 1990. "While driving drunk," he relates, "I hit head on into another car. I was buried by snow and I was not found for ten hours. I died! I know I died. I was in a tunnel lit by a heavenly glow, and at the end of the tunnel

BORN
July 11, 1964,
El Rito (north of Santa Fe),
New Mexico

RESIDES
El Rito, New Mexico

EDUCATION
Mesa Vista High School,
Ojo Caliente

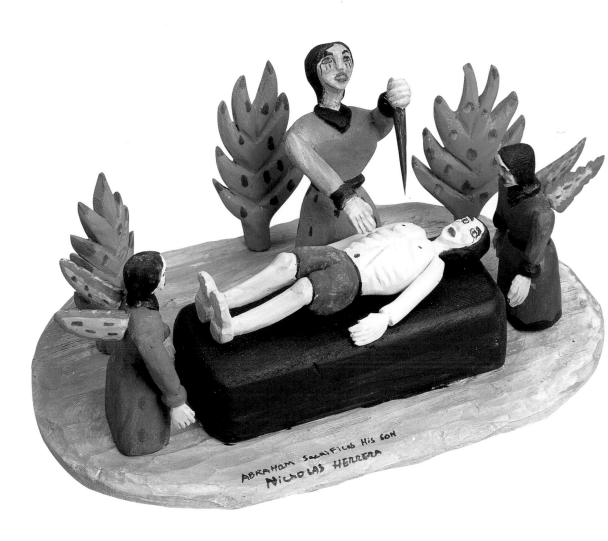

Nicholas Herrera,
ABRAHAM SACRIFICING
HIS SON,
1997, carved and painted
wood, 8½ x 6 x 11½ inches.
Chuck and Jan Rosenak.

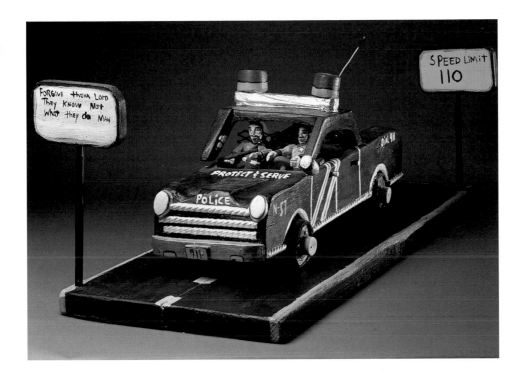

was the figure of La Muerte carved by my great uncle, the santero José Inez Herrera [the Santero de La Muerte]. God intervened. He brought me back to life to become a santero."

In order to help pay God back for saving his life, Herrera has built private chapels and done a great deal of work on the churches and moradas of Northern New Mexico. For instance, he helped in the restoration of the morada at Abiquiu and was the moving force in the restoration of the interior of the historic church at Ojo Caliente.

The El Rito Santero has work in the traveling show "Our Saints Among Us: 400 Years of New Mexican Devotional Art," organized by Barbe Awalt and Paul Rhetts (1997), and he participated in "Wind in My Hair" at the American Museum of Visionary Art in Baltimore, Maryland (1996). His work will be included in the forthcoming Smithsonian traveling exhibition "Contemporary Folk Art from the National Museum of American Art" (2000). His work is in the permanent collections of various museums, such as the Autry Museum of Western Heritage in Los Angeles, the Museum of International Folk Art in Santa Fe, the Sheldon Art Museum in Lincoln, Nebraska, and the Smithsonian's National Museum of American Art.

Nicholas Herrera has been exhibiting at Spanish Market since 1993, but like Eulogio Ortega, Enrique Rendon, Horacio Valdez, and Luis Tapia before him, his contemporary persona

Nicholas Herrera, PROTECT AND SERVE, *1994, carved wood, paint, metal, hair, 14 x 39 x 16 inches. National Museum of American Art, Smithsonian, gift of Chuck and Jan Rosenak and museum purchase.*

does not exactly fit within the traditional definitions and rules of the Spanish Colonial Arts Society. For this reason, most of his work is sold through the Leslie Muth Gallery in Santa Fe, the Big Sun Gallery in Taos, and from his restored dirt-floored adobe studio in El Rito. The artist also exhibits at a well-known New York gallery, Cavin-Morris, and in 1998 his work was included in a museum exhibit at the Halle Saint-Pierre, Paris, France. It appears unlikely that Herrera will continue to participate in Spanish Market.

Rubel U. Jaramillo

Rubel Jaramillo's faith was challenged by war, catastrophic injury (wounds in battle and an automobile accident after his return home), and alcohol and drugs, but he survived to carve simple, unadorned santos in the style of the Colorado San Luis Valley santeros of old.

BORN
October 31, 1930,
Mesitas (west of Antonito),
Colorado

RESIDES
Mesitas, Colorado

EDUCATION
Completed seven grades;
received GED in army

OPPOSITE:
Rubel Jaramillo,
Santa Rita/Saint Rita,
1997, aspen, oil paint, 17½ x
18 x 8½ inches. Chuck and
Jan Rosenak.

"I want to be remembered as a santero—
not as a warrior."

This santero is influenced by the artists who made the saints he has seen in the moradas and churches of Southern Colorado. "I don't socialize much," he states. "I don't go to Market and such to see what others are doing, but I let the wood tell me what it wants to become. In some cases, the saints come to me in my dreams, asking to be portrayed. For instance, my mother appeared to me three nights in a row, dressed in a brown robe and kneeling by my bed. The only saint I could find in a similar robe and position was Saint Rita, so I carved her with my mother's face."

Mesitas isn't even on the official map of Colorado. It is mostly abandoned now. The directions to Jaramillo's house include a turn onto a dirt road at the never-to-be rebuilt burnt-out Catholic church in the village. The town is mostly gone, but Jaramillo's roots go deeply into the remaining Hispanic community, whose way of life in the valley has changed very little.

His family received a land grant from Spain before there was a state of Colorado—9,000 acres of grazing land on the grassy slopes of a mountain, still called "Jaramillo's Vista" by the locals. His grandparents lost the land in 1940 because they could not pay the taxes (previously not assessed on grazing

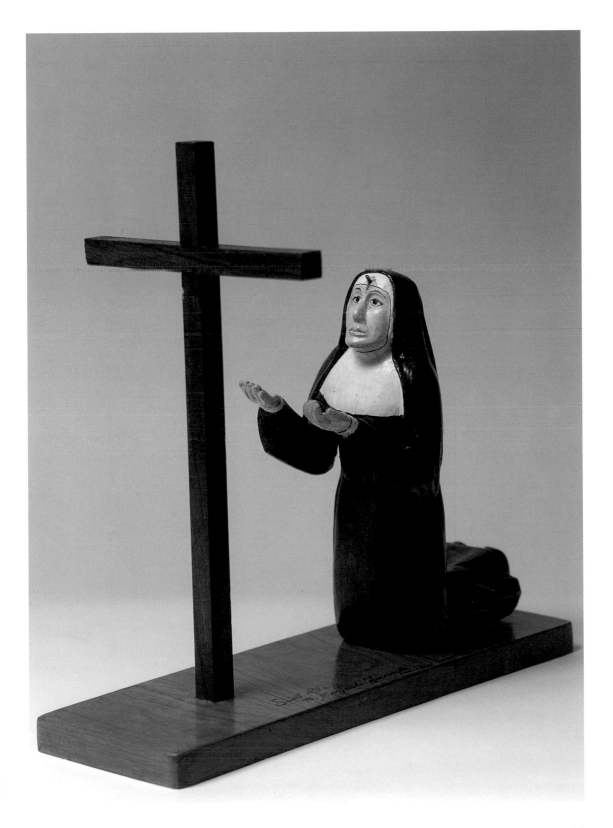

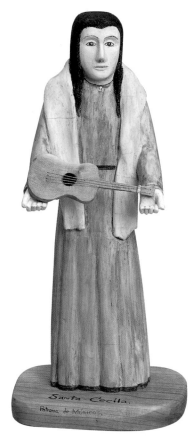

Rubel Jaramillo,
SANTA CECILIA, PATRONA
DE MÚSICOS/SAINT CECILIA,
PATRON OF MUSICIANS,
*1997, wood, wire, natural
pigments, 16½ x 7 x 5 inches.
Chuck and Jan Rosenak.*

land), but the tradition of self-reliance and the faith the family inherited were not abandoned with the town.

Jaramillo left Mesitas at sixteen (1946), a tough under-enlistment-age kid seeking adventure in the army, and he found more than he bargained for. He became a ranger, a helicopter pilot, a behind-the-lines operative in the Korean and Vietnamese Wars—spying on Chinese operations above the Yalu River, for instance. You name a bloody battle in those war years and he was there. In fact, Jaramillo has been referred to as the most decorated veteran in Colorado. "I was a destroyer of villages—a killer of women and children, and when I returned to Colorado with war injuries, I turned to alcohol and drugs."

"My life was turned around in a kiva [Native American place of worship] of the Jicarilla Apaches," Jaramillo remembers. "I am more than twenty-five percent Apache, and the elders invited me to take part in a cleansing ceremony. There were rattlesnakes in the kiva, and one shed its skin. I was reborn and given the Apache name 'Charee' or 'Rattlesnake.' I came back from the kiva on January 15, 1971, a new man."

There have been several generations of santeros in the family, and Jaramillo learned to carve from his grandfather, Marcelino Martinez, a santero and coffin maker. "I carved angels on the handles and lids of coffins as a child," Jaramillo relates. "When I returned from the cleansing ceremony, my stepfather said, 'Your grandfather's handmade tools are still in the attic. Why not take them up and dig yourself out of the grave?'"

About that time, a very old crucifix was stolen from a local church and a contest was underway to make a replacement. "I didn't know how to make gesso," Jaramillo states, "and I didn't win the contest, but Félix López [page 54], who came to the area to judge the contest, taught me how to make gesso and pigments—my career as a santero was launched."

Jaramillo became so successful that in 1991 he received a creative fellowship in the visual arts from the Colorado Council on the Arts and Humanities. Jaramillo's work is displayed in several local churches and moradas. His santos are also found in the collection of Thomas J. Steele, S.J., at Regis University in Denver, and he was included in the recent exhibition "Santos: Sacred Art of Colorado" at that university (1997).

Rubel Jaramillo has sold his art through some galleries, but mostly people hear of him by word of mouth and come to his home in Mesitas.

Anita Romero Jones

Anita Romero Jones is a pioneer santera, an expert carver of saints, painter of retablos, tinsmith, and maker of colcha. Sometimes she incorporates more than one of her skills into a single retablo (they might be framed by finely filigreed tin) or a bulto (perhaps dressed in colcha). She has set an example for, and influenced the style of, many of the younger generation of women. "I try to do them [bultos and retablos] as they were made in the past, but they come out in my style," she says.

> "I WON'T GET RICH, BUT IT'S AN INCOME
> WE CAN LIVE WITH."

Her style is very colorful and instantly recognizable. Jones starts a santo with a carefully researched iconography and reduces it in a technique that is almost minimalist in its concept—the bare essentials. Her modernized work is then covered with gesso and painted with the bright colors of contemporary life. The finished piece is decorative, fits nicely in modern interiors, and satisfies the needs of the devoted.

Jones was raised in a family of artisans who for generations earned their livings making useful and highly decorative objects out of tin. Romero tin work is present in some form (boxes, lighting fixtures, picture frames, etc.) in many New Mexico homes; it is part of what has been called the Santa Fe style. "The tin was just there," Jones remembers. "My parents [Emilio and Senaida Romero] and all of the brothers and sisters [see also Marie Romero Cash, page 28] spent our evenings together at the kitchen table working on the tin. But when my parents insisted that I go to work, I wanted to do something more.

"In 1974, my mother introduced me to Alan Vedder, who was at that time curator of the Spanish Colonial Arts Society Collection [housed then and now at the Museum of International Folk Art in Santa Fe]. He opened the door to the collection stored in the basement of the museum. That's where the folk art was. I was dumbstruck. Here was my culture that I knew very little about."

Vedder did much more for the fledgling santera. He let her borrow pieces from the collection, taught her the proper use of materials (sanding, gessoing, etc.), and encouraged her to perfect her craft.

BORN
December 12, 1930,
Santa Fe, New Mexico

RESIDES
Santa Fe, New Mexico

EDUCATION
Attended Loretto Academy,
Santa Fe

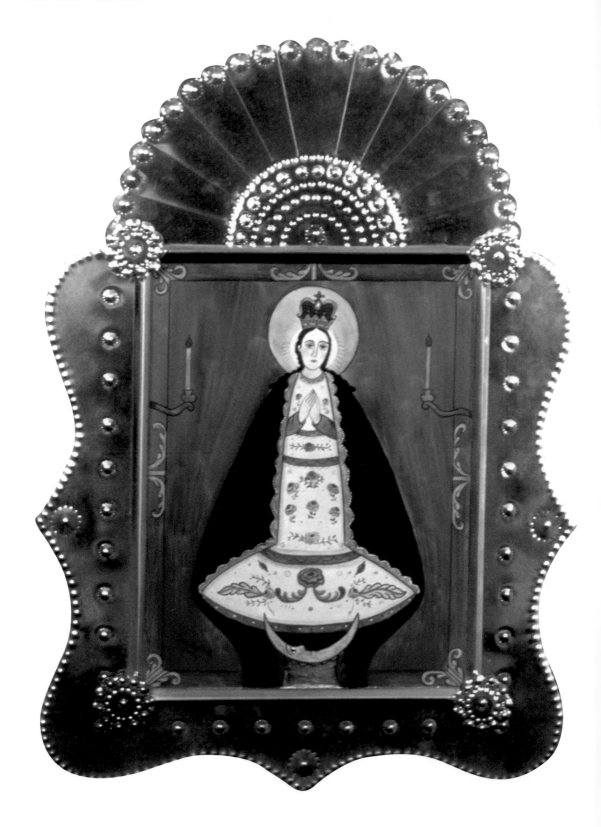

In 1974, Jones exhibited her first retablo at Spanish Market; she proudly notes, "I was the first woman doing painted bultos at Market."

Anita Romero Jones has also been an important influence as a teacher of her art. She encouraged and helped her sister, Marie Romero Cash, to get started and, among others, she has taught her two daughters, Donna Wright de Romero and Leslie Turner de Romero. Both are now recognized santeras; Donna has won Bienvenidos and Design Awards at Spanish Market and her work is in several museums, while Leslie, presently studying art in a master's program at Boise State University in Idaho, is an accomplished painter known for her retablos.

Anita Romero Jones has participated in numerous exhibitions, including "One Space/Three Visions" at the Albuquerque Museum (1979) and "Cuando Hablan los Santos: Contemporary Santero Traditions from Northern New Mexico," a traveling exhibition organized by the Maxwell Museum of Anthropology (1995).

Jones created "Our Lady of Guadalupe" on hide for Saint Joseph's Church in La Cienega (south of Santa Fe). Her bultos and retablos may be found in many museums, including the Museum of International Folk Art in Santa Fe; the Millicent Rogers Museum in Taos, New Mexico; the Taylor Museum for Southwestern Studies of the Colorado Springs Fine Arts Center; and the Albuquerque Museum.

Jones exhibits and sells her work at Spanish Market, where she has won many honors. She takes commissions and sells from her home as well. Her work, and that of her daughters, may also be found at the Clay Angel Gallery in Santa Fe.

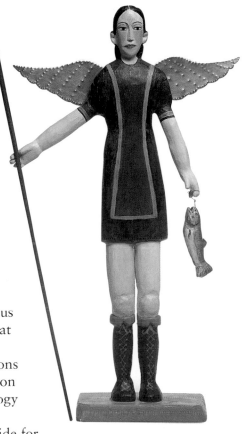

Anita Romero Jones,
SAN RAFAEL ARCÁNGEL/
SAINT RAPHAEL THE
ARCHANGEL,
1985, wood, paint, tin, 17 x 11¼ x 3⅜ inches. Museum of International Folk Art.

OPPOSITE:
Anita Romero Jones,
NUESTRA SEÑORA DE SAN
JUAN DE LOS LAGOS/
OUR LADY OF SAN JUAN
DE LOS LAGOS,
1994, tin, watercolor, 18 x 12¾ x ¼ inches. UNM

FÉLIX A. LÓPEZ

BORN
June 8, 1942,
Gilman, Colorado

RESIDES
La Mesilla (south of
Española), New Mexico

EDUCATION
Master's degree in Spanish,
University of New Mexico

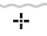

OPPOSITE:
Félix López,
LA SAGRADA FAMILIA/THE
HOLY FAMILY (EN NICHO),
1997, aspen, cottonwood,
pine, natural pigments, home-
made gesso, 58 x 32 x 26½
inches. Hijos de la Sagrada
Familia, Barcelona, Spain.

Félix López is part of the older generation that helped pre-serve the tradition of the santero during the turbulent years of the 1960s and 1970s. He is one of the most accomplished artists of his generation, a teacher and inspiration to the gen-erations that have followed him.

"A BULTO IS NOT A SANTO UNLESS IT'S FOR
DEVOTIONAL PURPOSES."

López remembers his father plowing fields behind a horse in the Northern New Mexico community of Santa Cruz where he grew up. Perhaps that is why his father became San Ysidro in the artist's classic depictions of one of the most popular saints of the area north of Santa Fe, a region of small, marginal, hillside farms and orchards where some still toil with hand tools to earn a living. "I was determined to teach Spanish and Spanish culture to the Spanish-speaking children of New Mexico. That's why I became a teacher and later a santero. I wanted the kids to improve their vocabularies and read in their language."

"I have had only limited success," López explains, "but I am really pleased when I meet a student who has done well or when a parent comes up to me and mentions the favorable influence I had on his or her child."

After obtaining a master's degree in Spanish, López returned to his alma mater, Española Valley High School, where for twenty-one years he taught Spanish to the sons and daughters of Spanish descendants, retiring in 1991 to become a full-time santero. Today he lives in an adobe compound, containing the family living quarters and a spacious studio/workshop that he shares with his talented offspring, Joseph A. López (page 62) and Krissa Maria López (page 64).

But the Spanish language is only one of the communal elements of the culture; another is fierce devotion to religion. According to López, he lost touch with an important part of his Hispanic roots while in college—the saints that stood by him during his youth. He rediscovered them at the funeral of his father in 1975. "We held the funeral service in the local morada [a Penitente chapel]," López says. "Alabados [religious songs chanted without instrumental accompaniment] were sung, and the coffin was surrounded by familiar saints. The saints surrounding my father's coffin appeared to me—I was

overcome with emotion—and I decided that, along with the language, I could teach the culture through the re-creation of traditional bultos."

According to López, "The death of my father turned my life around." Félix López became a santero, and, through his work, López has been an instrumental leader and teacher, helping to restore the prestige of a profession that had all but been abandoned by the late 1970s. López has long been a member of an informal group of woodcarvers, known as La Escuelita, which encourages members to work at traditional Spanish Colonial arts.

But López believes in a "living tradition, including innovation" that will attract the youth of today while at the same time demonstrating respect for the generations that came before. "I reposition the saints," he says, "and change their expressions and gestures. I try to carve something graceful, calm, and spiritual." His colors are vibrant, subtle, and, while for the most part traditional, may differ somewhat from the mixtures used by the santeros in Spanish Colonial times.

According to López, "God takes care of everything. I won't commercialize my work and I'd keep it all, if I didn't have bills to pay. Although I don't advertise, commissions come to me. I'm happy with my life."

López has, in fact, kept for himself the large, almost life-sized San Ysidro that he made for the much heralded traveling exhibition "Hispanic Art in the United States: Thirty Contemporary Painters and Sculptors," organized by the Museum of Fine Arts in Houston, Texas (1987). (The only other santero whose work was included in this exhibition was Luis Tapia, page 127). López's San Ysidro, like all except his very earliest bultos, was made in the traditional manner with homemade pigments that, on occasion, have included the artist's blood.

López recently helped in the restoration of a historic reredos at the Holy Cross Church in Santa Cruz, a work experts believe was painted by José Rafael Aragón in the mid-1800s. A large crucifixion by López is also installed in the Santa Cruz church.

In 1984, López was awarded a Visual Artists Fellowship from the National Endowment of the Arts, one of only two santeros who have received this honor (see also Ramón José López, page 69). In 1992, López was invited to participate in the Festival of American Folklife in Washington, D.C.

López's santos have been included in a number of major exhibitions, including such important early shows as "Hispanic Crafts of the Southwest" (1977) at the Taylor Museum

Félix López,
SANTA GERTRUDIS/
SAINT GERTRUDE,
1997, wood, natural pigments,
19½ x 9½ x 5½ inches.
Albuquerque Museum.

Félix López,
NUESTRA SEÑORA DEL
ROSARIO/OUR LADY OF
THE ROSARY,
*1994, aspen, homemade gesso,
indigo and mineral pigments,
pine resin, 42½ x 16¾ x 11½
inches. UNM Maxwell
Museum.*

for Southwestern Studies of the Colorado Springs Fine Arts Center and the Albuquerque Museum's "One Space/Three Visions" (1979). He was also one of the artists in "¡Chispas! Cultural Warriors of New Mexico" at The Heard Museum in Phoenix (1992–1993), as well as the traveling exhibition organized by the Maxwell Museum of Anthropology, "Cuando Hablan Los Santos: Contemporary Santero Traditions from Northern New Mexico" (1995), and the Taylor Museum's recent exhibition, "Living the Tradition: Contemporary Hispanic Crafts from the Taylor Museum Collection" (1997).

López's work is represented in the permanent collections of such museums as the Museum of International Folk Art, Santa Fe; the Albuquerque Museum; the Taylor Museum for Southwestern Studies of the Colorado Springs Fine Arts Center; the Autry Museum of Western Heritage, Los Angeles; and the Museum of American Folk Art in New York City.

López prefers to carve saints "that come into my head," but he will work on commission as well. The artist is a regular exhibitor at summer Spanish Market and has won various awards, including First Prize/Bultos and the Archbishop's Award.

JOSÉ BENJAMÍN LÓPEZ

José Benjamín López is known for his large Cristos (figures of Christ); one stands fourteen feet in height, with movable arms. The wounds on Christ's body appear as bloody sores. That is not to say that he does not sculpt other bultos, perhaps easier to live with, but his treatment of certain religious themes may not have mass popular appeal. López's signature works exemplify what has been referred to as the Penitente style. Lopez himself proclaims, "I follow the woodcarving traditions of New Mexico—life is graphic, not pretty, and I don't care whether people want to buy my work. It can stay right here."

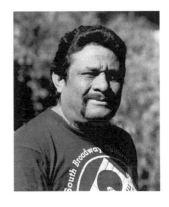

"ART IN COLLEGE WOULD HAVE WORKED FOR ME; THE OTHER STUFF I COULD NOT DO."

Museums that have studied and collected the work of Northern New Mexico santeros, as well as fellow practitioners of the art, recognize that José Benjamín López is indeed a master santero. Shortly before 1970, López became the founding father of La Escuelita (Little School). There are eleven members and, according to López, "No new members will be admitted to La Escuelita." The members of this group, all established santeros (many of whom have been friends since childhood), include Luisito Lujan and Félix López; they meet informally approximately once a month (sometimes less; there is no set schedule) to talk, exchange ideas, and work together.

López learned to love the religious and folk art of Mexico, and his work reflects Mexican influences. As a young student, he traveled with his parents to the Juárez area of Mexico on several occasions. "Mexico really opened my eyes to the culture," he says. "I was overcome by what I saw in the churches. Before I got out of high school, I was an artist. I sold my first bulto, a Saint Francis, to my typing teacher."

It was a good thing that López did learn to type. In the army (1966–1968), López saw overseas duty, but he was fortunate to work behind the lines as a clerk typist. "In Vietnam," he says, "I saw a large temple shaped like Buddha with carved stairs like dragons. This taught me that I could make large things."

Upon his return from Vietnam, López was employed as a penitentiary security guard, but in 1974 he gave up outside employment to devote full time to making art.

BORN
March 25, 1947,
Canjilón, New Mexico

RESIDES
Española, New Mexico

EDUCATION
Graduate, Española Valley
High School

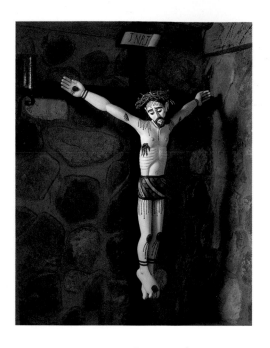

José Benjamín López,
CRISTO CRUCIFICADO/
CHRIST CRUCIFIED,
*c. 1993, aspen, Russian olive,
cottonwood, oil paint, 60
inches. Courtesy of José
Benjamín and Irene López.*

OPPOSITE:
José Benjamín López,
NUESTRO PADRE JESÚS/OUR
FATHER JESUS NAZARENE,
*c. 1980, carved wood, paint,
gesso, 84 inches. Courtesy of
José Benjamín and Irene
López.*

Today, López lives in a remarkable stone and adobe house that he has been building and adding onto for years. The fortresslike house is surrounded by a twelve-foot-high coyote fence made of slender ponderosa tree trunks with the bark still attached to the wood. There is no phone, but there is a large studio where his wife, Irene López, one of the best-known weavers of traditional New Mexico rugs, works on several handmade looms. And the López family maintains a private chapel, complete with a larger than life-sized Cristo.

López is also a teacher. He teaches a course in woodworking at Northern New Mexico Community College in Española. Recently, he received a small grant from the State of New Mexico to apprentice his son Cruz as a santero. Cruz has now embarked on an artistic career; a large bulto of his was awarded the grand prize at the "Faces of Our Lady of Guadalupe" show at the Santuario de Guadalupe in Santa Fe (1997).

The work of José Benjamín López was included in the traveling exhibition "Cuando Hablan Los Santos: Contemporary Santero Traditions from Northern New Mexico," organized by the Maxwell Museum of Anthropology, Albuquerque (1995); "¡Chispas! Cultural Warriors of New Mexico," The Heard Museum, Phoenix (1992); and "One Space/Three Visions," the Albuquerque Museum (1979). His work is in the permanent collections of the Albuquerque Museum, the Roswell Museum in New Mexico, The Heard Museum in Phoenix, the Autry Museum of Western Heritage in Los Angeles, and the Museum of International Folk Art in Santa Fe.

López has given his friends carvings, and he will sell his work occasionally if contacted at home. In the past, José Benjamín and Irene López have been asked to demonstrate at Spanish Market, but they do not maintain a booth.

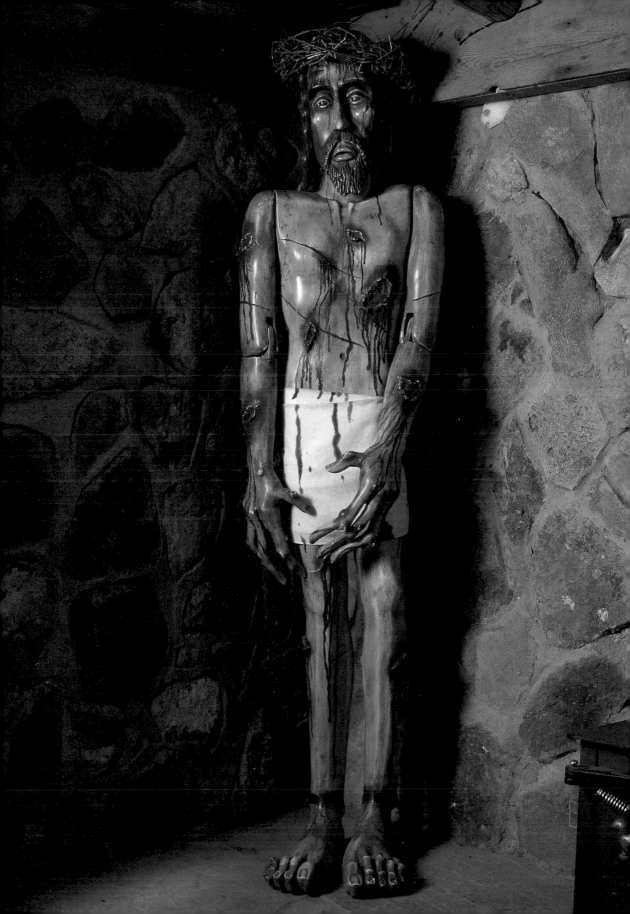

JOSEPH A. LÓPEZ

OPPOSITE:
Joseph López,
SAN ROQUE/SAINT ROCH,
1997, wood, natural pigments,
16½ x 9¾ x 9 inches. Roy
and Eileen Bidwell.

Joseph A. López, the son of Félix López (page 54), is introducing saints not previously the subject of traditional New Mexico santos to a younger audience that is eager to learn about them. "I am making bultos that fit within the present-day context of the Northern New Mexico way of life. My generation has never farmed," he states, "and Dad's generation grew up speaking fluent Spanish [López states he speaks "Spangalese"], but still the heritage of our tradition gives me the basic tools with which I can live and work in a world of change. I have to deal with trying to break away from what has already been done and to carve saints that my father did not carve, like Saint Clare of Assisi or San Roque [Saint Roch] who suffered from the plague but had a faithful dog that healed his wounds by licking them—I believe these saints to be relevant in our lives today."

"IT IS NOT ABOUT MONEY,
IT'S ABOUT SHARING OUR CULTURE."

Félix López, Joseph López, and Krissa Maria López (Joseph's sister) all share the same studio in their father's house; they make their pigments together and do research from the library accumulated over the years, but each has his or her own style of doing things and an individual vision. "There are generational differences," Joseph explains, "so now is the time for me to be my own man."

The church at Santa Cruz displays a santo by López on its altar, and his work has been exhibited at the Albuquerque Museum. Lopez has entered the summer Spanish Market for the last five years as an adult; before that he was a Youth Exhibitor. "I get enough commissions at Spanish Market," he declares, "that there is no need for me to try and produce an inventory for Winter Market. Also, my father, sister, and I participate in the annual miniatures exhibition at the Albuquerque Museum that opens in November. It would be hard to make enough pieces for the Albuquerque show and Winter Market."

A large San Ysidro by Joseph López is in the permanent collection of the Albuquerque Museum. In 1996, he was awarded First Prize/Bultos at Spanish Market.

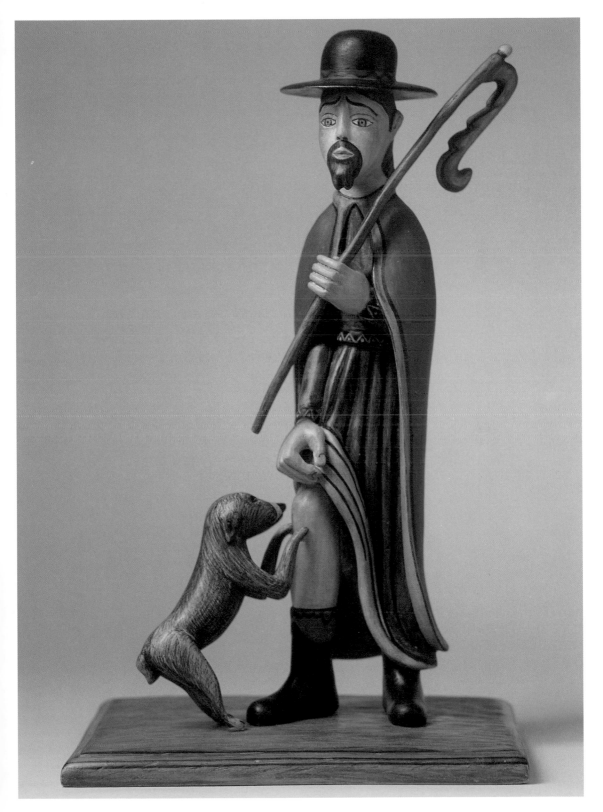

KRISSA MARIA LÓPEZ

Krissa Maria López, the daughter of Félix López, is a shining star among the next generation of santeras working "to keep the faith alive." She reminds us that "the only thing that really changes is style," and she is a stylish young lady—one that any parent would be proud of. But López is also a hard-working santera devoted to her religion and to her craft (she recently turned down tickets to a Rolling Stones concert and purchased carving tools with the money). "I'd like to work as a teacher or in a museum part-time and pass on our tradition," she theorizes about her future.

"MY MAIN INFLUENCE IS MY FAMILY AND MY FAITH."

Félix López (page 64) made sure that his daughter was well-grounded in her culture. López is fluent in Spanish; she hands in college papers in the language of her ancestors and has traveled to Puerto Rico and studied at the Universidad Autónoma de Chihuahua in Mexico. Maybe Félix López was a bit macho (he feared she might cut herself with carving tools), so he started her out on straw appliqué work at about the age of six. By age eight or so, López was competing and winning ribbons at Spanish Market in the Youth Exhibitors Division. By the time she went off to college, her father gave her a set of chisels.

"The saints and angels have always been around me," she states. "They are at my grandmother's house, they are in my dreams, and so it is only natural for me to paint them." At present, López is painting retablos with elegantly carved and painted frames. The retablos include her interpretation of some of her father's bultos placed in an imaginary, sometimes surreal, landscape, or edifice. These scenes come from her private vision of the saint in question and thus may differ from her father's interpretation.

López's style is contemporary in feeling, but it is based on tradition; her colors are more modern than those of her father—brighter and livelier. The feeling of serenity that is present in Félix López's work is not a concern of Krissa López. She also experiments with new materials; for example, she adds mica to her paint to give it sparkle and outlines with gold dust to make figures come alive. She is a truly creative person developing a style of her own.

BORN
July 7, 1971,
La Mesilla, (near Española),
New Mexico

RESIDES
La Mesilla, New Mexico

EDUCATION
Completing a master's in art
education, University of
New Mexico

OPPOSITE:

Krissa López,
LAS VISPERAS DE LA FIESTA
DEL PUEBLO DE POJOAQUE/
VESPERS AT THE FEAST OF
POJOAQUE PUEBLO,
1997, pinewood, mineral
pigments, gold leaf, varnish,
16½ x 11 inches. Courtesy
of Félix López.

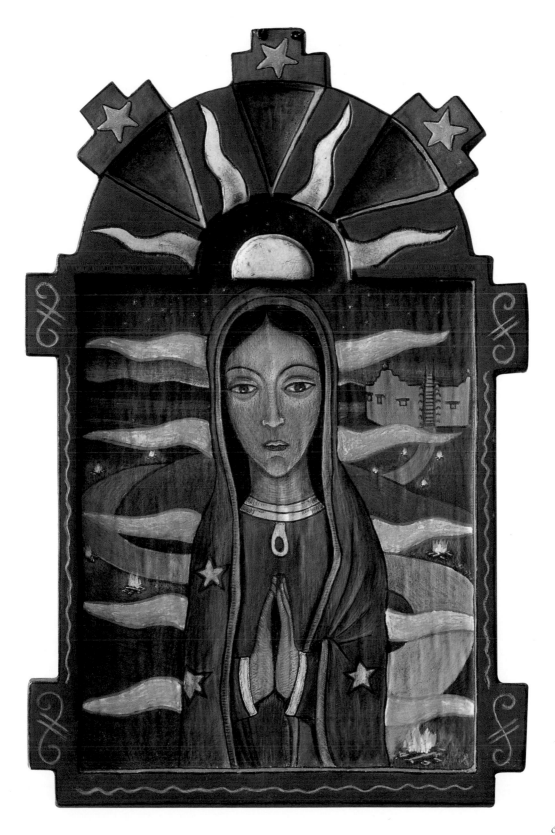

Besides the many ribbons López has taken home from Spanish Market, she won a Design Award for a retablo in 1997. Her retablos have been exhibited at the Albuquerque Museum.

BORN
May 14, 1940, Las Vegas, New Mexico

RESIDES
Montezuma (north of Las Vegas), New Mexico

EDUCATION
B.A., Art Education, University of New Mexico

PETER LÓPEZ

Peter López, who signs his work "Tio Pedro," is a trained artist and an extraordinary craftsman who commingles the historic images he has studied—Spanish provincial, Mexican baroque—with the modern art forms and technical proficiency he knows so well. "I'm creating a contemporary style of

> "MAESTRO DE ARTE DE PINTAR DE LAS IMÁGENES DE LOS SANTOS DE LOS RETABLOS" (MASTER CRAFT PAINTER OF RELIGIOUS IMAGES OF SAINTS ON WOOD PANELS)— THIS IS HOW ARTISTS OF EARLIER CENTURIES REFERRED TO THEMSELVES, AND I THINK IT'S A NICE WAY TO DESCRIBE WHAT I DO."

my own from northern New Mexico images of the 1700s to 1860s," he explains. "The santeros of the Spanish Colonial period did not make exact copies of the art of Spain or Mexico that they brought with them to the New World. Rather, they invented their own iconography, appropriate to their time and

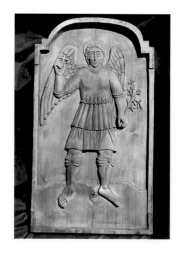

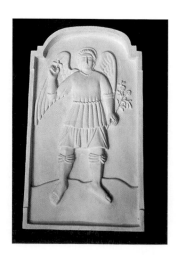

place. I carry on their tradition, creating forms that communicate emotion and beauty and devotion to a mystical faith of my time. The single element that contributes most to the vitality of New Mexico religious art is the dominant feature of Spanish thought, the concern with man's relationship to the divine."

Besides being an innovative santero, López is one of the most skilled craftsmen and painters in this book. "I had the spirituality," he says, "to become a santero, but a devil of a time learning the techniques of the trade, which are not taught in school. The Penitentes had their own style, but I was not included in their society—I had to learn how to make a gesso from rabbit-skin glue and how to grind my own pigments. I started with acrylics, then began to use natural pigments. While I often make my own, I can also buy ground natural pigments, the same mineral and vegetable pigments that are found here in nature, and, in some instances, they are easier to use and safer than homemade." The figures on López's unique retablos are often carved out of the wood, covered with gesso, then painted. He prefers old wood and uses it almost exclusively.

A few times a year, the artist makes trompe l'oeil backgrounds with brushes that are so fine they contain only a couple of bristles. His leatherlike and woodlike renditions on gesso are truly unique, but they are also very time-consuming. Another trademark of the artist is to include on the back (sometimes also on the face) of each completed retablo a carefully lettered appropriate prayer in both Spanish and English, "a kind of blessing." As a consequence of his painstaking techniques, López is able to complete only a few major pieces in a year's time.

López lives in a country cabin, hidden in pine trees in the hills above Armand Hammer United World College (where he sometimes lectures) in Montezuma, New Mexico. While he was born in Las Vegas and lives in New Mexico today, his parents took him to live in California during the late 1940s, the period when his father worked in the then booming wartime aviation industry. "I was Americanized in Los Angeles," López says, "but summers were spent with my grandparents in New

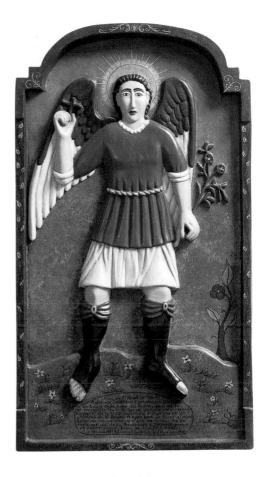

Peter López, *San Gabriel Arcángel/Saint Gabriel the Archangel, 1997, wood, gesso, natural pigments, 22 x 12 x 2 inches. Chuck and Jan Rosenak.*

OPPOSITE:
The above retablo in process. Left—roughed-out piece of old wood; center—carved bas-relief; right—retablo covered with gesso.

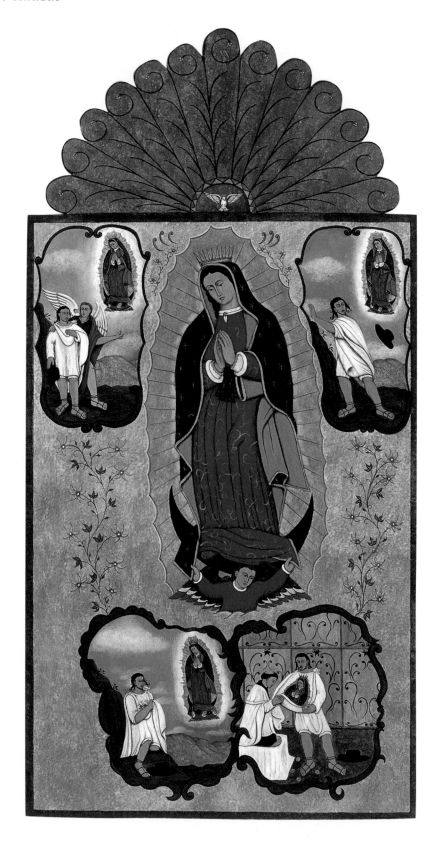

Mexico and each summer I would be reintroduced to the mysticism of the church as it existed prior to the 1960s." After a divorce, he returned to New Mexico for good in the early 1970s.

Peter López's work is included in several important private collections; one of his carved and painted retablos is in the collection of Michael J. Sheehan, Archbishop of Santa Fe. López is also represented in the permanent collection of the Museum of International Folk Art. In 1993, he won the Spanish Market Poster Award, and lucky is the collector who gets to Winter Market or Spanish Market early and finds López with a few works. He has been exhibiting at Market since 1990, but most of his major pieces are sold on commission. Occasionally, a López piece can be found at Móntez Gallery in Santa Fe or at Tito's Gallery in Las Vegas.

OPPOSITE:
Peter López,
NUESTA SEÑORA DE
GUADALUPE/OUR LADY
OF GUADALUPE,
1997, carved wood, trompe l'oeil, watercolor, 40½ x 20 x ⅝ inches. Courtesy of the artist.

Ramón José López

Ramón José López is a Renaissance man living for the "gift that God gave him"—moving people with the spirituality of his work. "God has inspired these hands," he frequently says. López works with his hands in wood (making reredos, retablos, bultos, and Spanish Colonial furniture), in silver (making fine hollow ware and jewelry), and in buffalo hide (making processional banners and clothing). Every media he has attempted, he has mastered. López is truly in the forefront of the renaissance of Spanish Colonial art forms. "When I make a processional cross, and feel the devotion, awe, and wonderment of a congregation at Easter or Christmas as it is carried to the altar, I know that I have succeeded."

"PEOPLE SHOULD SEE THE BEAUTY IN OBJECTS WHETHER THEY CAN AFFORD THEM OR NOT—MASS PRODUCTION OF ART HURTS THE ARTIST."

López even uses the tools of earlier centuries. The wood that goes into his furniture, frames, and reredos is cut with an adze and the joints are dovetailed; he gathers the natural materials for pigments; grinds and makes his own paint; and he hand cures brain-tanned buffalo hides that can weigh several hundred pounds. "You want to please people," he says. "You don't want to scare them away, but if you're not after

BORN
October 23, 1951,
Santa Fe, New Mexico

RESIDES
Santa Fe, New Mexico

EDUCATION
Graduate, Santa Fe
High School

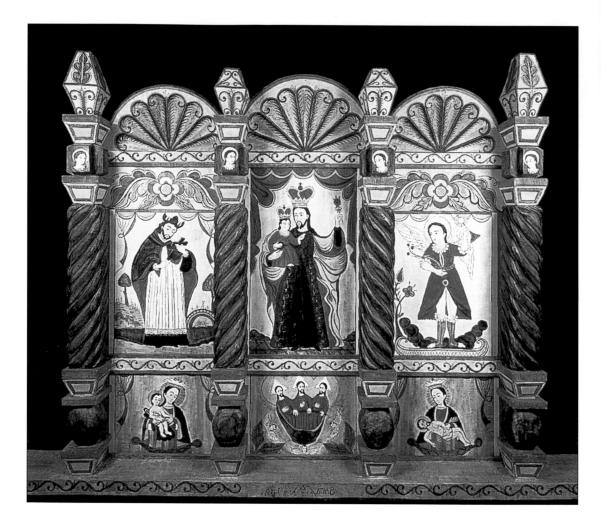

Ramón José López,
SANTA MARIA Y
JESÚS, REREDOS,
1986, pine, hand-adzed, gesso,
watercolor, 100 x 150 x 12
inches. Courtesy of the artist.

OPPOSITE:
Ramón José López,
SAN CAYETANO/
SAINT CAJETAN,
1996, water-soluble pigments
on brain-tanned buffalo hide,
72 x 55 inches. Courtesy of
the artist.

the almighty dollar, artwork must reflect the sorrow, the pain, and the suffering of the saints."

López's grandfather, Lorenzo López Sr. was a santero (see story of his meeting with Frank Brito, page 22). Lorenzo López built a capilla (chapel) on Cerro Gordo Road in Santa Fe, where Ramón José López used to play as a child. In 1990, Ramón José López undertook a labor of love, the restoration of his grandfather's capilla, which he completely restored by 1996. Now, every spring he leads a procession carrying a bulto of San Ysidro to the capilla, a blessing for the fields.

A story López told us illustrates why he feels that the hand of God may be present in his work: "Late one night, while I was kneeling to work on the frame of my large reredos [see photograph above], I was suddenly enveloped by swirling clouds. Out of the clouds, a voice, which I believe to have been one of the angels, spoke to me: 'Come to me,' it

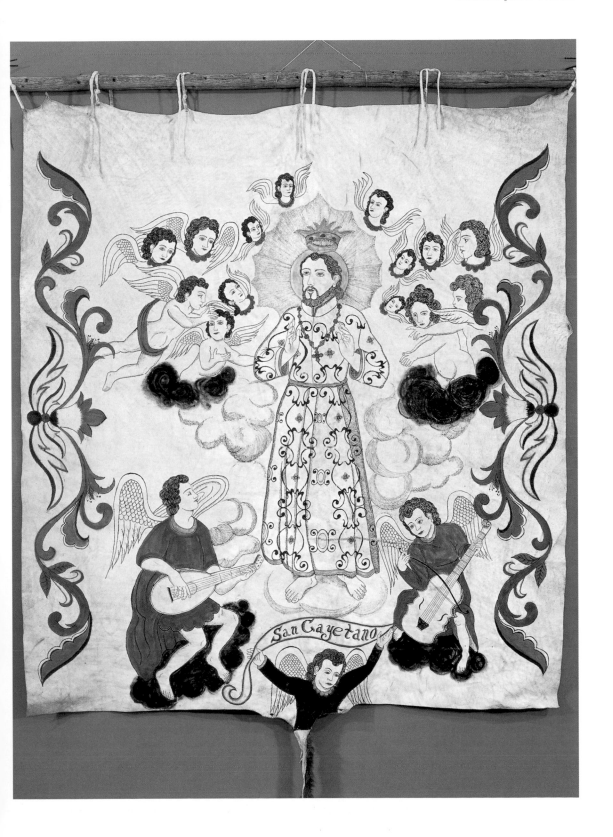

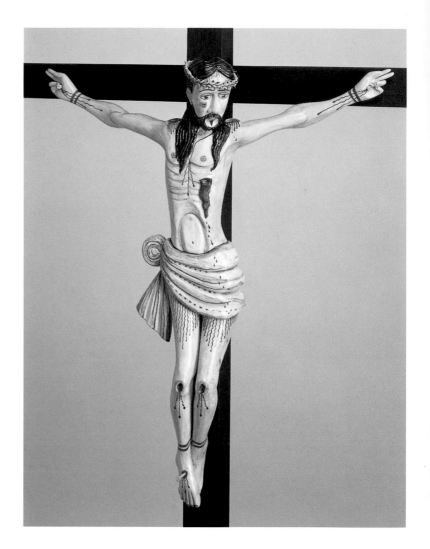

Ramón José López,
CRISTO CRUCIFICADO/
CHRIST CRUCIFIED
PROCESSIONAL CROSS,
1994 hand-carved aspen,
gesso, water-soluble pigments,
84 x 26 inches. Courtesy of
Santa Maria de La Paz
Catholic Community.

said. 'Come to my kingdom.' And I replied, 'Not yet. I have too much work to do on earth.'"

Not only does López work with the traditional crafts, but he has taught them to many of the younger santeras and santeros in this book. He conducts workshops on Spanish Colonial art at community colleges and at the Museum of International Folk Art, sometimes in conjunction with Charlie Carrillo (page 25). He is also teaching his four children (look closely at the upper corners of the reredos on page 70; his children were the models for the four angels).

The work of Ramón José López has been widely exhibited. He participated in such shows as "¡Chispas! Cultural Warriors of New Mexico" at The Heard Museum, Phoenix (1995), and "Cuando Hablan Los Santos: Contemporary Santero Traditions from Northern New Mexico," organized by the Maxwell Museum of Anthropology, University of New Mexico,

Albuquerque (1995). A one-person show of López's work opened at the Museum of International Folk Art in Santa Fe in 1998.

López's work is in the permanent collections of the Smithsonian's National Museum of American Art, the Millicent Rogers Museum in Taos, and the Albuquerque Museum, as well as other museums. He has work in several churches, including a reconciliation processional cross at Saint Francis Cathedral and a processional cross at Santa Maria de La Paz Catholic Community in Santa Fe.

López has exhibited at Spanish Market since 1981 and has won twelve First Place Awards and at least three Grand Prizes (1983, 1989, and 1993). In 1997, Ramón José López was honored with the National Endowment of the Arts National Heritage Fellowship. Besides participating in Spanish Market, López is represented by the Fenn Gallery in Santa Fe.

Raymond (Ray) López

Ray López (that's how Raymond López signs his work) creates a feeling of understated elegance that fits in wonderfully with the Spanish Colonial heritage. His sense of design captures the essence of a saint without unnecessary embellishment. Like a fashion designer, López is able to apply the right color and material where they're needed to emphasize a point. He elongates limbs and covers blemishes of configuration without offending. "Anybody can be technically correct," he theorizes. "But design is the thing. If you can design, you can do anything."

> "MOST IMPORTANT IS THAT THE FACE (OF A SANTO)
> HAVE A SPIRITUAL QUALITY—
> A QUALITY OF GODLINESS."

"It's God's grace" López states. "He gave me the desire of my heart (to be an artist). It became a reality, and I won't rush things by making more than ten or so major pieces a year." López works slowly and carefully. He clips newspaper photographs of faces that he feels have the potential of expressing saintly qualities. He then draws a composition and follows that up with a carving. Once he feels that he has captured godliness in a face, he matches it to a saint he wants to carve.

BORN
August 24, 1961,
Pojoaque (north of Santa Fe),
New Mexico

RESIDES
Pojoaque, New Mexico

EDUCATION
Graduate, Pojoaque High
School; some college courses

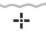

"I wanted to go to art school," López explains. "But out of respect, I couldn't lay my desire to be an artist on my parents (his father is an engineer)." López abandoned college and worked for a Spanish Colonial furniture maker. After a brief apprenticeship, he opened his own studio. By 1992, he had been admitted to Spanish Market in the furniture classification, and, in 1994, he won the first-place award in that category.

But López felt a greater calling. "I wanted to make faces so good and pure that they would move people to tears," he says, "so I began to make santos." He enrolled in a workshop run by Charlie Carrillo and Ramón José López at the Museum of International Folk Art in Santa Fe. His original intention was to learn to use homemade gesso, paint, and varnish to decorate furniture. "But I ended up dropping the furniture altogether and making bultos," he says.

Ray López's work may be found in the collection of the Spanish Colonial Arts Society, the Museum of International Folk Art, and the Santa Maria de La Paz Catholic Community in Santa Fe, as well as the Taylor Museum for Southwestern Studies of the Colorado Springs Fine Arts Center.

López has been exhibiting his bultos at Spanish Market since 1994. His work was chosen for the 1995 Spanish Market poster. In 1995, he received a blue ribbon in mixed media, in 1996 the Vedder Award for traditional materials, and in 1997 he garnered first place for bultos.

López states that he sells by word of mouth. "Good people know good people and they commission me."

Raymond López,
Job,
1997, carved wood, natural pigments, potsherd, ashes, 16½ x 16 x 12 inches. Chuck and Jan Rosenak.

OPPOSITE:
Raymond López,
Santiago,
1997, carved wood, copper, natural pigments, rawhide, gesso, tin, 16 x 15 x 11 inches. Courtesy of the artist.

DAVID NABOR LUCERO

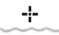

BORN
November 22, 1957,
Santa Fe, New Mexico

RESIDES
Santa Fe, New Mexico

EDUCATION
Graduate, Santa Fe
High School

OPPOSITE:
David Nabor Lucero,
THE CORONATION OF
THE VIRGIN BY THE
HOLY TRINITY,
1996, wood, gesso, natural
pigments, tin, 30¼ x 20 x
11½ inches. Taylor Museum
of the Colorado Springs Fine
Arts Center.

David Nabor Lucero fashions bultos characterized by strong lines of color, extravagant forms, and elaborate gestures. His meticulously crafted bultos contrast sharply with the simple folk forms so often prevalent in New Mexico. His work takes on a modern romantic complexity that assimilates unconsciously the best of the historic traditions of Europe and Mexico into twentieth-century religious art. Lucero is a leader of the school recognized today as the "Baroque Santeros," and he is, perhaps, their leading practitioner. The Baroque Santeros are just beginning to forge a revolutionary new (dare we say?) avant-garde style of American art. They call themselves "La Gavia" (the gang): Charlie Carrillo, Nick Herrera, Ramón José López, Jerome Lujan, Alcario Otero, and Arlene Cisneros Sena are all members. Although it cannot be said that they all work in exactly the same style, there are similarities.

"I WASN'T ON THE RIGHT PATH. JESUS GAVE ME A SECOND CHANCE."

Lucero did not deliberately set out to become an avant-garde artist, and he is too modest to consider himself in such grandiose terms. He was just another rather wild high school graduate with time on his hands. While studying electronics at a vocational school in Phoenix, Lucero ran out of money and joined the army to learn electronics (1977–1980). After his period of service, Lucero went to work for a firm specializing in the installation of burglar alarms. The wild life of his youth came to a calamitous and abrupt end in 1989. In that never-to-be-forgotten year, Lucero was involved in a crippling accident while tooling around Santa Fe on his beloved motorcycle.

Luckily for Lucero, his wife Kimberly was employed, and luckily for Lucero, Jesus spoke to him through the pain of his lengthy period of recuperation, setting him on the right path and commanding him, "Work through my hands and pull beauty out of wood."

Even after he got the message, it took some time for Lucero to learn the art of the santero. In 1990, Lucero's parents and Kimberly accompanied the still-on-crutches artist to his first Spanish Market. He was so awestruck that he became determined to get juried into Winter Market. However, his first efforts were crude and the figures were painted with

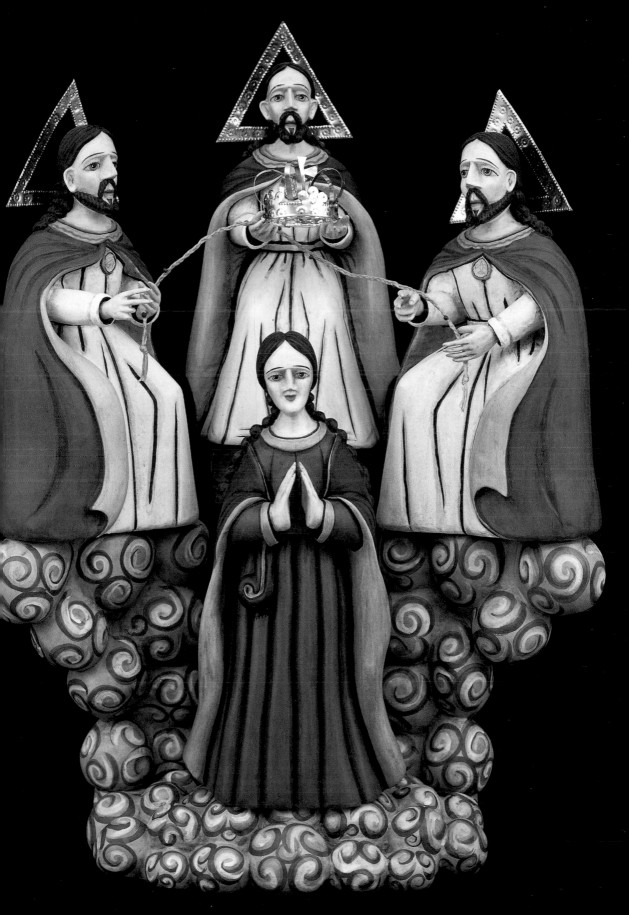

acrylics, a medium that is not a favorite of the Spanish Market jury. Lucero was rejected.

In order to help her husband gain entry into Spanish Market, Kimberly Lucero sent away for a video from a paint company that demonstrated the art of gathering and grinding natural material to make pigments for paint. The following summer (1991), Lucero was admitted to the Market. The style of his early santos showed promise and won ribbons, but the work was more traditional than his mature style that came to fruition about three years later.

The making of bultos is still very much a team effort. Kimberly Lucero does the basic grunge work, gathering and grinding the pigments, harvesting the piñon sap and mixing it with alcohol for varnish, boiling the rabbit glue to make gesso, and sanding the rough-carved work. Recently she has painted designs on the bases, as well. "I can't stop work," David Nabor Lucero is fond of saying. "I feel that every santo I pull out will help someone down the line."

David Nabor Lucero's work has been included in the traveling exhibition, "Our Saints Among Us: 400 Years of New Mexican Devotional Art," which opened in New Mexico in 1997 and is scheduled to travel to additional venues in California and Colorado. His work has gained amazing public acceptance in a short period of time. It is already included in the permanent collections of the Albuquerque Museum, the Taylor Museum for Southwestern Studies of the Colorado Springs Fine Arts Center, the Museum of International Folk Art in Santa Fe, and the collection of El Rancho de las Golondrinas, also in Santa Fe. A multifigured Nativity by David Nabor Lucero may be viewed every Christmas season at Santa Maria de La Paz Catholic Community, a new church, dedicated in 1994, which has continued the tradition of hand-crafted religious images in Northern New Mexico churches.

Lucero was one of the artists featured in the 1998 Gallery 10 exhibition in Scottsdale, Arizona, called "Northern New Mexico Devotional Art." His baroque style has also won acceptance at Spanish Market. He has taken home the Market's Grand Prize/Best of Show Award two years in a row (1996 and 1997).

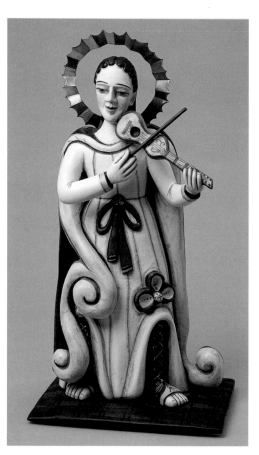

David Nabor Lucero,
SANTA CECILIA/
SAINT CECILIA,
1997, wood, gesso, natural pigments, 17½ x 9 x 6½ inches. Chuck and Jan Rosenak.

FRANKIE NAZARIO LUCERO

Frankie Nazario Lucero, who signs his work "Nazario," is developing a style of presenting Biblical themes that pushes the limits of the traditional. His audience is either young and Hispanic or collectors who realize that religious art must be innovative if it is to survive. "I carved a 'Temptation of Christ,' which included the devil," he explains. "I don't believe anyone before me in New Mexico would attempt this subject matter. But I did it with traditional methodology, so that it could offend no one." The younger generation, as well as adventurous collectors, do not necessarily seek out romantic versions of saints. They look for new saints and Biblical themes that have rarely been depicted in the religious art of the Hispanic community.

> "I AM COMPETITIVE. I HAVE THE DRIVE TO
> PUSH THIS ART TO THE LIMIT."

To satisfy his audience, Lucero's carvings and tableaus are, in modern art terminology, "hard-edged." His colors are not as soft and friendly as those of his famous older brother, David Nabor Lucero. "But," he says, "I must change tradition slowly or my work will not be accepted."

Frankie Lucero has a large local following; he and his brother José were football heroes at Santa Fe High School. In 1979, their school won the state championship, and Lucero is proud of the fact that he scored the last touchdown on the school's now abandoned Mager's Field.

After high school, Lucero ran a hotel reservation service and tour business in Santa Fe. "I had always been an artist," Lucero says. "My brother [David Nabor Lucero] urged me to try my hand at bultos. But it was when I saw his success that I knew I could also succeed."

Lucero got inspiration from his brother David and his brother's wife Kimberly on the technical aspects of grinding pigments and making gesso. By 1995, Frankie Lucero was able to quit his work for the hotel industry and support himself as an artist. He presently works full-time on the making of santos. (He makes all of his own pigments, varnish, and gesso). His small studio is located in back of his family home, where he works with his brother José Lucero. There's competition among the brothers, but it's more like it was on the football field—team spirit prevails.

BORN
April 2, 1962,
Santa Fe, New Mexico

RESIDES
Santa Fe, New Mexico

EDUCATION
Graduate, Santa Fe High
School; some college courses

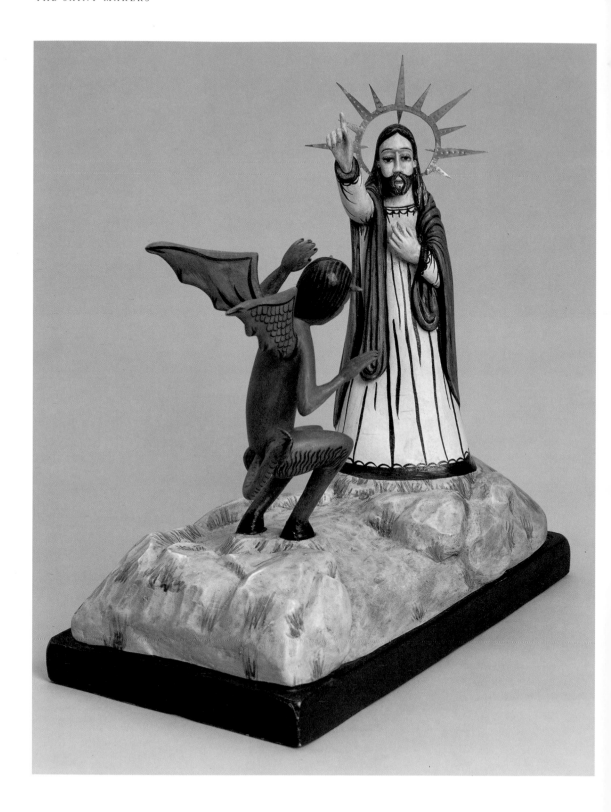

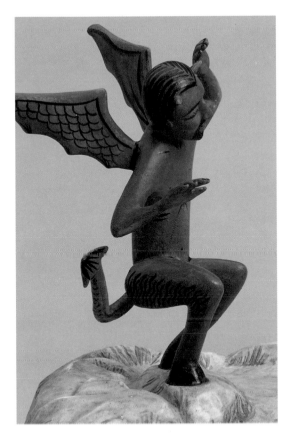

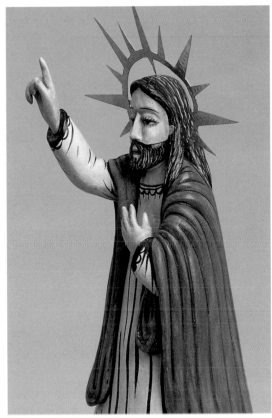

They are a team in another respect, also. In 1995, Frankie Lucero was awarded a large commission to build a reredos and Nativity for a church in El Cajón, a suburb of San Diego, California. Brothers José Lucero and David Nabor Lucero, together with their late father Nabor Lucero (who was an experienced carpenter and furniture maker), all pitched in and helped on the project.

Frankie Nazario Lucero's work is in the Regis Collection of Santos (a teaching collection organized by Father Thomas Steele, S.J.) at Regis University, Denver, Colorado.

Although Lucero has only been exhibiting at Spanish Market since 1995, he won the first Artist Collaboration Award and a Spanish Colonial Arts Society Purchase Award in 1997. His work can sometimes be purchased at John Isaac Antiques, Albuquerque; the El Potrero Trading Post, Chimayó (north of Santa Fe); and the Móntez Gallery in Santa Fe. "But," he says, "right now I can't keep up with the orders I get right here at home."

OPPOSITE AND ABOVE:
Frankie Nazario Lucero,
THE TEMPTATION OF CHRIST,
1994, wood, natural pigments, tin (Richard Lucero), 16 x 15 x 8 inches. Chuck and Jan Rosenak.

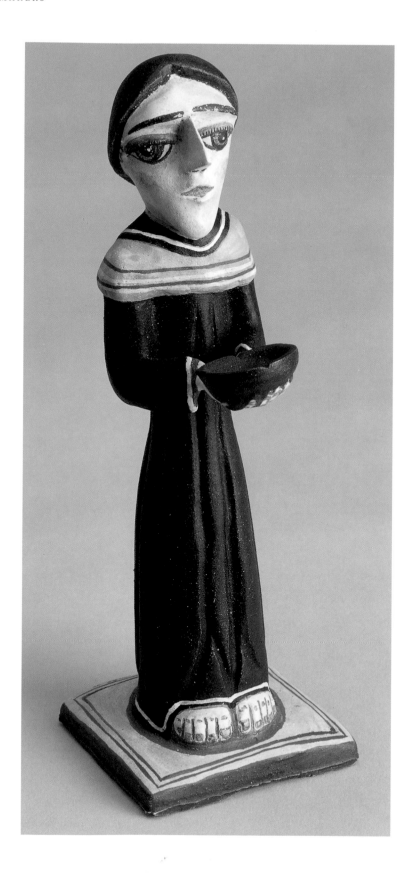

JOSÉ LUCERO

José Lucero carves in a style that we call pure folk art. Others have described his work as "byzantine"—perhaps because of its formality of design, stylized frontal presentation, elongated faces, noses, and limbs. But we feel that "byzantine" is far too elaborate a word to use in conjunction with this artist or his art. We recognize the folk artist in Lucero. He is expressing his feelings out of an unexplainable inner compulsion. You don't have to use fancy language to describe Lucero the man or his art. Folk art is well within the tradition of religious painting in Northern New Mexico. In fact, in recent years, a number of sophisticated collectors have turned away from academic art; folk art is very much in vogue.

"THE WAY I CARVE AND THE WAY I PAINT COMES OUT OF MY MIND. MY PIECES ARE WHO I AM."

After graduating from high school, where he played on the same state championship football team as his brother, Frankie Lucero, José Lucero worked as a tour guide for the Gray Line Bus Company in Santa Fe. "I saw and learned about all the old Northern New Mexico churches," he says. "It really opened my eyes." Several years ago, David Nabor Lucero gave his younger brother José a carving knife, and he quit his job as tour guide (although he still maintains some part-time employment) and took up the profession of santero.

José Lucero and Frankie Lucero share a small workshop behind their parents' home. There is good-natured fellowship among the brothers, competition, and the exchange of ideas—they are also a team. José Lucero helped his brother Frankie on the important commission for the Church of Saint Luke, near San Diego, California. José Lucero is an emerging artist who has just begun to gain recognition. We hope that he

BORN
*September 22, 1963,
Santa Fe, New Mexico*

RESIDES
Santa Fe, New Mexico

EDUCATION
*Graduate, Santa Fe
High School*

José Lucero,
CHRIST IN DESERT,
1997, carved and painted wood, cloth, 12 x 10 x 5½ inches. Chuck and Jan Rosenak.

OPPOSITE:
José Lucero,
SAN JOSÉ/SAINT JOSEPH,
1997, carved and painted wood, 8¼ x 3 x 3 inches. Chuck and Jan Rosenak.

keeps his individuality and does not take on the artistic personalities of his famous brothers.

José Lucero entered Spanish Market for the first time in 1997 and was generally considered a rising star—someone to keep your eyes on. He has sold work through the Eiteljorg Museum store in Indianapolis, Indiana, as well as through John Isaac Antiques in Albuquerque. Lucero also sells from his home.

BORN
*January 13, 1951,
Nambé, New Mexico*

RESIDES
Pojoaque, New Mexico

EDUCATION
*Graduate, Pojoaque
High School*

OPPOSITE:
Ernie Lujan,
NUESTRA SEÑORA CARMEN/
OUR LADY OF MOUNT CARMEL,
*gesso relief, carved wood,
paint, gesso, 30 x 17½ inches.
Courtesy of the artist.*

Ernie R. Lujan

Ernie Lujan, during his working years, was called "the people's cop," and, now that he's retired, Lujan is called the "santero of the people." He is known for his carved depictions of the saints in the Santuario de Chimayó, a short drive from his Pojoaque home. Thousands of pilgrims make the annual trek to Chimayó by foot and car each Good Friday. They come from as far away as Texas, and they leave behind their crutches, braces, and orthopedic shoes as a sign of cures performed or benefits received. They carry home with them the mud that continually seeps through a hole in the Santuario de Chimayó floor. This holy mud is believed to aid the arthritic joints and other ailments of the devout. The saints in the Santuario de Chimayó are truly the saints of the people, and Lujan says, "I keep returning to them—the Archangel San Rafael, Santiago, and Our Lady of Guadalupe.

"I STARTED CARVING TO MAKE PEACE WITH MY OWN HEART."

Shortly after leaving high school, Lujan served in the navy (1969–1973). "It was all right at first," he says, "but on my second tour, I was given shore duty in Vietnam and saw death and worse. By the time I returned to New Mexico, I had lost my faith in God." Upon his return home, Lujan joined the Santa Fe Police Department, where his uncle was chief of police. "For twenty years [he retired in 1993], I drew foot patrol on the Plaza in Santa Fe. I knew all the kids, their parents, locals and tourists alike. I was known as 'the people's cop.'"

It was the Archangel San Rafael from the Santuario de Chimayó who restored Lujan's faith in God. The famous bulto by José Aragón was stolen from the church in 1988

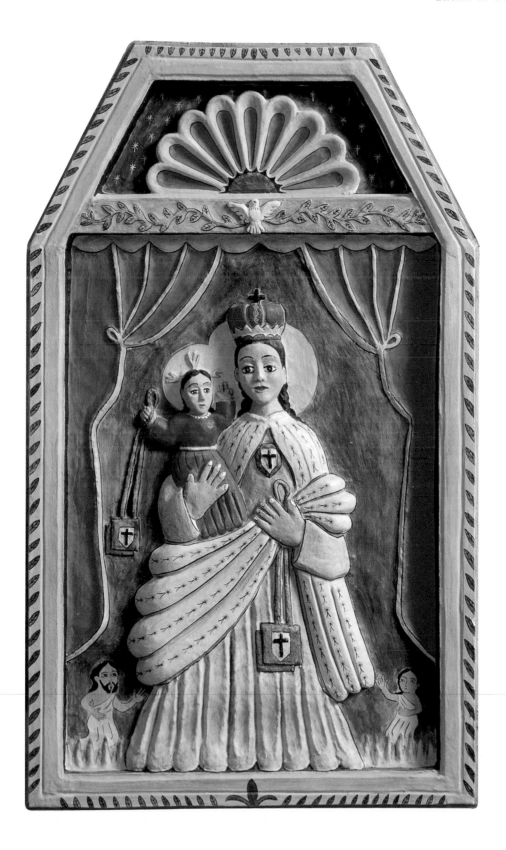

(this bulto was stolen on two occasions and influenced two different santeros; see also Eulogio Ortega, page 99) and purchased by the owner of a gallery on the Plaza in Santa Fe. Suspicious of the circumstances, the gallery owner queried his friend, "the people's cop." "I believe in miracles, and it was the first time I had ever held a saint in my hands," said the cop. "It was like San Rafael was saying, 'Take me home.' Rafael is also the saint of the blind. I had been blind to my faith, and now he was speaking to me at yet another level."

It all ended happily; the saint was returned to his home, and Lujan returned to his faith. In gratitude, he took up the occupation of santero. He had been helping his cousin Luisito Lujan (page 89), who is partially color-blind, with his colors for several years. With the help of his cousin, who was his inspiration, and Charlie Carrillo, the well-known teacher of santeros, Lujan learned the traditional craft of his newfound profession (how to make pigments, gesso, varnish, et cetera).

Today the work of Ernie Lujan may be seen in several churches, including the Sacred Heart Church at Nambé and the morada at Abiquiu. His bultos are in the collections of the Spanish Colonial Arts Society, the Taylor Museum for Southwestern Studies of the Colorado Springs Fine Arts Center, and El Rancho de las Golondrinas.

"I work for the spiritual sense of creating—not for awards or money," Lujan explains. But the artist does appear at Spanish Market and has won awards, including the coveted Hispanic Heritage Award at his first year at Market (1991). Most of his work is sold, however, through private commissions "by word of mouth." Lujan has also taught his children, hoping they will follow in his footsteps. Anthony, seventeen, and Melissa, sixteen, have participated in the Youth Exhibitors Division of Spanish Market; both are award winners in this division.

Ernie Lujan,
NUESTRO PADRE JESÚS
NAZARENO/OUR FATHER
JESUS NAZARENE,
*1997, carved and painted
wood, mica, 24 x 10 x 9
inches. Courtesy of the artist.*

JEROME LUJAN

Jerome Lujan is a comer, a young man with ambition and social and leadership qualities that were, no doubt, partially acquired from his father, Ben Lujan, a senior state legislator. Lujan's skill and drive to create unique pieces and, as he states, "push the envelope forward" are clearly apparent in his work. His style is instantly recognizable: "There's a bit of me in each piece (the pudgy fingers) and a bit of my mother (the large wide-open eyes)," he explains.

> "FLIPPING THROUGH THE PAGES OF BOOKS DOES NOT DO THE OLD SANTOS JUSTICE. YOU HAVE TO SEE THEM AND HANDLE THEM TO UNDERSTAND."

Lujan is a highly skilled electrician who works for Johnson Controls, a subcontractor at Los Alamos National Laboratory. Strangely enough, it was his electrical skills that led Lujan down the path to becoming a santero. In 1987, he took what he described as "a side job," wiring a studio for Jerry Sandoval (one of the Córdova santeros), and ended up trading the electrical work for carving lessons. "I had seen the finished santos of Luisito Lujan," he comments, "but I was afraid to try until Sandoval demonstrated the whole process for me."

"At first," he says, "I made unpainted bultos in the Córdova style. Later, in 1989, after I took a workshop from Charlie Carrillo and Ramón José López, sponsored by the Spanish Colonial Arts Society at the Museum of International Folk Art, I began using paint." The course turned out to be star-studded (Arlene Cisneros Sena; Nicholas Herrera; Ernie Lujan; Kim Lucero, wife of David Nabor Lucero; and others in attendance). Jerome Lujan can also call on his first cousin, Ernie Lujan, and his second cousin, Luisito Lujan, for help, if needed.

Because of his full-time job, Lujan does not find the time he would like to work on his art. "But," as he says, "I want to leave a message with every piece." Inside the skirt of a hollow-frame santo, for instance, he inscribes a message and the request that the finder of the message "say a little prayer for my family."

The social side of Lujan is evident in the large buffet parties Jerome and Johnell Lujan give in November for the Day of

BORN
November 21, 1964,
Nambé (north of Santa Fe),
New Mexico

RESIDES
Nambé, New Mexico

EDUCATION
Graduate, Pojoaque High
School; four-year
apprenticeship, International
Brotherhood of Electrical
Workers (IBEW); some
college courses

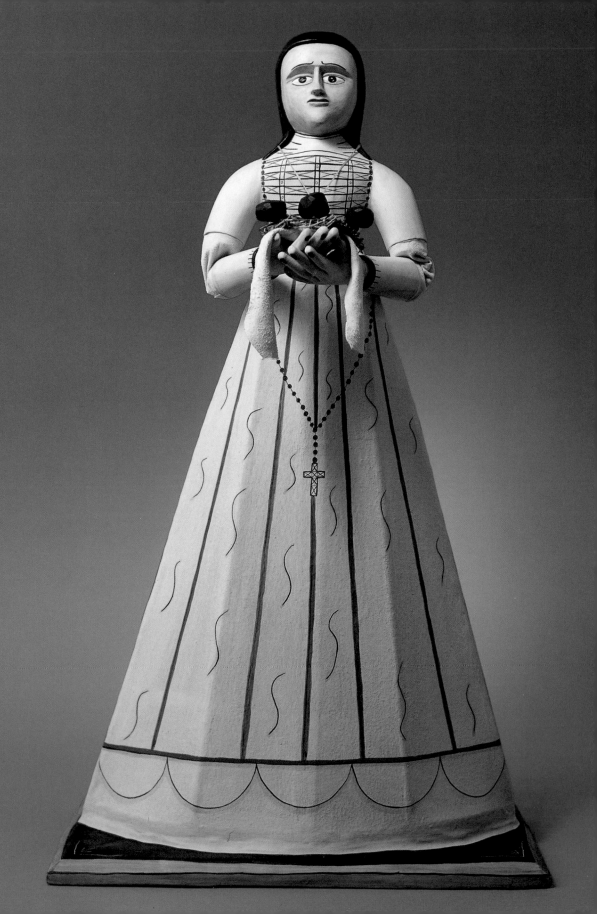

the Dead, just before Christmas, and again on Valentine's Day. Their affairs have become a regular part of the Santa Fe art scene. The santeros bring work that is appropriate for the season. Collectors join in the spirit of the holiday and celebrate with the santeros, and the work of the santeros is for sale. These buffets are by invitation only, but the Lujans authorized us to say that an invitation is easy to come by for interested parties.

Lujan's work may be found in the permanent collections of the Spanish Colonial Arts Society (housed in the Museum of International Folk Art) and the Regis University Collection in Denver, Colorado. The artist has a bulto in Our Lady of Guadalupe Church in Pojoaque.

Lujan has been exhibiting in Spanish Market since 1990. In 1997, he won the Spanish Colonial Arts Society Purchase Award (see photograph, opposite). His work is also for sale at Cline Fine Arts in Santa Fe.

OPPOSITE:
Jerome Lujan,
NUESTRA SEÑORA DE LA SOLEDAD/OUR LADY OF SOLEDAD,
1997, hollow frame, leather, wood, twine, 29 x 11 x 8 inches. Ben and Carmen Lujan.

Luisito Lujan

Luisito Lujan is a superb and careful craftsman, who first researches the lives of saints and then painstakingly employs the traditional techniques of the region, once isolated by geography from the mainstream, to make some of the most outstanding bultos of the latter half of this century. "My inspiration comes from the heart," he explains, "and from God." Lujan is, in fact, a man of God, a santero who makes santos for the use of the faithful out of religious conviction and never advertises or commercializes his work.

"THE SAINTS ARE LIKE A BLUEPRINT IN MY HEAD."

Lujan's physical activities are somewhat limited, giving him the time to live in his head and commune with saints. A rare bone disease has confined the artist to a wheelchair device that enables him to get about the house, pull up to his work space with efficiency, et cetera, but he requires assistance outside of his Nambé home. Lujan's house is a splendid example of turn-of-the-century (or earlier) adobe architecture; it is the home built by his father, a former probate judge. Lujan's family has owned and farmed the land along the

BORN
Nambé (north of Santa Fe), New Mexico; does not wish age disclosed

RESIDES
Nambé, New Mexico

EDUCATION
Graduate, Pojoaque High School

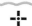

Nambé River (now dotted with the estates of new arrivals) for several centuries. The Lujan home in Nambé is almost in the shadow of Sacred Heart Church, one of the most famous and often illustrated adobe mission churches in New Mexico.

"My mother's face comes to me," the artist explains. "It's where I usually start, but I change it a bit from piece to piece." Faces are important to Lujan, but he has also researched the work of the master nineteenth-century santero José Rafael Aragón, and tries to follow him in the sense that he applies gesso to local wood and makes some of his own pigments. However, he imparts his personal spirituality to the santo. Lujan carves some of the traditional saints of the master, but he also experiments with saints new to New Mexico, such as Saint Lucy, who is called upon to help preserve eyesight. His idol, José Rafael Aragón, may have been of the nineteenth century, but Lujan's work cannot be mistaken for the art of the last century. Rather, it is contemporary in feeling—his images and colors are bold, new, and fresh in appearance.

Lujan can take all the time he needs to work in the quiet of his home; he pays no heed to the pressure caused by "orders," and, perhaps for that reason, he carves with a lot more detail than most contemporary santeros. One of the first things you notice about a Lujan bulto is the face; his faces, especially those of female saints, are unique and radiate a classic twentieth-century sense of beauty. One of the reasons the artist's colors appear vivid, not always traditional, is that Lujan claims to be at least partially color-blind. He says he has to rely on visitors to tell him "if he got the color right." The artist jokes, "I may be the only santero that paints by ear."

In order to ensure that the santero tradition survives, there must be teachers, and Lujan is a patient teacher. He has taken on several students, including his cousin Ernie Lujan, who are carrying on the work of the santero: "Sometimes they pay me a little—sometimes not—I don't care," he says. Lujan is also a member of a group of woodcarvers who call themselves La Escuelita (Little School), started by the santero José Benjamín López (page 59) in about 1975. According to López, "There are eleven of us [newcomers will never be initiated] who meet, sometimes at my home, sometimes at the homes of others, on an irregular basis. We are a family. We exchange jokes, ideas, carve together, and learn from each other." Lujan agrees that the group is like a family, that all enjoy the companionship and sharing of ideas.

OPPOSITE:
Luisito Lujan,
SANTA INÉS DEL CAMPO/
SAINT AGNES,
1991, wood, natural pigments,
33 x 15 x 9 inches. Chuck
and Jan Rosenak.

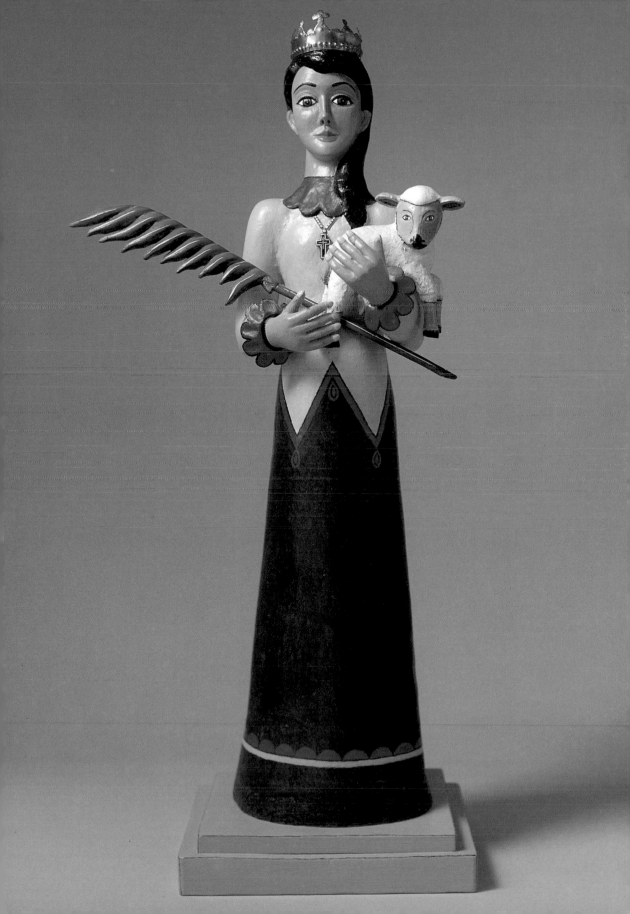

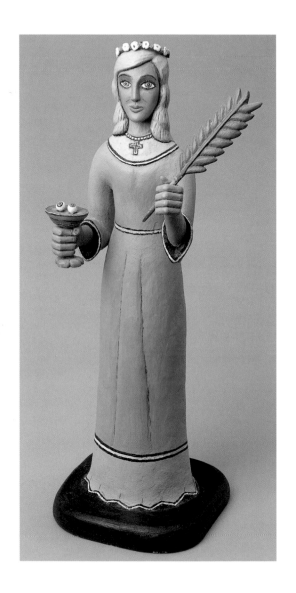

Luisito Lujan does not take a booth at Spanish Market, partly because of the long hours involved and partly because he does not believe in commercializing his art. However, he was honored by the Spanish Colonial Arts Society during the 1992 Spanish Market. That summer Lujan and the great carver Horacio Valdez (who had stopped coming to Market by then) were designated as "Honored Artists." Also, in recent years Lujan has been invited to demonstrate on the Plaza during Market, an invitation the artist usually accepts.

Lujan's work may be found in various churches, including the church at Nambé and Saint Anne's in Santa Fe. Work by the artist is in the collections of the Albuquerque Museum, the Museum of International Folk Art in Santa Fe, the Autry Museum of Western Heritage in Los Angeles, and the Taylor Museum for Southwestern Studies of the Colorado Springs Fine Arts Center.

Luisito Lujan tells us, "People come here. I don't care if I sell or not—I just want to make santos." That is the main reason the artist does not advertise or have gallery representation. Lujan states that he makes no more than five major works a year, as well as several smaller pieces and retablos— if he's lucky, no one will buy them and they remain part of the impressive display of santos on view in his home.

OPPOSITE:
Luisito Lujan,
SANTA LUCIA/SAINT LUCY,
1988, wood, natural pigments, 23 x 9 x 7½ inches. Chuck and Jan Rosenak.

Luisito Lujan,
SAN PEDRO/SAINT PETER,
1988, wood, gesso, natural pigments, 28 x 9 x 7 inches. Courtesy of the artist.

Jacob Martinez

BORN
*August 16, 1971,
near Albuquerque, New
Mexico*

RESIDES
*Dixon (south of Taos),
New Mexico*

EDUCATION
Graduate, Taos High School

Jacob Martinez is a young santero whose craftsmanship is admired by his compatriots and connoisseur collectors who are willing to take a risk on an emerging talent. "The art of the santero is evolving," he explains. "Collectors constantly want something new for their shelves. I'm sticking with this profession, and I will develop a unique style and carve saints that have never been attempted before."

"THE DEEPER YOU CUT INTO THE WOOD, THE MORE YOU FIND."

In 1993, Martinez married Veronica Valdez, the daughter of the late master santero Horacio Valdez. Martinez remembers the exact moment during their courtship, on January 17, 1992, when the master invited him into his shop in back of the Valdez hilltop home in Dixon, New Mexico. "It was like a revelation," Martinez remembers. "His bultos inspired me to carve, yet I was frightened to try. In a gentle tone of voice Horacio said to me, 'If you can do a crucifix, you can do anything. Start with the feet!'" Martinez started with the feet as directed. The crucifix Martinez made that day was soon sold and now hangs in a Taos bed and breakfast.

Unfortunately, Horacio Valdez died on August 16, 1992, but "I knew by then," Martinez says, "that it was destined to be—my career as a santero." For the first few years, Martinez worked in the style of the master, perfecting the techniques that he learned from Valdez. In the last two years, however, he has gradually developed his own individuality. But there is a lesson he will never forget: "Start with the feet"—and he does.

Jacob Martinez had a big breakthrough into the top ranks of santeros in April of 1997. The Taylor Museum for Southwestern Studies of the Colorado Springs Fine Arts Center purchased for its permanent collection a carving by Martinez depicting "The Flight into Egypt."

Martinez says he has not been able to accumulate a body of work in order to have pieces available to be juried into Spanish Market. "As fast as I make them," he explains, "collectors who have pieces by Horacio Valdez buy my work." Another problem Martinez mentions is that Spanish Market judges generally favor the use of natural pigments. "Horacio

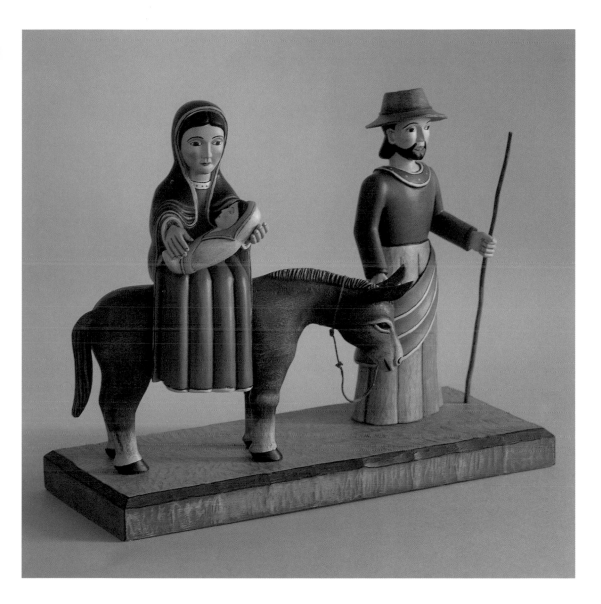

Valdez did not enter Spanish Market in his later years; he preferred acrylic paints. I use acrylics now (that is how I started), but I intend to learn to make my own pigments in the future so that I will have a better chance to get into Market," he says. The Móntez Gallery in Santa Fe and John Isaac Antiques in Albuquerque occasionally are able to obtain work by Martinez, but most collectors visit his home in Dixon, New Mexico.

Jacob Martinez,
THE FLIGHT INTO EGYPT,
1997, wood, gesso, acrylic paint, 16¼ x 18 x 7 inches. Eulogio and Zoraida Ortega.

Margarito R. Mondragon

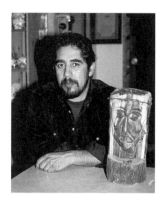

BORN
May 30, 1950,
Ocate, New Mexico

RESIDES
Las Vegas, New Mexico

EDUCATION
Completed high school,
Las Vegas, New Mexico

OPPOSITE:
Margarito Mondragon,
BREAKING THE BREAD,
1997, carved and painted
wood, 18½ x 9½ x 12½
inches. Chuck and Jan
Rosenak.

Margarito Mondragon, who signs his work "MRM," is an artist to keep an eye on. He has only been exhibiting in Spanish Market for two years (1996 and 1997), but his retablos and bultos, in the traditional style of Northern New Mexico, have already gained him considerable recognition. We thought that his reredos in the form of a large retablo in the exhibition "Our Saints Among Us: 400 Years of New Mexican Devotional Art" was a showstopper. Mondragon is part of the School of Las Vegas (see also Peter López, page 66, and Cruzito Flores, page 39); any serious collector of Northern New Mexico art should try to visit all three of these artists or see their work at Spanish Market.

"BEING A SANTERO IS SOMETHING THAT CAME FROM MY ANCESTORS."

Mondragon's great-grandparents settled near Ocate, New Mexico, where they ranched. The artist relates that his great-grandfather and grandfather were santeros of some repute in the local community, but unfortunately their work does not survive; it was destroyed when the morada at Ocate burned to the ground many years ago. Mondragon's father, however, moved the family to Las Vegas, where the artist attended school. After high school, Mondragon worked for the State Highway Commission as a heavy-equipment operator until 1988.

In 1991, the artist had a vision that changed his life: "My son was in the hospital awaiting open-heart surgery, and I went to the mountains to cut a load of firewood," he says. "I found a cedar log and saw the face of Christ in the wood. God had spoken to me, and I rescued Him from the wood. I knew then that my ancestors intended me to become a santero. I feel proud that I have inherited their talent."

At first, the artist just painted on old boards, working with acrylics and oils, but Charlie Carrillo and David Nabor Lucero encouraged him to go further. Gradually he learned to use traditional materials—natural pigments, gesso, and piñon sap varnish. But Mondragon's basic technique remains true to his original revelation; he visualizes his subject in the wood and just "works to bring it out."

Mondragon is gradually becoming recognized as a master and a teacher in his own right. Besides teaching his son and

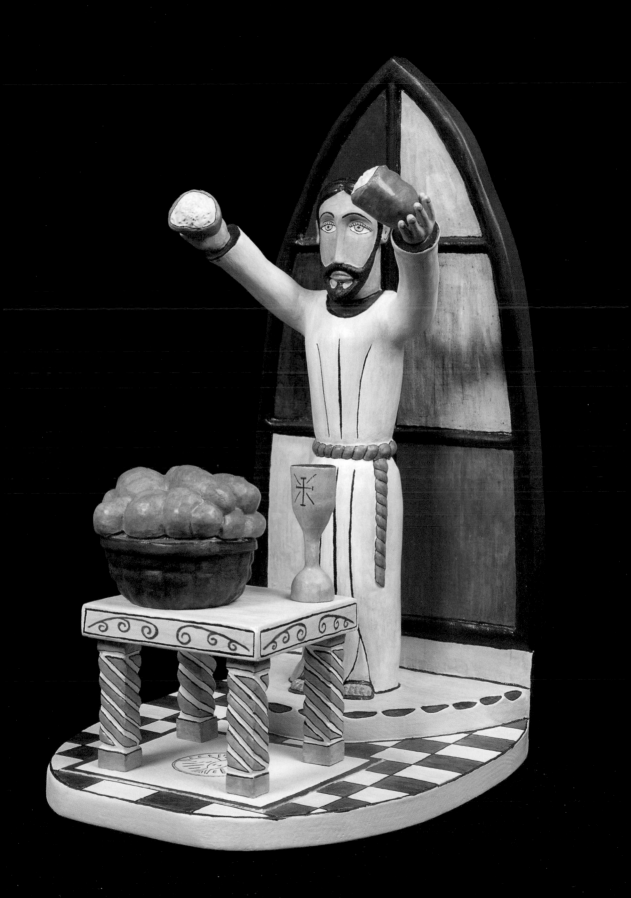

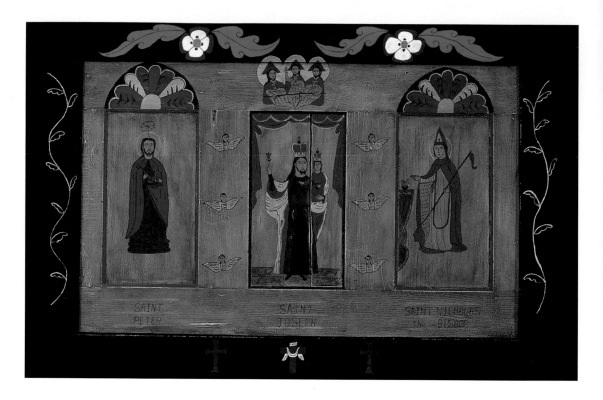

Margarito Mondragon,
MINIATURE REREDOS/
ALTAR SCREEN,
*c. 1993, painted wood,
30 x 45 inches. Courtesy of
the artist.*

daughter (who are becoming quite proficient), he teaches a class on retablo making at Robertson High School in Las Vegas. "The kids make them and give them to parents and relatives as presents," he explains.

Mondragon's work may be found in the Las Vegas Museum, in the Santuario at Chimayó, and in the Carol Burnett collection, among others. His work is included in the exhibition "Our Saints Among Us: 400 Years of New Mexican Devotional Art," which opened in Farmington, New Mexico, in November of 1997 and will travel to various other venues.

Margarito Mondragon sells his retablos and bultos at various fairs throughout the year, including the Indian-Spanish Market sponsored by the Taylor Museum for Southwestern Studies of the Colorado Springs Fine Arts Center. In addition, Tito's Gallery in Las Vegas and the Móntez Gallery in Santa Fe have Mondragon's work available from time to time.

EULOGIO AND ZORAIDA ORTEGA

Eulogio Ortega is a quiet man of great devotional strength who, with inspiration and assistance from his wife Zoraida, built a capilla (private chapel) and created some of the best religious art of this century. His sincerity and humility shine forth in his work. When one comes upon his unadorned and uncontrived bultos and crucifixes in churches or in museums, they speak to the devout and to the art critic alike. They represent the very essence of what the religious art of Northern New Mexico is all about.

"WE ALL HAVE THE SPIRIT WITHIN US—
WE'RE SURROUNDED BY MYSTERY."—EULOGIO

Ortega explains his philosophy as follows: "I have so much respect for the santeros of old—they were not interested in fame or material goods. They were only interested in filling the spiritual needs of the people. I feel unworthy to be called a santero; I call myself a maker of religious art."

We met Ortega over ten years ago and know that his old friends, now gone, the great santeros Horacio Valdez and Enrique Rendon, patterned their lives and their art partly on his example and referred to him as a santero out of respect, and so we will call him a santero's santero—a holy man.

Ortega and his wife Zoraida spent their working years teaching in the public schools of New Mexico—at first, in the Pecos area east of Santa Fe during the Depression. Later, after returning from duty in the army (1941–1945), Eulogio Ortega became principal of the school in Dixon, New Mexico. Zoraida taught in Velarde, retiring in 1975. Ortega says his aim was always "to educate Hispanic kids so that they could fit into the mainstream."

"FINALLY, OUR CAPILLA WAS COMPLETE,
A DREAM COME TRUE."—ZORAIDA

Ortega became a santero and helped to build the family's famous capilla with the help of a series of events that could be classified only as fortuitous, miraculous, or inspired by God's intervention, depending upon your personal belief. It all started this way: In 1977, a bulto of San Rafael by the famous nineteenth-century santero José Aragón was stolen from the Santuario de Chimayó (this bulto was stolen on two occasions;

EULOGIO ORTEGA

BORN
December 28, 1917,
Las Vegas, New Mexico

RESIDES
Velarde (north of Santa Fe),
New Mexico

EDUCATION
Bachelor's Degree, Art
Education, Highlands
University, Las Vegas,
New Mexico

ZORAIDA ORTEGA

BORN
June 22, 1918,
Velarde, New Mexico

RESIDES
Velarde, New Mexico

EDUCATION
Graduate, Highlands
University, Las Vegas,
New Mexico

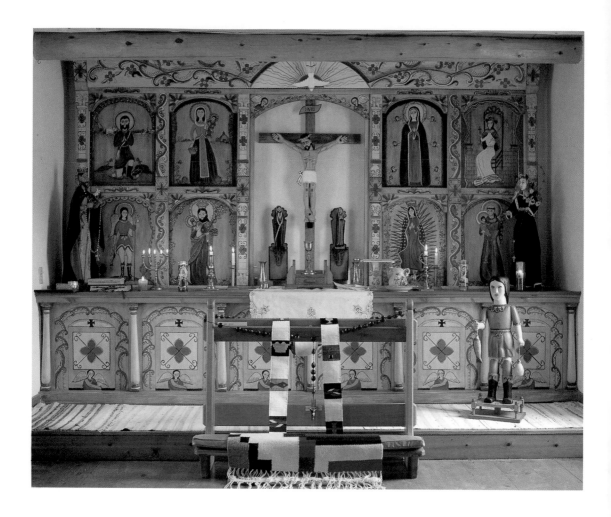

Eulogio and Zoraida Ortega,
REREDOS, INTERIOR OF
ORTEGA CAPILLA AT
VELARDE, DEDICATED TO
OUR LADY OF GUADALUPE,
c. 1982, 12 x 10 feet.
*Courtesy of Eulogio and
Zoraida Ortega.*

OPPOSITE:
*Zoraida Ortega,
detail of reredos:* LA HOYA.
*Courtesy of Eulogio and
Zoraida Ortega.*

see also Ernie Lujan, page 84; its loss inspired both santeros).
Ortega, although trained in art, had not worked at artistic
pursuits for many years, but, upon hearing of the theft, he
decided to make his first bulto, a San Rafael, for the historic
santuario. However, before he could complete the carving, the
original was recovered. And that's how Ortega came to make
his first bulto, which is now a permanent fixture in the Ortega
chapel in Velarde.

Once started, however, the artist began working on his
newfound vocation in earnest. But it's a team effort, as the
Ortegas will tell you. Zoraida Ortega has long been known
for her weaving, which she took up shortly after retirement,
but she also helps with the painting of Eulogio's pieces, since
he is color-blind. Along with painting the bultos, Zoraida also
makes retablos. She was one of the santeras featured in the
Museum of International Folk Art's "Art of the Santera" (1993).

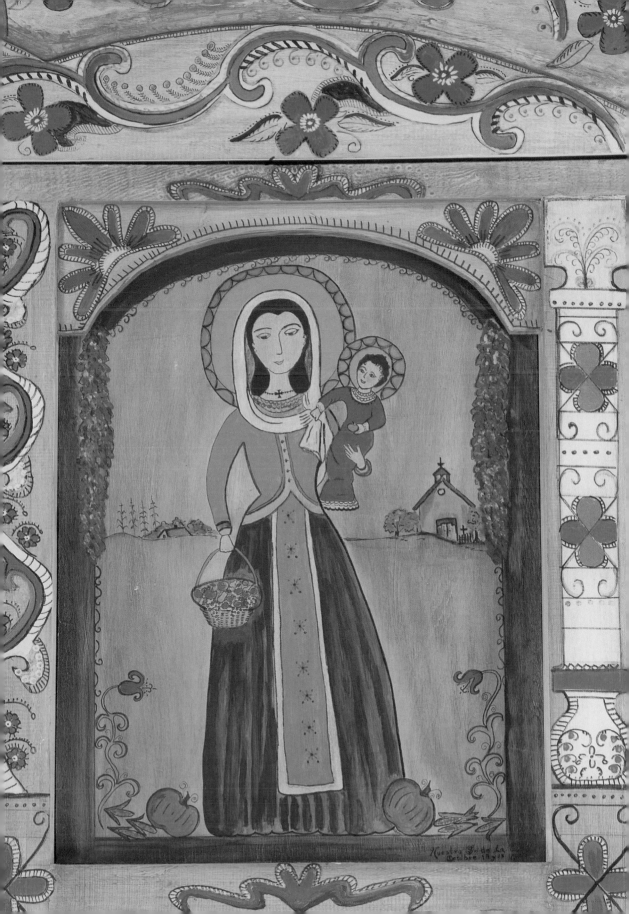

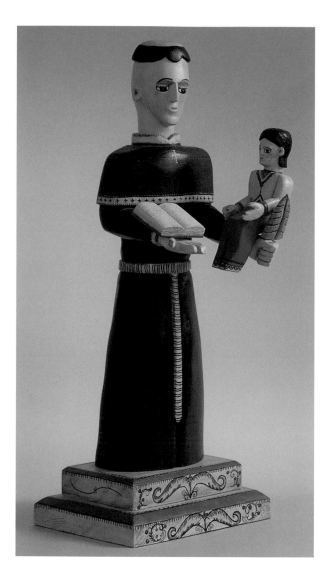

Eulogio and Zoraida Ortega,
SAN ANTONIO/
SAINT ANTHONY,
*1988, carved aspen, gesso,
acrylic, 24 inches.
Courtesy of Eulogio and
Zoraida Ortega.*

The next traumatic event, which helped to shape the Ortegas' future, occurred in 1980 when Zoraida became seriously ill and was given only a 50-percent chance of survival. She prayed to Our Lady of Guadalupe and recovered her health. In gratitude, Zoraida wanted to build a capilla in honor of Our Lady of Guadalupe. However, her husband was reluctant, feeling he lacked the finances and necessary building skills to undertake the project. So Zoraida prayed, and again her prayers were answered in the form of three laborers from Mexico whom she met on a lane near their house; they were looking for work and she took them home to meet Eulogio. The capilla was built in short order. The three laborers built the foundation and stayed to complete the basic structure and the bell tower. Eulogio Ortega carved the altar and santos; Zoraida herself painted the altar screen, and their friend Horacio Valdez provided assistance with laying the floor.

Only one thing was missing—a bell. Again Zoraida's prayers were answered. The Ortegas, who have an apple orchard next to their house in Velarde, drove to the town of Las Vegas on a fruit-selling trip. They spied a chapel with a new bell in the nearby community of Montezuma. In response to their inquiry regarding the old bell, they were told it was in a sheep corral across the road. Twenty-five dollars' worth of apples later, a hundred-year-old bell, cast in St. Louis, Missouri, was theirs. And the sound—its tonal qualities are a delight!

The capilla, dedicated to Our Lady of Guadalupe, has become famous. Bishop Arthur Tafoya of the Archdiocese of Colorado has said Mass there; a bishop from Italy, local people from New Mexico, and tourists from numerous foreign countries have all journeyed there to pray. "A cousin with throat cancer came here to pray," Zoraida Ortega says, "and was cured."

Ortega, the quiet man of strong faith, has given crucifixes he carved to fifteen churches located along the Pecos River and has donated crucifixes and bultos to local churches in his area. The Ortegas' work is also in the permanent collections of the Museum of International Folk Art in Santa Fe, the Albuquerque Museum, the Millicent Rogers Museum north of Taos, New Mexico, the Autry Museum of Western Heritage in Los Angeles, and the Taylor Museum for Southwestern Studies of the Colorado Fine Arts Center.

For several years, in the late 1970s, both Ortegas exhibited at Spanish Market, but Eulogio Ortega did not like the idea of commercializing his work, which he seldom sells. "What makes my work art," Ortega explains, "is the religious part; it must affect the person buying it. I do not intend to make money."

Sabinita López Ortiz

Sabinita López Ortiz carries the "Córdova style" of unpainted, unadorned, chip-carved bultos into the third generation, and she is teaching her children and grandchildren, the fourth and fifth generations, to carve as she does. "People come from so far to buy my work, I can't see changing my style much," she explains. Her family is one branch of carvers (see also Gloria Lopez Cordova, page 32) who are members of what has come to be known as "The School of Córdova."

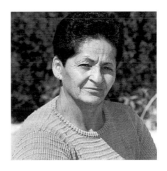

BORN
September 14, 1938,
Córdova, New Mexico

RESIDES
Córdova, New Mexico

EDUCATION
Graduate, Santa Cruz
High School

> "ALMOST EVERYTHING HE [GEORGE LÓPEZ,
> UNCLE/FATHER] MADE, I MAKE."

The School of Córdova's founding father was José Dolores López (1968–1937), Ortiz's grandfather. López captured the hearts of the religious community of Northern New Mexico, and later the museum and art world, with his santos that relied on the skill of his knife and the pale color of unpainted wood to speak volumes about religious and village life in isolated Northern New Mexico. "Our family has lived together here in a compound always," Ortiz told us. "We have something that God left us through my grandfather, and we have to keep carving so that those who come after know what God left to us."

Ortiz carves her saints with a sharp pocket knife. Her material is dried aspen wood that is plentiful in the New

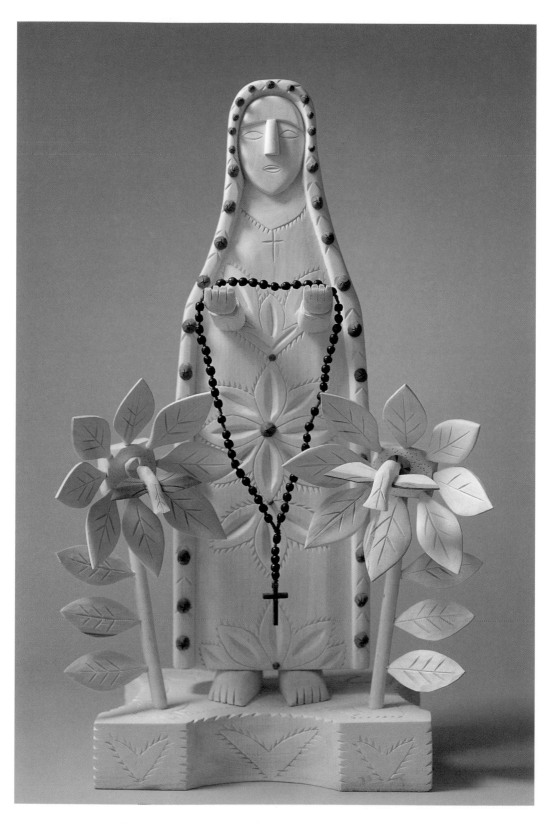

Mexico mountains above about 8,000 feet. It's a soft, almost white wood that may turn slightly yellow as it ages. The carvings are inlaid with rosettes, leaves, or other decorative elements of pinkish-red cedar—no paint or other form of coloring is used. As the years have gone by, Ortiz's "Tree of Life," "Our Lady of the Rosary," and "Virgin of Guadalupe," for instance, have become more and more elaborate. "I put extra branches and extra leaves on them," she says. "I develop my own style, but almost everything George López made, I make."

Sabinita López Ortiz is the daughter of carver Ricardo López—son of carver José Dolores López and the recipient of the 1997 Master's Lifetime Achievement Award at Spanish Market—who made his mark on the art world with his chip-carved depictions of saints. She is following in the footsteps of another carver, her uncle George López (1900–1993), also a son of José Dolores López. (While Ortiz is the niece of George López, she was adopted by George and his wife Silvianita when she was five years old. In fact, the present Ortiz home is the one where she grew up in the López family.) "From age eight onward," she remembers, "I helped George López with the sanding and chip-carving. After my marriage, at age eighteen, I struck out on my own and began to sign my own work. Now I have children and grandchildren to help me."

For about twelve years after she was married, Ortiz worked in homes in Los Alamos to supplement her income, but after that she was able to support herself as a santera in the village of Córdova.

Our first visit to Córdova was in the 1970s. Córdova wasn't even on the New Mexico road map then. A dirt road led down the mountainside from the state highway onto a plateau overlooking a valley where there was a cluster of adobe houses. George López guided us to the picturesque church that displayed his santos and those of his father. The church is still there, and so are the López bultos on the altar, but the rest of the town is quite different. Córdova has become a sightseer's mecca. The road is narrow but paved; tour buses stop at the homes and shops of the members of the "Córdova School," and a brisk business in small carved animals and saints is carried on daily.

Sabinita López Ortiz makes a lot of carvings to satisfy the demands of the tourists, but her major works are finding their way into museums such as the Smithsonian's National Museum of American Art, the Taylor Museum for Southwestern Studies of the Colorado Springs Fine Arts Center, and the Maxwell Museum of Anthropology in Albuquerque.

OPPOSITE:
Sabinita López Ortiz,
OUR LADY OF FATIMA,
1997, aspen, cedar, 27 x 15¼ x 9 inches. Chuck and Jan Rosenak.

In 1986, Ortiz and George López were invited to exhibit and demonstrate at the Smithsonian's Festival of American Folklife on the Mall in Washington, D.C. Ortiz has been included in several major shows: "One Space/Three Visions," "Our Saints Among Us: 400 Years of New Mexican Devotional Art," and "Cuando Hablan Los Santos: Contemporary Santero Traditions from Northern New Mexico."

Ortiz keeps a table in the entryway of her home well stocked with carvings of various sizes and prices to satisfy the many visitors, collectors, and tourists to Córdova. She has been a regular participant at Spanish Market in Santa Fe since 1987.

BORN
January 1, 1951,
Los Lunas (south of
Albuquerque), New Mexico

RESIDES
Los Lunas, New Mexico

EDUCATION
Graduate, Los Lunas
High School

OPPOSITE:
Alcario Otero,
EL SANTO NIÑO PERDIDO/
THE CHRIST CHILD LOST,
1993, wood, gesso, natural
pigments, 23¾ inches.
Joseph L. and Reine Moure.

ALCARIO OTERO

Alcario Otero is a master carver who has personally known pain and suffering and has pulled himself out of despair into the top ranks of religious artists. "I lead a righteous life today," he says, "but it is only because of a gift from my creator." His trials along the road of life are part of the creative process and his no-nonsense, no-sentimentality approach to art. When you combine his vision and life experience with his skills as a carpenter and painter, you get art that moves people and innovation that brings forth new and revived traditions.

> "I ASKED THE LORD JESUS CHRIST TO DELIVER
> ME FROM ALCOHOL AND HE GAVE ME THE
> GIFT TO BECOME A SANTERO."

Otero saw a gesso-relief retablo by the master santero Molleno (who worked during the first half of the nineteenth century) in the Museum of International Folk Art and was struck by its beauty. "I experimented with the form," he remembers, "but couldn't make built-up gesso stick to wood. Then I discovered that dextrin obtained from starch was the solution to the problem." Working with Charlie Carrillo (page 25), Otero revived the tradition of gesso-relief retablos (see also Jacobo de la Serna, page 124, who was working on this problem at the same time). The revival of this tradition has added renewed vigor to the contemporary forms produced in New Mexico.

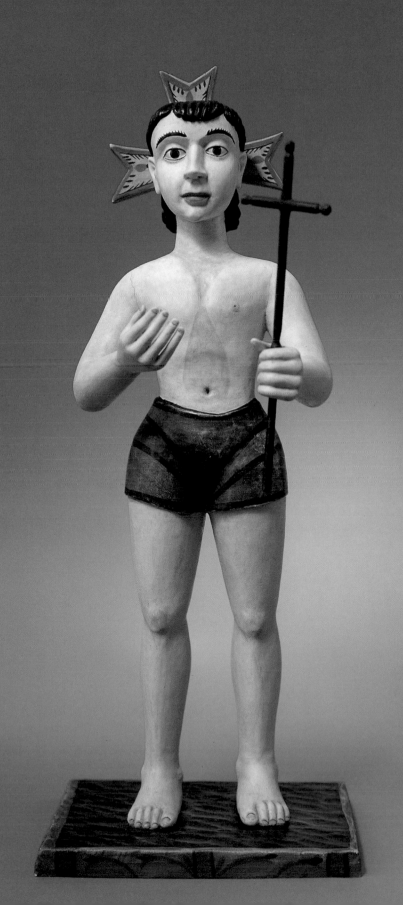

Before Otero became a leader in the renaissance of New Mexico art, there were years when his life appeared doomed by alcohol. He worked as a journeyman carpenter for twenty years, but he eventually lost family and work because of drink. In the mid-seventies, during a period when he was down on his luck, Otero showed up in Albuquerque's Old Town and was taken in by Dominican nuns who were building a chapel. The nun in charge of the project, Sister Giotto Moots, said, "God must have sent you because we need a carpenter." It was while working on the chapel that Otero discovered his love for religious art.

In 1986, during another period of despair, he says, "I went as a pilgrim to the Santuario de Chimayó and asked the Lord for deliverance from drink. He gave me the gift to be a santero."

In order to learn his newfound vocation, Otero apprenticed with Charlie Carrillo from 1987 to 1989 and attended workshops run by this renowned artist/teacher. "But," Otero

Alcario Otero,
SANTIAGO,
gesso relief, 1996, wood,
gesso, natural pigments,
31 x 31 inches. Joseph L.
and Reine Moure.

says over and over again, "do not say that I have anything to do with it [making santos]—it all comes from God."

"I had a recurring dream. A man in a white robe, it was either an angel or Jesus Christ, showed me a museum with shelves stocked full of beautiful santos. I asked Him, who did these? He replied, 'You did.' Now, when I want to know what to make next, sometimes I can call up my original vision and make an object that was on those shelves."

Alcario Otero's work was included in the traveling exhibition "Our Saints Among Us: 400 Years of New Mexican Devotional Art" (1997), and it is in the permanent collection of the Taylor Museum for Southwestern Studies of the Colorado Springs Fine Arts Center and in the Regis Collection in Denver, as well as in the Museum of International Folk Art in Santa Fe. His bultos may be seen in the Santa Maria de La Paz Church in Santa Fe and at El Rancho de las Golondrinas in La Cienega. Otero's bulto of San Ignacio de Loyola was selected by Regis University as a gift to Pope John Paul II on the occasion of his visit to Denver and the university, where he met with President Clinton, in 1993.

Otero has been exhibiting at Spanish Market since 1990. He has won many ribbons and awards, including a Design Award in 1992, First Prize/Bultos in 1993, and Best of Show in 1995. A bulto of his has been selected for the 1998 Spanish Market poster. Most of Otero's work is sold either at Market or through private commissions.

Alcario Otero,
NUESTRO PADRE JESÚS NAZARENO/OUR FATHER JESUS NAZARENE, *1995, carved and painted wood, gesso, cloth, 28 inches. Joseph L. and Reine Moure.*

Marco A. Oviedo

Marco A. Oviedo is an artist who possesses enormous talent and has embarked on an almost holy mission to preserve "what is truly Spanish Colonial art." He carves santos out of wood and has installed a magnificent home altar in his workshop, complete with reredos and a changing arrangement of bronze and wooden bultos. But his crowning achievement is a foundry that he constructed and engineered in 1989. The Oviedo foundry is contained in outbuildings near his rural home close to the Santuario de Chimayó. Casting santos in bronze (sometimes larger than life size) is certainly a modern innovation in Northern New Mexico and one guaranteed to draw attention to the art form.

> "My grandfather's last request was
> 'Immortalize the saints.'"

"Look at the old santos," Oviedo is fond of saying. "They have broken fingers, chipped paint, even missing heads and arms. If they had been cast in bronze, they would have been preserved intact. If a church or a house burns to the ground, the santos would still be there. After the Spanish Civil War, my grandfather went back to Spain and saw the carnage caused by revolution; his last request of me was to immortalize the saints. Also," the artist states, "I can show more of the carved detail, like eyes and hair, when the piece is done in bronze."

Marco Oviedo can trace his Spanish ancestry back to the early 1700s, but he did not move from Mexico City to New Mexico until 1977. The entire Oviedo family is dedicated to the foundry and the casting of saints. Oviedo's four children and his wife, Patricia Trujillo Oviedo, who can trace her own Spanish heritage in New Mexico back to the 1700s, work on the art. She comes from a family of artisans known for their weaving of traditional Northern New Mexico rugs and other textiles, but she has chosen wood and bronze over wool.

Oviedo makes his forms out of wood, as he explains it, "so the final casting will take on some of the patina and look of wood, and I do no more than thirty-five in any santo edition before destroying the original mold."

Folk artists have ventured into lithography and T-shirts; santeros have begun making lithographs and multiple castings in plastic; and these ventures have, for the most part, brought

BORN
June 11, 1948,
Mexico City, Mexico

RESIDES
Chimayó, New Mexico

EDUCATION
Ph.D., Animal Sciences,
New Mexico State University

OPPOSITE:
Marco Oviedo,
San Antonio/
Saint Anthony,
c. 1994, carved wood,
bronze, paint, 17 x 7 x 4
inches. Courtesy of the artist.

a certain amount of pleasure to the artists involved, but to date public recognition has been limited. Oviedo's bronzes, on the other hand, although they are very expensive, sell out as fast as he casts them.

Bronzes by Oviedo are in various public collections, including the Albuquerque Museum, the Air and Space Museum in Washington, D.C., the Museum of International Folk Art in Santa Fe, and the Autry Museum of Western Heritage in Los Angeles.

According to Oviedo, "Collectors buy my bronzes as art. The world comes here to the foundry—we ship to London, Japan, Australia, and other countries." However, the Oviedos have also been exhibiting at Spanish Market since 1977. Marco Oviedo maintains a booth in the Contemporary Market, and Patricia Trujillo Oviedo runs their booth at the Traditional Spanish Market.

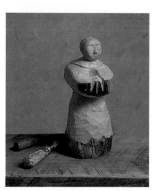

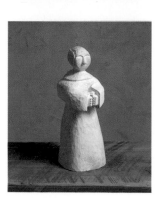

Marco Oviedo,
SAN PASCUAL/SAINT PASCAL
(in process and complete),
c. 1988, wood, paint, gesso,
13½ inches. Courtesy of
the artist.

BERNADETTE PINO (DE GOLER)

Bernadette Pino can paint and she can carve; she is also a storyteller through religious art. She is recognized as a leader among women who have the vocation and desire to work as santeras. According to Pino, she is carrying on the "traditional role of mothers and grandmothers" in her culture. "It's more than an art form and it's more than a craft; each saint has his or her own symbols—I learned from my grandmother, and I am teaching those who come after me."

> "WHEN PEOPLE NEED COMFORTING,
> THEY NEED A SAINT."

Pino's grandmother was also a storyteller, and, although she was not a santera, she would tell age-old Biblical tales to her granddaughter—illustrating them with sketches of saints and angels in retablo form. "Growing up," Pino explains, "other children were surrounded by fairy tales and nursery rhymes, but in my family the saints were everywhere."

After high school, Pino avoided most of the turbulent years of the 1970s and 1980s by journeying and studying abroad. She studied architectural design in the south of France and later obtained a job as a design consultant for the

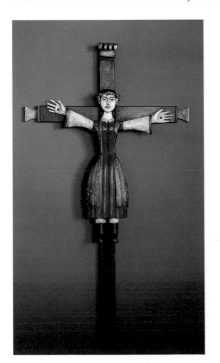

Hotel Vajra in Katmandu, Nepal. From there, her odyssey took her to New Delhi, India. "I was initiated into Buddhism and studied painting. But after a time," she explains, "I found myself painting the landscapes of New Mexico—it was time to go home." On Christmas Eve of 1991, the wandering artist returned to her native land.

Back home in New Mexico, Pino married Raul Goler, a conservator and restorer of historic santos, also an uncle of Victor Goler. She soon

BORN
August 4, 1950,
Albuquerque, New Mexico

RESIDES
Taos, New Mexico

EDUCATION
Architectural Design,
Aix-en-Provence, France

Bernadette Pino (de Goler),
SANTA LIBRADA/
SAINT LIBERATA,
1997, wood, natural pigments, nails, 38 x 2½ x 4¼ inches. Chuck and Jan Rosenak.

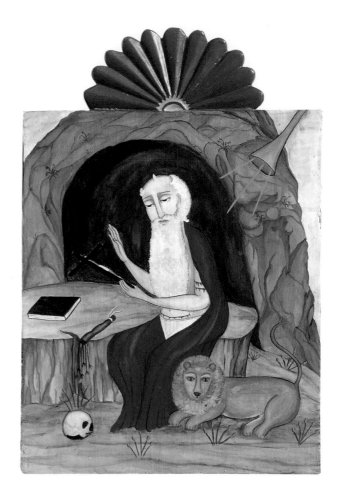

Bernadette Pino (de Goler),
SAN GERONIMO/
SAINT JEROME,
*1997, carved and painted
wood, 26 x 18 inches. Chuck
and Jan Rosenak.*

established a studio in Taos and launched her career as a santera. "I sit and meditate as my Buddhist teachers taught me," she said, "and the saints in grandmother's stories come to me to be painted."

Pino's carving skills were perfected through the tutelage of her husband. "And," she explains, "I don't usually grind my own pigments and gather piñon sap because it takes too much time, but I can achieve the same effect." She has also learned to use techniques employed by restorers to give her work a slightly antique finish.

Bernadette Pino has had an important gallery showing at the Móntez Gallery in Santa Fe (1997) and has completed a large reredos for a winery in Carmel, California. Her work is available at several galleries, including the museum shop at the Hacienda Martinez in Taos and John Isaac Antiques in Albuquerque. Pino also has been exhibiting at Spanish Market since 1995. "But mainly," she says, "people find me. It's comforting to know that, when there is a person in need, they can order a saint."

Catherine Robles-Shaw

Catherine Robles-Shaw's bultos and retablos are rich in muted tones of red, yellow, and brown, tones that make her work instantly recognizable. Her art is also rich in terms of spiritual symbolism and devotion. In her words, "I have suffered, and I have found my faith through my art."

"AT FIRST I FOLLOWED THE BOOKS. BY 1995, THE SAINTS TOOK OFF ON THEIR OWN— I COULD MAKE THEM MORE INTERESTING THAN BOOK ILLUSTRATIONS."

BORN
February 23, 1953,
Denver, Colorado

RESIDES
Boulder, Colorado

EDUCATION
GED, Denver
Vocational Center, 1982

Robles-Shaw's signature pieces to date are large retablos with strong lines of color. They are almost abstract representations of reredos found in the famous old churches of Northern New Mexico. Her images contain a mixture of elements, both three-dimensional and flat. She starts with her memory of the original altar screen and adds an abstract dimension from her personal vision—what the reredos revealed to her.

"Every santera has a story to tell about what brought them to this work," Robles-Shaw theorizes. "Mine was one of tragedy. I became pregnant with Sherry at sixteen, and when Sherry was only three, she was diagnosed with brain cancer. I was determined to take care of my daughter, and she lived with me until she was seventeen. Even though I had other children by then, when she died I was empty. We had been visiting the historic churches of Southern Colorado and New Mexico, looking for inspiration. I believe that the sacred earth seeping through the floor at the Santuario de Chimayó, for instance, helped Sherry to live beyond the doctors' expectations. I dreamed of the saints in color. On waking up one morning after Sherry was gone, I knew how to fill the empty place in my heart by making devotional art."

There's another empty place in Robles-Shaw's heart as well—she is driven to return to the San Luis Valley in Southern Colorado, to the place where her mother and grandmother were born. Historically, the small towns of the San Luis Valley, surrounded by the high peaks of the Rocky Mountains, were the home of many santeros. Robles-Shaw knows that she had ancestors who were involved in the traditional Hispanic

crafts of the area, and she would like to return to the simple small-town devotional life. For now, she is content to spend some of her time at the rustic family cabin (without running water or electricity) where, as she puts it, "I can split ten cords of wood as good and as fast as any man."

When Robles-Shaw started to carve in 1991, she experienced initial difficulty. "I could work with wood," she says, "but the detail work did not come easily." So she returned for help to Mesitas, in the San Luis Valley, where her second cousin, Rubel Jaramillo (page 48), was a santero. When she wanted a better understanding of how to make pigments, piñon-sap varnish, and gesso, she took a 1994 workshop run by Charlie Carrillo (page 25) at the Taylor Museum for Southwestern Studies of the Colorado Springs Fine Arts Center. "But," she relates, "now that I know what to do, I don't work from illustrations or stick to tradition. I get rid of the bland and work for the new." Robles-Shaw is also teaching the art of the santera to her sixteen-year-old daughter, Roxanne, who has already won ribbons in the Youth Exhibitors Division of Spanish Market.

Catherine Robles-Shaw won a blue ribbon in the important 1997 exhibition, "Faces of Our Lady of Guadalupe," at the Santuario de Guadalupe in Santa Fe. Robles-Shaw's work is included in the permanent collections of the Taylor Museum for Southwestern Studies of the Colorado Springs Fine Arts Center, the Harwood Museum in Taos, and the Regis Collection of Santos at Regis University in Denver. She is the only santera from Colorado to gain admittance to Spanish Market, where she has been exhibiting since 1994.

Robles-Shaw makes many lesser works, primarily small retablos, which are for sale at various galleries, including the shop at the Millicent Rogers Museum in Taos, the Móntez Gallery in Santa Fe, the shop at the Colorado Springs Fine Arts Center, and John Isaac Antiques in Albuquerque. To obtain a major work, you would probably have to commission one from the artist or get to Spanish Market early in the morning.

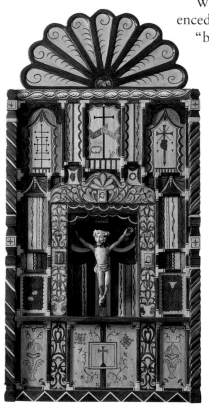

Catherine Robles-Shaw,
El Santuario de Chimayó/
Chimayó Altar,
1997, wood, natural pigments, artificial flowers, 43 x 22½ x 4½ inches. Chuck and Jan Rosenak.

OPPOSITE:
Catherine Robles-Shaw,
San José de Laguna,
1997, wood, natural pigments, 27½ x 16¼ inches. Chuck and Jan Rosenak.

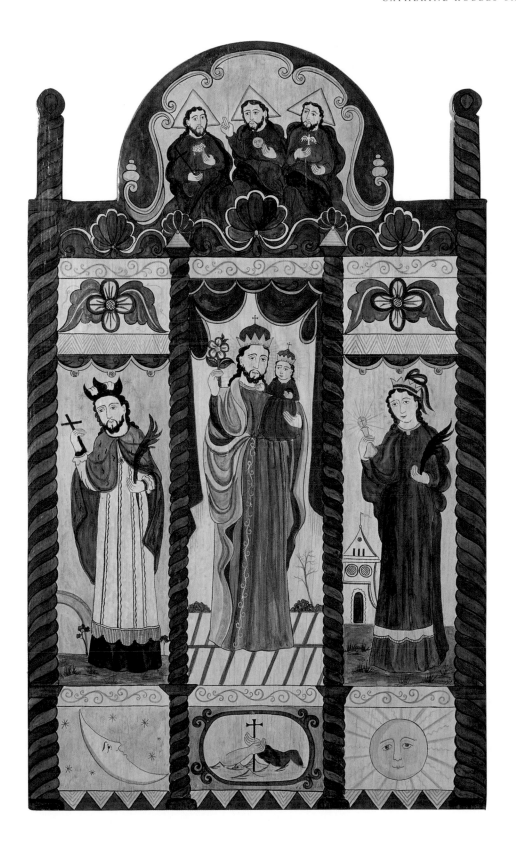

CARLOS A. SANTISTEVAN

Carlos A. Santistevan is a political activist, as well as a santero. He is known for what Thomas J. Steele, S.J., one of the foremost scholars in this field, describes as the southern "Colorado Style." "I carve deep into old cottonwood barn siding," Santistevan explains, "revealing the light wood underneath the dark exterior," giving the unpainted portion of a bulto or retablo an instantly recognizable individuality. Santistevan is an artist who has mastered many styles, from welded metal to more traditional, and he has become a recognized teacher and lecturer on the art of the santero.

> "MY ARTWORK FEEDS MY SOUL. MY JOB FEEDS MY
> BODY AND THREE CHILDREN."

BORN
Denver, Colorado,
prefers not to disclose
his date of birth

RESIDES
Denver, Colorado

EDUCATION
B.A., Antioch College,
Yellow Springs, Ohio; M.Ed.,
Education Administration,
University of Colorado,
Denver

As a teacher, Santistevan has given workshops and lectured at the Denver Art Museum and other locations throughout the state. He emphasizes the traditional methods of making bultos and retablos and the need for saints in the Hispanic community. In that vein, one day while he was lecturing at the Denver Art Museum, a woman suddenly left the room. When she returned an hour later during the question and answer period, she explained her absence with the following statement: "Thank you for finding my necklace. When you mentioned your Saint Anthony, I noticed that it was gone. A short prayer later, I remembered that I had left it on a store counter. Saint Anthony found it for me, and I'm not even Catholic!"

Santistevan has produced several programs for public television, including "Qué Linda Mi Raza," a biweekly program that ran in 1974 and 1975 and was devoted to the many facets of the Chicano community.

Santistevan has served as liaison to the Hispanic community for former Congresswoman Patricia Schroeder and is currently Executive Director of People of Color Consortium Against AIDS. In addition to his community work, Santistevan is fond of saying, "I've been an artist all my life, and that is my first calling."

Santistevan's work was included in "Santos: Sacred Art of Colorado" (1997) at Regis University in Denver. He has work in the permanent collection of that university, a teaching collection of santos assembled by Father Thomas Steele. His work may also be found in the permanent collections of the

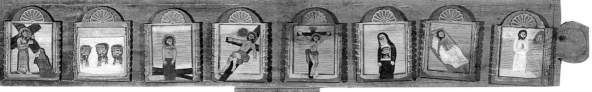
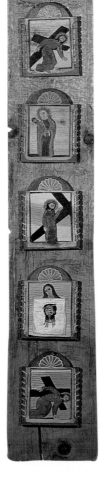

Carlos Santistevan,
STATIONS OF THE CROSS,
1996, hand-pegged wood,
wood stain, 70 x 20 x 3 inches.
Courtesy of the artist.

Smithsonian's National Museum of American Art in Washington, D.C., and the Millicent Rogers Museum in Taos, New Mexico.

Santistevan was the first artist from Colorado accepted into Spanish Market (1977), and he exhibits there on a regular basis.

BORN
October 27, 1952,
San Luis Valley, Colorado

RESIDES
Moved to Santa Fe,
New Mexico, in the 1950s;
resides there today

EDUCATION
Graduate, Santa Fe
High School

ARLENE CISNEROS SENA

Arlene Cisneros Sena's retablos cast a magic spell that instantly draws the attention of the viewer away from secular thoughts into her realm—the mystery of faith. Perhaps it's the use of gold leaf to highlight faces, perhaps it's Sena's purity of character shining through. Whatever the composition of her talent, the magic is there. "I put me into it," the artist explains. While viewing the touring exhibition "Our Saints Among Us: 400 Years of New Mexican Devotional Art" in Farmington, New Mexico, we stood back and saw it happen. The audience and hardened critics alike immediately proclaimed Sena's retablo of La Sagrada Familia (Holy Family) a star of the show.

> "I HAVE PRAYED TO SAINTS AS INTERMEDIARIES
> SINCE I WAS A BABY. YOU NEED SOMETHING
> BEAUTIFUL TO PRAY TO."

One of the paths modern art is taking is a return to romanticism, and Sena certainly takes us down that road. The artist explains her theory as follows: "I can't paint something ugly. I want to make beautiful what I feel in my heart. I soften the features—I make a contemporary retablo in a traditional form."

Sena comes from a long tradition of the faithful with roots in the San Luis Valley of Southern Colorado. "I had a grandfather who was a Penitente and painted saints. He was a sheep herder. Grandmother maintained a beautiful home altar. We learned how to pray, and I knew the stories of the saints and what they looked like. But I always said I wanted to be an artist."

It took a while for Sena to become a santera. After high school, she ran a business out of her home while raising a family. Later, she worked for a few years at a law firm and

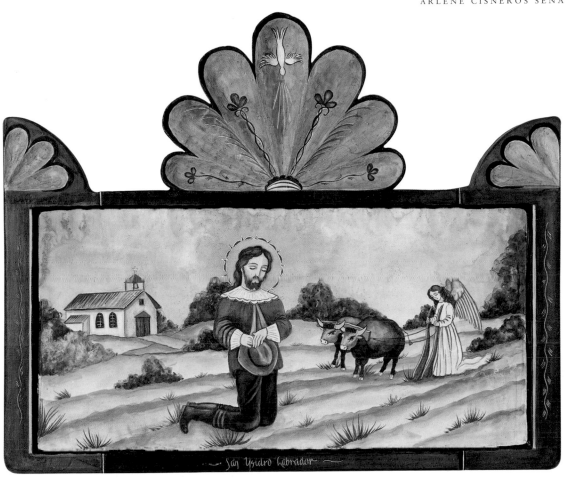

took some painting lessons on the side. Her early oils could be best described as Santa Fe style (still lifes of Indian pottery, surrounded by chile peppers). In the late 1980s, while working as a Spanish Market volunteer, Sena took a retablo workshop course led by Charlie Carrillo (page 25) and sponsored by the Spanish Colonial Arts Society at the Museum of International Folk Art.

Several years later, Sena took another workshop. At that time, she felt that her media was oil-based paints. Her research of the collection housed in the Museum of International Folk Art revealed that nineteenth-century santeros did use some oil-based house paints (as well as anything else they could get their hands on).

Because of her natural inclination toward oil-based paint, Sena hesitated to enter the judging for Spanish Market. However, at the urging of her brother Fred Cisneros, a former president of the Spanish Colonial Arts Society, and her husband Richard Sena, she submitted a retablo for judging in 1992. She became the first artist working in oil-based paint to be accepted into Market. "I still use oil paints occasionally," she

Arlene Cisneros Sena,
SAN YSIDRO/SAINT ISIDORE, *1997, wood, natural pigments, gold leaf, 16½ x 20 x 1 inches. Chuck and Jan Rosenak.*

says. "If for no other reason, it's important to show the way for those who care to follow."

And now this santera—tradition-breaking or -reviving, depending on your point of view— has taken a course on woodcarving from José Benjamín López (page 59) at Northern New Mexico Community College, and we can look forward to new forms to come.

Besides her inclusion in "Our Saints Among Us: 400 Years of New Mexican Devotional Art" (1997), Sena's work was included in the Día de la Raza Miniature Art Show at the Albuquerque Museum (1996) and the traveling exhibition "La Guadalupana: Images of Faith and Devotion," organized by the Museum of International Folk Art in Santa Fe (1996). Her work may be found in the permanent collections of the Taylor Museum for Southwestern Studies of the Colorado Springs Fine Arts Center and the Museum of International Folk Art in Santa Fe. The artist also helped Nicholas Herrera (page 45) and several other santeros remake the reredos at the historical church at Ojo Caliente, north of Santa Fe, and she painted some of the Stations of the Cross at El Rancho de las Golondrinas in La Cienega.

Since entering Spanish Market in 1992, Sena has won several awards, including the Poster Award (1994), First Place/Mixed Media (1996), and an Altar Screen Award (1997).

The prestigious Gallery 10 in Scottsdale, Arizona, selected Sena as one of the four santeras/santeros for its inaugural exhibition of Northern New Mexico religious art in 1998. For the most part, however, the artist sells at Market and from home. Presently, she is backed up with orders.

Arlene Cisneros Sena,
HOLY FAMILY,
1997, wood, natural pigments, gold leaf, 21½ x 11 inches. Private Collection.

OPPOSITE:
Arlene Cisneros Sena,
OUR LADY OF GUADALUPE,
1997, wood, natural pigments, gold leaf, 29 x 14 inches. Courtesy of the artist.

Jacobo de la Serna

BORN
January 16, 1965,
Española, New Mexico

RESIDES
Alcalde (north of Española),
New Mexico

EDUCATION
Graduate, McCurdy
High School, Española

OPPOSITE:
Jacobo de la Serna,
CRISTO CRUCIFICADO/
CHRIST CRUCIFIED,
1996, wood, natural pigments,
nails, 54 x 36 x 4½ inches.
Archbishop Michael J.
Sheehan.

Jacobo de la Serna was one of the first santeros in the 1990s to revive the time-consuming art of making gesso-relief retablos. Instead of carving a bas-relief, he builds up the surface of the wood with homemade gesso of rabbit glue and gypsum. The gesso-relief form of retablos had all but been abandoned since the nineteenth century when it was practiced by masters such as Molleno and the Laguna Santero. De la Serna is also known for his Cristos Crucificados and bultos that are, in turn, more or less influenced by the master carvers of the last three centuries. "I worked with a restorer for several years for no pay," he says. "I wanted the privilege of handling the historic pieces and learning how they were made."

> "MY ROLE IS MORE THAN THAT OF AN ARTIST.
> I BELIEVE I AM A CATECHIST."

After high school, Serna worked as a record keeper at the Los Alamos National Laboratory and then he went into the tour business. "I built tours for museums," he explains, "and that is how I began my study of the old churches and the art they contained." And then, in 1990, he was traumatized by an event that changed the course of his life. "A friend of mine was dying," he remembers. "She wanted a retablo of Our Lady of Sorrows and asked me for one. Having almost no money, I sat down on the kitchen floor and made a crude retablo out of old barn wood. Her face lit up with pleasure, and I believe she had a happy death because of my gift."

Because of his gift, which de la Serna believes to be catechistic, he became determined to become a santero. In 1991, he apprenticed for a year with Charlie Carrillo, learning the basics of Spanish Colonial art and then decided, "It was time for me to get to work." He was able to carve bultos but still had trouble getting built-up gesso to hold fast on wood. In order to get a better understanding of this art form, he spent some time at a university in Granada, Spain. The solution he learned, known to the historic santeros but forgotten, is to mix starch or dextrin into the gesso (others discovered the method at about the same time; see, for instance, Alcario Otero, page 106).

Today de la Serna is also teaching his art. "As a catechistic individual, I am charged with educating others about my faith," he says with pride. "The saints have chosen me for

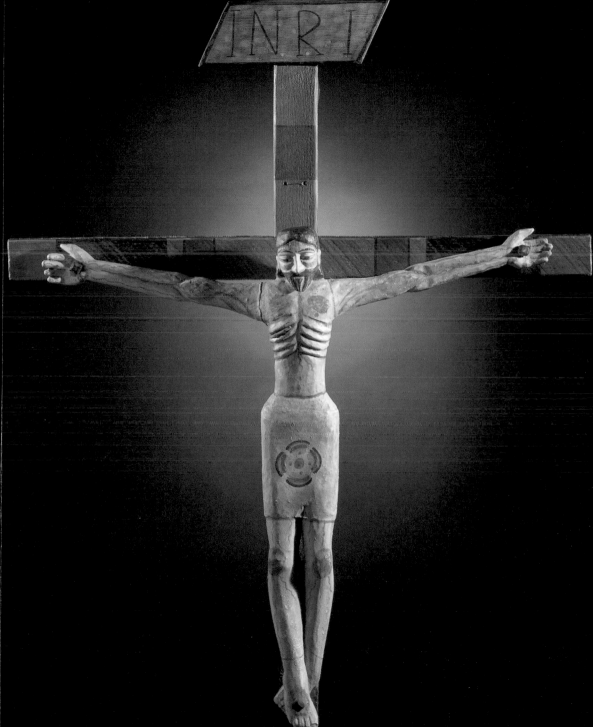

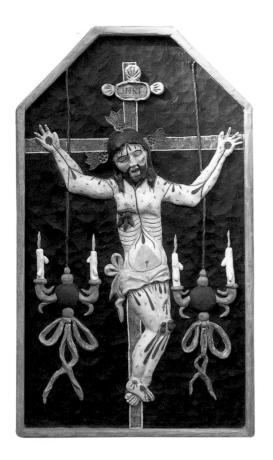

Jacobo de la Serna,
CRISTO/CHRIST,
*c. 1994, wood, gesso, natural
pigments, tin, 36 x 21 inches.
Ramón José López.*

this purpose and dictate when they will come out in my work." He holds classes at Northern New Mexico Community College and has taken on several apprentices in his studio.

Jacobo de la Serna has work in the traveling exhibition "Our Saints Among Us: 400 Years of New Mexican Devotional Art" (1997) and "La Guadalupana: Images of Faith and Devotion" (1996). His work is in the Denver Art Museum, the Regis University Collection in Denver, and the Museum of International Folk Art, as well as several churches. He was one of the artists who worked on the reredos at El Rancho de las Golondrinas in La Cienega, New Mexico. Serna received the first private commission by Archbishop Michael J. Sheehan, a Cristo Crucificado for the archbishop's private chapel (see page 125). The Archbishop of the Archdiocese of Santa Fe was so pleased with the Cristo Crucificado that he has asked the artist to complete an entire reredos for the chapel.

Jacobo de la Serna has participated in Spanish Market since 1994, winning First Prize/Gesso Relief in 1995 and a Spanish Colonial Arts Society Purchase Award in 1997.

LUIS TAPIA

Luis Tapia is the embodiment of the living tradition of Hispanic art in New Mexico. The art of the historic santeros mirrored the harsh struggle for the survival of Christian faith in an unfriendly land, and he does the same thing for a disoriented, urbanized culture. His iconography includes prostitutes, gangs, and low-riders (a souped-up car that rides low in the rear). "They are all part of our present-day traditional life," he explains. "In depicting my culture, I am doing what the santeros did two hundred years ago. My work is religious: It is made of wood, and it is covered with gesso and paint. I speak for my generation. Why should I try to be a Rafael Aragón, for instance?"

> "EVEN IF I AM TALKING ABOUT HISPANIC GANGS, PROSTITUTION, OR PEOPLE IN PRISON, THERE'S A RELIGIOUS LIFE IN ALL THOSE ACTIVITIES."

BORN
July 6, 1950,
Santa Fe, New Mexico

RESIDES
La Cienega (south of Santa
Fe), New Mexico

EDUCATION
Graduate, Saint Michael's
High School, Santa Fe

In the mid-1970s, the few santeros who came to Spanish Market were mostly working in the Córdova style that consisted of unpainted chip-carved bultos, a tradition that had been encouraged by Anglo artists in the 1920s and 1930s. Tapia, along with such giant figures as Horacio Valdez, reintroduced color and was thus thrust into the forefront of the current renaissance of religious art. "Valdez's bultos were more conventional than mine," the artist states, "but we both used acrylic paint, and I liked the idea of being able to get my materials at an art store."

Over his working years (more than twenty-five now), Tapia has remained consistent in his presentation of subject matter and his use of materials and color. His carving skills have improved, however. His figures contain more detailed work and have become very graceful. "I'm challenging my carving," he says. "There has to be growth." We have also observed a growth in his use of symbolism. For instance, Tapia employs a rainbow of color—red, yellow, blue, and green. He says, "The rainbow is God's way of promising new covenants with Him."

Tapia was and is controversial; traditionalists feel that saints should be presented as they have always been presented—looking beautiful and composed. In other respects, Tapia does live the life of a traditional santero. He works a good part of

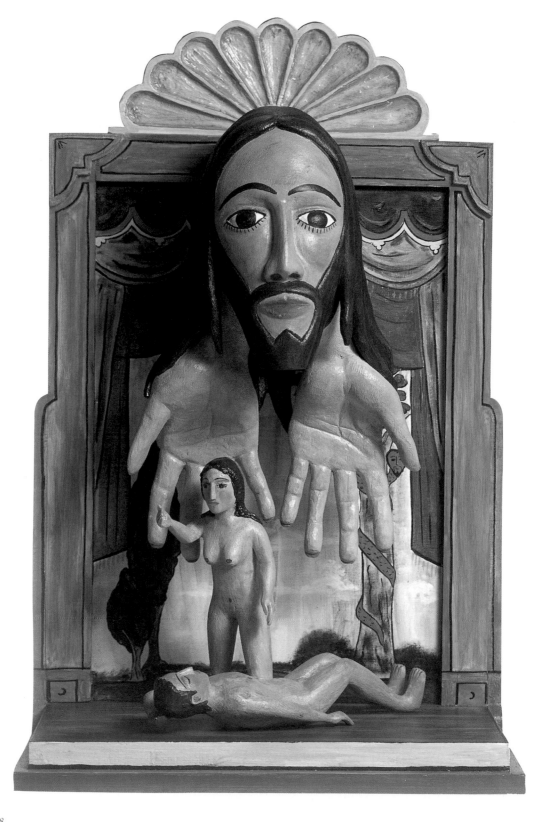

the year at "very reduced rates" on bultos and reredos for churches throughout the Southwest. He doesn't talk much about these accomplishments, but, when we last interviewed him, the artist was engaged in carving a large Nacimiento (Nativity) for the Church of the Nativity in Rancho Santa Fe near San Diego, California. He modestly admits to having completed at least a dozen such commissions for churches in recent years. "My true religious life," Tapia says, "is working on churches." Tapia has done major restoration work at several churches, including Ranchos de Taos, where he helped restore an early reredos.

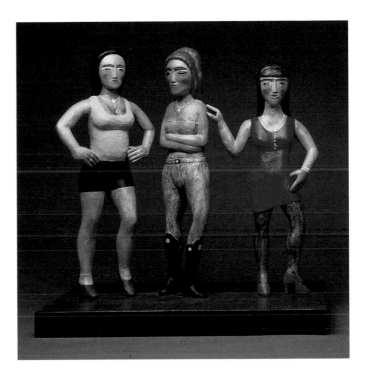

While Luis Tapia's work has been included in too many exhibitions to list them all, some of the more important were the following: "One Space/Three Visions" at the Albuquerque Museum (1979); "Hispanic Art in the United States," a traveling exhibition organized by the Museum of Fine Arts, Houston (1987); "¡Chispas! Cultural Warriors of New Mexico," The Heard Museum, Phoenix (1992); and "Crafting Devotions" at the Autry Museum of Western Heritage, Los Angeles (1994). Tapia is also one of the artists who will be included in a Smithsonian traveling exhibition scheduled for the year 2000, "Somos la Luz: Latino Art from the National Museum of American Art."

Some of the museums that include Tapia's work in their permanent collections are the Smithsonian Institution's National Museum of American Art, the Museum of International Folk Art and the Museum of Fine Arts in Santa Fe, and the Museum of American Folk Art in New York City.

Tapia exhibited at Spanish Market from 1975 through 1977. Like Horacio Valdez, he felt no need to continue, although on at least one occasion, at the request of the Spanish Colonial Arts Society, he did appear at an adjunct exhibition for contemporary artists. "It's too difficult for the Spanish Colonial Arts Society to maintain rules that make sense.

Luis Tapia,
THE THREE EVES,
1993, carved and painted wood, 17½ x 17 x 10½ inches. Private collection, courtesy of Owings-Dewey Fine Art.

OPPOSITE:
Luis Tapia,
CREATION OF EVE
FROM ADAM'S RIB,
1990, carved and painted wood, 30 x 19¼ x 12⅛ inches. Museum of International Folk Art.

Rules tend to stagnate the culture," he says in explanation. "I tell young santeros to develop their own style." This is advice he has also given to his son Sergio, who has embarked on an artistic career. On the other hand, Tapia has often stated that he believes in tradition. "I am the tradition. But tradition is not copying. What I do to continue my heritage is renew it, like a growing plant."

The truth is that Tapia's art has reached the stage where it has become part of the wider contemporary art scene. He can sell everything he makes through Owings-Dewey Fine Art in Santa Fe.

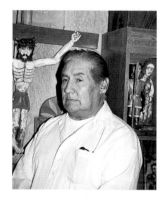

BORN
July 22, 1933,
Cimarron, New Mexico

RESIDES
Roy (west of Wagon Mound),
New Mexico

EDUCATION
GED acquired while
in the army

LEROY L. TRUJILLO

Leroy Trujillo makes santos and retablos that are part of a folk art tradition. They contain elements of his present-day observations, like the comet Hale-Bopp that recently lit up the clear skies over his house and elements of historic observations that he takes from the popular culture. He is a living reminder that, wherever the faithful live and work, there will always be a need for saints in their lives. Untaught and untutored in his chosen profession, Trujillo's work is pure folk art.

"I WANT MY SANTOS TO BE WAY OUT— DIFFERENT FROM ALL THE NEW ONES."

Roy, New Mexico, where the artist makes his home, is in the center of a large ranching area of low, grass-covered hills. It is a nineteenth-century town near a junction of two-lane highways. There is a general store, a gas station with a pump that wheezes out regular only, and a small Catholic church. The town is in the backwater of mainstream Hispanic centers of Northern New Mexico and Southern Colorado. Trujillo says, "A few doctors in Raton and Las Vegas, New Mexico, collect my work," but, "Most of my customers live and work nearby and just appear because they 'need a saint.'" Trujillo is content to stay in town and just work on his art. "I did set out once," he continues, "to visit Horacio Valdez [one of the greatest and most respected santeros of his time], but snow turned me around that day, and he died before I ever got there to meet him."

About the only time that Trujillo left home was when he served in the Army Air Corps (1951–1955) and later the

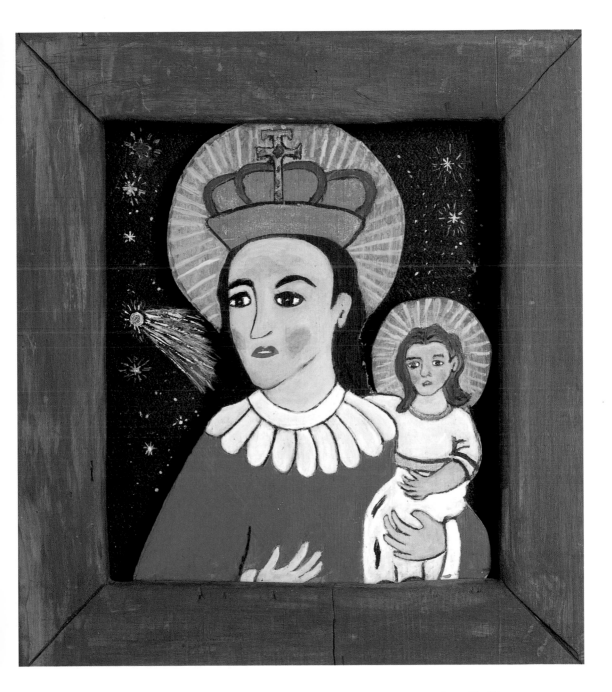

Leroy Trujillo,
SANTA MARIA (WITH
HALE-BOPP),
1997, carved wood, paint,
9¼ x 8¼ x 1 inches. Chuck
and Jan Rosenak.

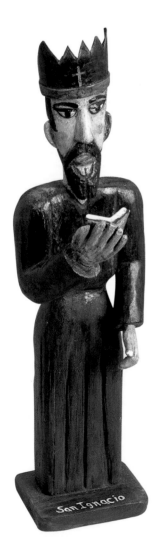

Leroy Trujillo,
SAN IGNACIO,
c. 1995, wood, natural
pigments, 22 x 5 x 7 inches.
Chuck and Jan Rosenak.

Army Special Forces (1956–1959). "General Westmoreland himself pinned on my wings," he boasts. "I also learned to be a mechanic and fix up old cars, customize them into low-riders [a Hispanic version of a hot rod]. When there is a car in need of repair in Roy, Trujillo is often called upon, and he has several low-riders in progress on his front lawn, but he earns his living as a santero.

The artist has been carving since he was about seven years old and has a wicked scar on his forearm to show for a deep wound from carving that his mother "fixed up" when he was a kid. "But," he explains, "although I was born for this work, I couldn't do saints until after the service when I understood more about them." He was also influenced by an uncle, Henry Trujillo, a santero, and by his grandfather, who was a Penitente. As a child, he remembers watching the Good Friday Penitente procession from a hiding place in an alley. "They used matracas [bull roarers] and whips. It frightened me," he remembers.

Partly because of his isolation, Trujillo has developed a style that is quite different from the other santeros. He discovered that "people want them to look old, and I like them when they look old, because we are used to praying to old santos. So I find old wood from dilapidated houses or churches that are being torn down. At other times, I go down to the rivers in the canyons for old wood. After I carve them, I apply my own mixture, like a varnish, and throw them out under the trees for a while."

Fortunately there is little chance that collectors will mistake Trujillo's work for an antique piece, because each is signed on the base, and the iconography appears quite contemporary.

Trujillo has a Cristo in Sacred Heart Church in Roy, and his work is included in the permanent collection of the Museum of International Folk Art, Santa Fe, as well as the Regis University Collection, Denver.

Occasionally, Trujillo sells his work through Tito's Gallery in Las Vegas and the Heirloom Shop in Raton, New Mexico. "Mainly, though," he explains, "people just seem to know me and come here."

Malcolm Withers

Malcolm Withers is a perfectionist. She knows how to use line, color, form, and materials to express the devotional art of the santera. She is an anthropologist who has spent a lifetime studying the masters in New Mexico and in Mexico. "I make them the way they did," she explains, "historically correct as an art form, but how do you know what a saint looked like? In Mexico, I saw carved angels that looked like Pancho Villa. I don't care what others do—I'm going to do it my way. It's up to you what a saint looks like."

"SUBCONSCIOUSLY I MAKE SAINTS FOR MY OWN USE.
I ASK THEM TO DO FAVORS FOR ME."

In the 1940s through the 1960s, when this art form was all but dead, Malcolm Withers and her husband, Arnold M. Withers (he died in 1993), who was chairman of the anthropology department at the University of Denver for thirty years, and a few others, like E. Boyd and her husband, anthropologist Ned Hall, were studying and teaching the craft, ensuring its survival. "I went on digs in Mexico (Casa Grande, 1958–1961), and, when I started carving, it was my goal," Withers explains, "to teach."

In the late 1940s, the State Historical Society of Colorado asked Withers to make santos and other historical subjects for a diorama at a museum in Fort Garland, Colorado. She continued carving saints right along, "But," she says, "I just gave them away to fellow anthropologists and friends, or I kept them. I never thought of selling my saints. I need them to perform favors for me."

Withers works in her sun porch/studio in Santa Fe in winter and in summer from a home she maintains in Rye, Colorado, south of Pueblo within the historic center for Hispanic art in Southern Colorado. She has taught, first at the University of Denver, but lately through studio demonstrations for younger santeras and santeros. "They are welcome in my studio," she explains, "and they just come, watch, and chat." Charlie Carrillo (page 25) and Marie Romero Cash (page 28) both made a point of crediting Withers for her help.

Malcolm Withers has not exhibited her work widely. Recently, however, she was honored with an exhibition at the inaugural opening of the new Denver International Airport;

BORN
January 11, 1921,
Clovis, New Mexico

RESIDES
Santa Fe, New Mexico

EDUCATION
B.A., University of Eastern
New Mexico; graduate
degree, anthropology,
University of Denver

FOLLOWING PAGE:
Malcolm Withers,
SANTO NIÑO DE ATOCHA/
THE HOLY CHILD OF ATOCHA,
c. 1986, wood, natural pigments, 15 x 5 x 4½ inches.
Private Collection.

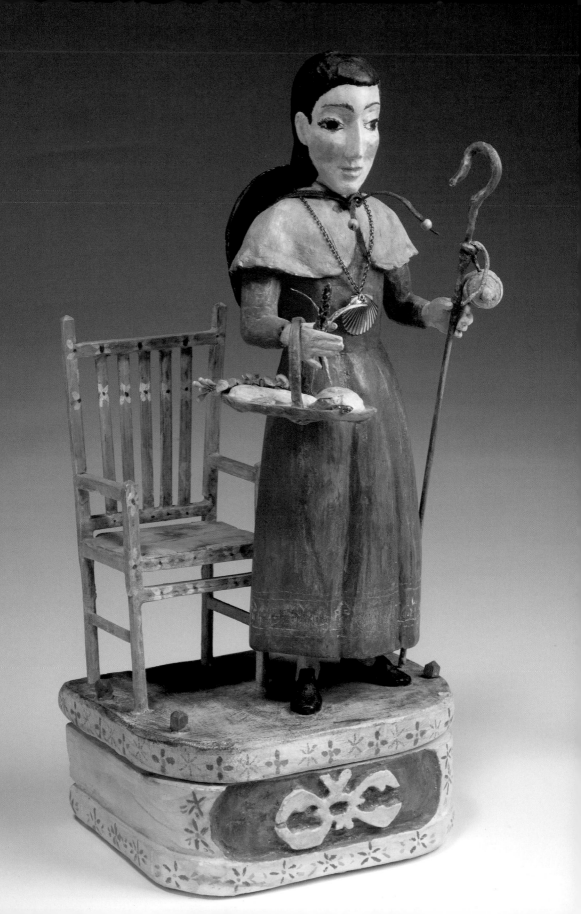

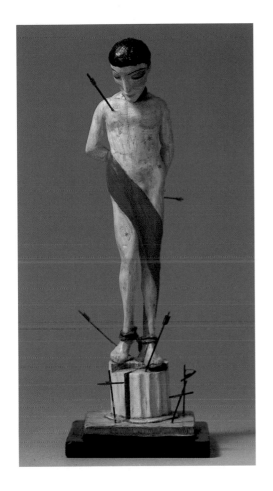

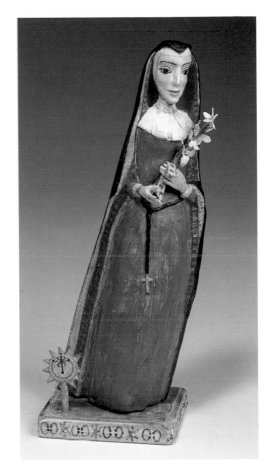

her bultos and retablos were also included in "Santos: Sacred Art of Colorado" at Regis University, Denver (1997).

Withers has been a member of the Spanish Colonial Arts Society since 1954. "But I don't exhibit at Market," she explains. "I don't believe in telling people how or what to make. Forest Fenn [former owner of what is currently Nedra Matteucci's Fenn Galleries in Santa Fe] insisted on buying a few bultos. The gallery may still have one or two, but mostly I have given them away to friends."

LEFT:
Malcolm Withers,
SAINT SEBASTIAN,
1992, wood, gesso, cloth, rope, 19½ x 6½ x 5½ inches. Chuck and Jan Rosenak.

RIGHT:
Malcolm Withers,
SANTA CLARA/SAINT CLARE,
c. 1987, wood, natural pigments, 14 x 3½ x 3 inches. Private Collection. Courtesy of the artist.

Appendix: Museums, Galleries, and Santeros Guide

This appendix contains a list of galleries and museum shops that carry contemporary Hispanic santos on a regular basis. Since many of the santeros show primarily at Spanish Market and at their studios or homes, a list of the featured artists is also included. Selected museums with extensive collections are noted.

While the list is fairly comprehensive, this type of art is rapidly increasing in popularity. It is likely, therefore, that additional galleries, particularly in New Mexico, may add the work of santeros to their present offerings. Additionally, the field is a changing one—galleries may relocate or change names, others may open. For that reason, we recommend that you check with local collectors, museums, or galleries to make sure you do not miss a new source. In addition to the galleries and museum shops listed below, bultos and retablos can often be found by visiting other galleries in art centers such as Santa Fe and Taos.

Hispanic art is featured in annual auctions sponsored by the Spanish Colonial Arts Society and El Rancho de las Golondrinas. Jerome Lujan has been hosting informal exhibitions and sales events at his home in Nambé several times a year (Day of the Dead/All Saints' Day, Valentine's Day, and the Nativity). While the Lujan events are by invitation only, it may be possible to obtain an invitation through a santero in the Santa Fe area. The New Mexico State Fair, held in Albuquerque every September, is another source of this type of art. In 1997, more than 500 Hispanic artworks were exhibited. Saint John's College in Santa Fe also holds a Spanish Colonial Art Market every fall.

ARIZONA

Adalante Gallery
El Pedregal at the Boulders
34505 N. Scottsdale Road, No. 10
Scottsdale, AZ 85262
(602) 488-1285
This gallery carries works by Fernando Bimonte on a regular basis. In addition, Adalante features santos and religious works by artists from a number of countries around the world.

Gallery 10
El Pedregal at the Boulders
34505 N. Scottsdale Road
Scottsdale, AZ 85262
(602) 945-3385
This prestigious gallery (which also has a location on Canyon Road in Santa Fe), specializes in Native American art. In 1998, Gallery 10 showed work by four contemporary New Mexico carvers: Charlie Carrillo, Gustavo Victor Goler, David Nabor Lucero, and Arlene Cisneros Sena. The gallery plans to continue to exhibit work of this nature.

The Heard Museum
22 East Monte Vista Road
Phoenix, AZ 85004–1480
(602) 252-8848
The Heard, a museum of Southwestern culture, is known for its collection of American Indian art. However, the museum's permanent collection also includes Hispanic art, and its changing exhibitions feature such art from time to time. In 1992 and 1993, for instance, The Heard showed "¡Chispas! Cultural Warriors of New Mexico," an important exhibit that featured a number of santeros and santeras (Charlie Carrillo, Marie Romero Cash, Félix López, José Benjamín López, Ramon José López, and Luis Tapia). Several of these artists (Charlie Carrillo, Marie Romero Cash, and José Benjamín López) have work in The Heard's permanent collection. The museum also has a collection of historical santos.

COLORADO

Denver Art Museum
100 West 14th Avenue Parkway
Denver, CO 80204
(303) 640-2295
The Denver Art Museum is well worth a visit for its fine collection of Southwestern art. In addition to its collection of American Indian art, the museum has a newly redesigned exhibit space for its outstanding collection of historic Spanish Colonial works, as well as a small number of contemporary pieces.

REGIS UNIVERSITY
3333 REGIS BOULEVARD
DENVER, CO 80221–1099
(303) 458-4100
Regis University is the repository for "The Regis Santos," a teaching collection assembled by Thomas J. Steele, S.J., between 1966 and the present. The collection, on permanent display in the University's library, includes both historical and contemporary material, as well as an altar screen created in 1996 by ten Colorado santeros. Worth a detour! (For half of the year, the screen is on display in the Saint John Francis Regis Chapel). In 1997, the O'Sullivan Arts Center at Regis exhibited "Santos: Sacred Art of Colorado," a show of over 150 works by 17 Colorado artists, including José Raul Esquibel, Carlos Santistevan, Catherine Robles-Shaw, and Malcolm Withers.

TAYLOR MUSEUM FOR SOUTHWESTERN STUDIES
COLORADO SPRINGS FINE ARTS CENTER
30 WEST DALE STREET
COLORADO SPRINGS, CO 80903
(719) 634-5581
The Taylor Museum is a "must visit" for santo collectors. It has one of the most definitive collections of bultos and retablos anywhere, ranging from the late seventeenth century to the present. Many contemporary santeros are represented in the collection (although the work is not always on display. These artists include Charlie Carrillo, Marie Romero Cash, David Nabor Lucero, Félix López, and Luis Tapia, among others. In 1997, contemporary work was included in two exhibitions: "Living the Tradition: Contemporary Hispanic Crafts from the Taylor Museum Collection" and "La Guadalupana: Images of the Virgin of Guadalupe." Recently, the Taylor has initiated an Indian-Spanish Market that will be held every June.

NEW MEXICO

ALBUQUERQUE

ALBUQUERQUE MUSEUM
2000 MOUNTAIN ROAD, NW
ALBUQUERQUE, NM 87104
(505) 243-7255
The Albuquerque Museum houses a number of pieces by Hispanic artists, including older works and contemporary objects. The permanent collection includes works by the late Horacio Valdez, as well as a number of artists in this book (Frank Brito Sr. and Joseph López, for example). Every December, the museum hosts a miniatures show, which usually includes a number of santeros.

Among the exhibitors in 1997 were Félix López, Joseph López, Krissa López, Frank Brito Sr., Charlie Carrillo, Gloria Lopez Cordova, David Nabor Lucero, and Alcario Otero. The works at the show are for sale as part of a fundraising event organized by the Albuquerque Museum Foundation.

EL CONDOR WEST, INC.
400 SAN FELIPE NW, SUITE 7
ALBUQUERQUE, NM 87104
(505) 243-4363
El Condor handles a wide variety of handcrafts of the Americas. Among the objects usually on hand are often-humorous bultos by santero Frank Brito Jr.

THE GOOD STUFF
2108 CHARLEVOIX NW
ALBUQUERQUE, NM 87104
(505) 843-6416
Located in Old Town, The Good Stuff offers a wide range of collectible objects, ranging from bits and spurs to bultos and retablos, some from Mexico.

HISPANIAE
2032 SOUTH PLAZA (DOWNSTAIRS)
ALBUQUERQUE, NM 87104
(505) 244-1533
John Isaac has opened a new gallery on the Plaza in historic Old Town. The ground-floor gallery, Hispaniae, carries a wide variety of work by contemporary santeros, including, on a regular basis, carvings by Charlie Carrillo, Gustavo Victor Goler, Alcario Otero, Bernadette Pino (de Goler), and Catherine Robles-Shaw. Works by other santeros are carried from time to time, or for special shows. (Also see listing for John Isaac Antiques.)

JOHN ISAAC ANTIQUES
2036 SOUTH PLAZA (UPSTAIRS)
ALBUQUERQUE, NM 87104
(505) 842-6656
Upstairs from Hispaniae on the Plaza in historic Old Town, John Isaac Antiques offers antique Native American and Hispanic devotional art, together with American folk art.

MAXWELL MUSEUM OF ANTHROPOLOGY
UNIVERSITY OF NEW MEXICO
ALBUQUERQUE, NM 87131
(505) 277-4404
The Maxwell Museum has organized such important exhibitions as "Cuando Hablan Los Santos: Contemporary Santero Traditions from Northern New Mexico" (1995). The thirteen santeros in that show each created a new santo for the exhibition; those pieces are now part of the Maxwell's permanent collection. The museum continues to collect contemporary work.

UNIVERSITY ART MUSEUM
UNIVERSITY OF NEW MEXICO
ALBUQUERQUE, NM 87131
(505) 277-4001
The art museum at the University of New Mexico has a small display that changes every semester or so and shows Spanish traditions in the New World (New Mexico) and the Old World (south of the border). Twentieth-century work is often included in this display.

SANTA FE

ARCHDIOCESE OF SANTA FE
223 CATHEDRAL PLACE
SANTA FE, NM 87501
(505) 983-3811
The Archdiocese of Santa Fe owns a large collection of Hispanic religious art, most of which is on loan to the Museum of International Folk Art. The Archdiocese does, however, maintain a small museum in downtown Santa Fe that is open to the public on weekdays.

CLAY ANGEL
125 LINCOLN AVENUE
SANTA FE, NM 87501
(505) 988-4800
The Clay Angel gallery carries the work of santera Anita Romero Jones and her daughters, Donna Wright de Romero and Leslie Turner de Romero. There is also a Clay Angel in Ashland, Oregon, (541) 482-8007, that occasionally carries work by these artists.

CLINE FINE ART GALLERY
526 CANYON ROAD
SANTA FE, NM 87501
(505) 982-5328
Cline Fine Art Gallery is one of the few places a collector can sometimes find work by the young Nambé santero, Jerome Lujan.

EL RANCHO DE LAS GOLONDRINAS
(RANCH OF THE SWALLOWS)
334 LOS PINOS ROAD
SANTA FE, NM 87505
(505) 471-2261
Located just south of Santa Fe in La Cienega, El Rancho de las Golondrinas is a living history museum. It sponsors tours, workshops, and seminars. Several festivals portraying life in Spanish Colonial New Mexico are held annually (June, August, and October). A number of santeros exhibit and sell work at these festivals. The Summer Festival emphasizes work by new and emerging artists. There is a chapel on the premises, with an altar screen dedicated to San Isidro, patron of fields and crops; many of the artists in this book were among those commissioned to work on the various pieces that comprise the reredos. In addition, a number of santeros participated in painting and constructing the Stations of the Cross in the Golondrinas chapel. Las Golondrinas also maintains a museum shop.

LA BODEGA
667 CANYON ROAD
SANTA FE, NM 87501
(505) 982-8043
La Bodega, a gallery known for its fine Native American jewelry and interesting clothing, often has work on hand by Marie Romero Cash.

LAUREL SETH GALLERY
1121 PASEO DE PERALTA
SANTA FE, NM 87501
(505) 988-7340
Laurel Seth Gallery specializes in fine art—paintings and sculptures. However, for many years the gallery has handled santos by Frank Brito Sr., and an occasional Brito can still be found there.

LESLIE MUTH GALLERY
131 WEST PALACE AVENUE
SANTA FE, NM 87501
(505) 989-4620
Leslie Muth Gallery, which specializes in Southwestern folk art, usually has sculptures and retablos by contemporary artist Nicholas Herrera.

LEWALLEN CONTEMPORARY
129 WEST PALACE AVENUE
SANTA FE, NEW MEXICO 87501
(505) 988-8997
LewAllen Contemporary has exhibited the work of Luis Tapia's son, Sergio Tapia.

MÓNTEZ GALLERY
125 E. PALACE AVENUE
SANTA FE, NM 87501
(505) 982-1828

Móntez is one of the best sources for a wide variety of bultos and retablos by top santeras and santeros. On a regular basis, Rey Móntez handles work by artists such as Charlie Carrillo, Marie Romero Cash, Fernando Bimonte, and Bernadette Pino (de Goler). He also sells older works by santeros such as Horacio Valdez and George López. Works by other artists are often available. Señor Móntez is extremely knowledgeable, and the gallery is a worthwhile stop for collectors of this material.

NEDRA MATTEUCCI'S FENN GALLERIES
1075 PASEO DE PERALTA
SANTA FE, NM 87501
(505) 982-4631

This gallery, which exhibits historical American art and contemporary Southwestern paintings and sculptures, carries works by Ramón José López and Malcolm Withers.

OWINGS-DEWEY FINE ART
76 E. SAN FRANCISCO STREET
SANTA FE, NM 87501
(505) 982-6244

Owings-Dewey exhibits paintings and sculpture, American Indian art and textiles, Spanish Colonial furniture, and santos. The gallery represents Luis Tapia. In addition, the gallery has some older santos on hand by such masters as José Aragón and Rafael Aragón. From time to time, sculptures by Patrocino Barela, a well-known Taos woodcarver who died in 1964, turn up at the gallery.

MUSEUM OF INTERNATIONAL FOLK ART
706 CAMINO LEJO
SANTA FE, NM 87505
(505) 827-6350

The Museum of International Folk Art houses a large collection of folk art, including an extensive collection of bultos and retablos. The Spanish Heritage wing of the museum, opened in 1988, exhibits Spanish Colonial and contemporary Hispanic art. There are frequent changing exhibitions in the wing, as well as a permanent display of older material. In addition to its own collection, the museum is presently the repository for most of the collection of the Spanish Colonial Arts Society. The museum store carries some retablos, as well as a selection of books dealing with the devotional art of New Mexico.

PALACE OF THE GOVERNORS
105 WEST PALACE
SANTA FE, NM 87501
(505) 827-6483

Santos are among the many objects on display at the Palace of the Governors, Santa Fe's history museum, located on the north side of the Plaza.

SPANISH COLONIAL ARTS SOCIETY
239½ JOHNSON STREET
SANTA FE, NM 87501
(505) 983-4038

The Spanish Colonial Arts Society (SCAS) sponsors the annual Spanish Market and Winter Market and can provide detailed information about these events. SCAS also has an extensive collection of traditional and contemporary Hispanic art, a large portion of which is presently housed at the Museum of International Folk Art. A sizeable library is maintained at the Society's office.

TAOS

BIG SUN GALLERY
P.O. BOX 2397
RANCHOS DE TAOS, NM 87557
(505) 758-3100

This gallery, just south of Taos (in Ranchos de Taos), carries the work of several santeros, including Nicholas Herrera and Bernadette Pino (de Goler). Other santeros are shown in the gallery from time to time.

HACIENDA MARTINEZ (PART OF THE KIT CARSON HISTORIC MUSEUMS)
RANCHITOS ROAD (2 MILES WEST OF TAOS PLAZA)
P.O. DRAWER CCC
TAOS, NM 87571
(505) 758-1000

Hacienda Martinez, dating from the early 1800s, is one of the few restored examples of New Mexican Spanish Colonial architecture and life. Several of the twenty-one rooms display historic santos and a few contemporary works. The museum shop often has small retablos and bultos for sale, together with numerous books on Spanish Colonial art and architecture. Hacienda Martinez is the site of the Taos Trade Fair held each fall. It is also often the site of demonstrations by artists and craftsmen.

HARWOOD MUSEUM
238 LEDOUX STREET
(MAIL-4080NDCBU)
TAOS, NM 87571
(505) 758-9826
Works by many painters who lived in Taos are on display at the Harwood Museum. In addition, there is a gallery devoted to Hispanic tradition, with an exhibit of santos from earlier periods and a few contemporary pieces by artists such as Gustavo Victor Goler, Anita Romero Jones, and Catherine Robles-Shaw. The museum also houses a collection of sculptures by the late Taos woodcarver Patrocino Barela.

LUMINA OF NEW MEXICO
239 MORADA LANE
P.O. BOX LL
TAOS, NM 87571
(505) 758-7282
The Lumina gallery, with a large outdoor sculpture garden, specializes in the art of New Mexico. It carries work by several New Mexico santeros, including José Lucero and Bernadette Pino (de Goler).

MILLICENT ROGERS MUSEUM
1504 MUSEUM ROAD (5 MILES NORTH OF TAOS)
TAOS, NM 87571
(505) 758-2462
The museum collection, largely based on material collected during the 1940s by Millicent Rogers—American Indian textiles, basketry, pottery, jewelry, and paintings—has been expanded to include Hispanic art, as well as contemporary Native American material. Recent displays have included works by Eulogio and Zoraida Ortega and santos by George López, Luis Tapia, and Horacio Valdez. The permanent collection includes pieces by other artists, such as Marie Romero Cash and Anita Romero Jones. The museum shop usually sells contemporary bultos and retablos by Catherine Robles-Shaw and others.

OTHER NEW MEXICO LOCATIONS

EL POTRERO TRADING POST
SANTUARIO ROAD
CHIMAYÓ, NM 87522
(505) 351-4112
El Potrero has a wide selection of contemporary bultos and retablos. The trading post usually has santos on hand by Charlie Carrillo, James Cordova, the Lucero family (David, Frankie, and José), Jacob Martinez, and Alcario Otero, among others. The gallery owner has an extensive collection of bultos by Enrique Rendon; these are not for sale, however, and special arrangements must be made to see the Rendon pieces.

HEIRLOOM SHOP
P.O. BOX 1225
132 S. FIRST STREET
RATON, NEW MEXICO 87740
(505) 445-8876
This antique shop carries folk art as well as other items. It offers work by the Roy santero Leroy Trujillo on a regular basis.

MERCADITO MILAGROSO
GIFT SHOP AND CAFE
SANTUARIO ROAD
P.O. BOX 188
CHIMAYÓ, NM 87522
(505) 351-4824
Located across the street from the El Potrero Trading Post, Mercadito Cafe has santos by the owners' sons, Arthur (Lolo) and Charles Medina, and a Tucumcari artist, Maximiliano Miguel. The shop also carries Chimayó weavings, tin work, and religious articles.

TITO'S GALLERY
157 BRIDGE STREET
LAS VEGAS, NM 87701
(505) 425-3745
Tito's Gallery handles the work of local carvers such as Margarito Mondragon, Cruzito Flores, and Leroy Trujillo, when available. The gallery has an angel show every December, and most of the Las Vegas santeros participate in the exhibition.

TOMÉ CLAY
2930 HIGHWAY 47
P.O. BOX 131
TOMÉ, NM 87060
(505) 866-4030
Tomé Clay, a gallery in Tomé near Los Lunas
(south of Albuquerque), carries the work of
Alcario Otero and other santeros from the area.
The gallery also features tin work and straw
appliqué.

SELECTED ADDITIONAL
MUSEUMS WITH COLLECTIONS
OF CONTEMPORARY SANTOS

AUTRY MUSEUM OF
WESTERN HERITAGE
4700 WESTERN HERITAGE WAY
LOS ANGELES, CA 90027-1462
(213) 667-2000
The Autry Museum is devoted to preserving the
heritage of the West. The collection centers on
Western memorabilia and objects representing the
heritage of the Western United States, but a number
of contemporary santeros are represented in the
museum's permanent collection (Gustavo Victor
Goler, Nicholas Herrera, Luisito Lujan, José
Benjamín López, and Luis Tapia, for example).
From time to time, the Autry exhibits this material,
as it did in "Crafting Devotions: Tradition in
Contemporary New Mexico Santos" (1994).

NATIONAL MUSEUM OF AMERICAN ART
SMITHSONIAN INSTITUTION
8TH & G STREETS NW
WASHINGTON, D.C. 20560
(202) 357-1771
The National Museum of American Art has a
small collection of contemporary Hispanic material,
including works by such santeros as Nicholas
Herrera, George López, Enrique Rendon, Luis
Tapia, and Horacio Valdez. It is presently acquir-
ing additional works. Some of these pieces will be
included in national touring exhibitions in the year
2000: "Somos la Luz: Latino Art from the National
Museum of American Art" and "Contemporary
Folk Art from the National Museum of American
Art." The museum also has a large collection of
historical Puerto Rican santos.

GLOSSARY OF TERMS

BULTO: A sculpture in the round, a three-dimensional carving. Various woods can be used. However, cottonwood and cottonwood root are preferred by many of the artists. On the other hand, aspen and cedar are generally used by the Córdova carvers.

CAPILLA: Chapel. The term is often used in regard to a small private chapel, but it is sometimes also used to mean a church.

COLCHA: This word loosely means "coverlet." As used in this book, it denotes a type of embroidery traditional in New Mexico. It also is used to identify a particular type of long stitch.

CRISTO: Christ.

CRISTO CRUCIFICADO: Christ Crucified.

FOLK ART: Work by untrained, self-taught artists. Sometimes called visionary, isolate, naive, outsider, or vernacular art. The work is highly personal, idiosyncratic, and nonutilitarian, representing an individual vision. The craft may be derived from communal traditions, but as used in this book, something personal and innovative must be added to qualify it as art. The craft may be learned, but the art is self-taught.

GESSO: A preparation used as a base or surface for painting. Traditionally, gesso was made of native gypsum, baked to eliminate moisture, and homemade rabbit-skin glue. Some santeros continue to make it in this fashion. Gypsum and rabbit-skin glue can also be purchased commercially.

GESSO RELIEF: Wood panels built up in relief with gesso. These were common in Europe, and were made in Spain into the sixteenth century. Such panels have been documented in New Mexico in the nineteenth century, many of them thought to be by one hand, perhaps the santero Molleno. More than ten of these gesso-relief panels are in the collection of the Museum of New Mexico; they have been seen by some of the artists in this book. Several santeros have tried their hand at gesso reliefs, among them Charlie Carrillo, Alcario Otero, and Jacobo de la Serna. Currently, in fact, there is a Spanish Market Award for gesso reliefs. The medium is very time-consuming, however, and, to date, it has not become popular with most santeras and santeros.

HIDE PAINTINGS: The earliest known religious works in New Mexico were paintings made on brain-tanned buffalo hides, and occasionally on elk and deer hides. Church inventories indicate there were hundreds of these paintings in the eighteenth century. Unfortunately, various clerics thought the hides unseemly and most were destroyed. While this art is little practiced today, several artists in this book, including Ramón José López and Anita Romero Jones, have done paintings on hides.

MORADA: Meeting place of the Penitentes. Usually composed of several rooms, most moradas were constructed between 1870 and the early 1920s. Many of the moradas had life-sized figures of Christ and other religious images. The santo-making tradition declined in New Mexico following the arrival of the railroad. Thus, the continuing need for santos for moradas was an important factor in the survival of the tradition.

NACIMIENTO: A Nativity scene, with figures around the crib. In addition to the Holy Family, other figures are often included: angels, shepherds, animals, the Three Wise Men.

NICHO: A recess in a wall for holding a bulto or other object.

PENITENTES: The Brotherhood of Our Father Jesus the Nazarene, or Los Hermanos Penitentes, or the Penitentes, a lay religious society that is active in Northern New Mexico and Southern Colorado. The religious observances of the Penitentes are centered on Lent and Holy Week. As well as fulfilling spiritual needs, the Brotherhood performs important functions as a charitable society. The Archbishop of Santa Fe recognized the Penitentes as an official society of the Catholic Church in 1947. Several of the santeros featured in this book are members.

PIGMENTS: Of necessity, the early santeros used natural pigments. Most of the colors were of mineral and vegetable origin, although indigo, cochineal, and vermillion were probably imported. Many saintmakers today continue to use natural pigments. It is also possible to obtain these pigments commercially—from New York suppliers, for example—which avoids the necessity of grinding them. Other santeros use acrylics or even oil paints. Entrants have told us that, when jurying for Spanish Market, additional credit is given with regard to materials if natural pigments are used.

Piñon Sap: Mixed with grain alcohol, piñon sap is often used as a varnish on bultos and retablos.

Reredos: Altar screen. The term is most commonly used for altar screens in churches, an architectural framework containing individual retablo panels and one or more bultos in nichos. A number of the santeras and santeros have worked on restoring or creating reredos for Northern New Mexico churches. Eulogio and Zoraida Ortega made the reredos for their capilla. At least ten artists collaborated on the construction of the reredos at El Rancho de las Golondrinas in La Cienega. Also, some artists (Margarito Mondragon and Catherine Robles-Shaw, for example) are making reredos for sale, usually in the form of large retablos. One of the current Spanish Market award categories includes altar screens with retablos and gesso-relief works.

Retablo: Flat, two-dimensional image, usually on board. The term generally refers to pine panels coated with gesso and painted. The boards were initially hand-adzed, but currently milled lumber is often used. Many retablos are not large—11 x 14 inches or 13 x 16 inches are typical sizes—but several contemporary artists are making very large retablos (Fernando Bimonte, for example).

Santero: One who makes images of saints, a saint maker. While the term is broad enough to include women, it is generally used today in reference to men who make saints. Traditionally, santeros were holy men, often sacristans of the church (José Dolores López, for example), in which position they were involved with care, and sometimes repair, of holy images. It was thought that the more religious the santero, the more powerful the image.

Santera: A woman who makes images of saints.

Santo: Holy or sacred image, image of a saint.

Tin Work: New Mexico has long been known for its tin work, which was an important part of the religious arts and crafts of the area during the second half of the nineteenth century. (Tin was used for crosses, nichos, retablo frames, altar ornaments, et cetera.) Tin work survived in a more secular world, due in part to the efforts of the Spanish Colonial Arts Society, which—in addition to the annual market—established a Spanish arts shop that was open for a few years in Santa Fe in the late 1920s and early 1930s. A number of santeras and santeros use tin today as frames for retablos or to decorate their bultos. A few, like Anita Romero Jones and David Nabor Lucero, do their own tin work. Others use tin made by family members (Marie Romero Cash) or friends (Luisito Lujan).

Glossary of Saints[2]

In addition to God and the Holy Family, the following angels and saints (familiar and unfamiliar) appear in the text or illustrations of this book.

ANGELS

ÁNGEL GUARDIÁN/GUARDIAN ANGEL: Angels are considered less powerful than archangels. Shown as winged figures, guardian angels protect against evil spirits and are invoked as guides on journeys.

SAN GABRIEL ARCÁNGEL/SAINT GABRIEL THE ARCHANGEL: One of the seven archangels, Saint Gabriel is a heavenly messenger. He announces the coming births of John the Baptist and Jesus. Usually winged, Gabriel may hold a chalice, a lily, an olive branch (symbolic of peace), or a trumpet announcing the end of the world.

SAN MIGUEL ARCÁNGEL/SAINT MICHAEL THE ARCHANGEL: Michael is known for his triumph over the devil. He is usually shown holding balance scales to weigh souls and standing on a snakelike monster that symbolizes the devil. He often also holds a sword or spear. Saint Michael is invoked against all forms of evil.

SAN RAFAEL ARCÁNGEL/SAINT RAPHAEL THE ARCHANGEL: Like the other angels, San Rafael is usually winged. He is clad in pilgrim's garb, often carrying a staff (sometimes topped with a water gourd) and a fish. He is the patron saint of travelers and may be invoked for restoration of physical or spiritual health. San Rafael is also a protector against eye trouble; the miraculous fish he carries has cured blindness.

MALE SAINTS AND BIBLICAL FIGURES

JOB: A figure in the Old Testament, Job is portrayed in a sitting position, covered with bleeding wounds or sores. Job represents patience in suffering and acceptance of God's will.

SAN ANTONIO/SAINT ANTHONY: San Antonio is a popular New Mexico saint. While generally known for his ability to help find lost articles, in New Mexico he is also invoked to find good husbands, by women who want children, and as a patron of miracles. He wears a blue robe and holds the Christ Child. He is sometimes depicted holding a flowering branch and/or a book.

SAN CAYETANO OR GAETANO/SAINT CAJETAN: Cofounder of an order devoted to the care of the poor and sick, San Cayetano is said to have founded nonprofit pawnshops. He is the patron saint of gamblers.

SAN GERONIMO/SAINT JEROME: A scholar who lived as a hermit for a time, San Geronimo translated the Bible from Hebrew and Greek into Latin. In New Mexico, he is ordinarily shown as a hermit, often clad in a red robe, with a lion at his feet. Supposedly, he removed a thorn from a lion's paw, after which the lion stayed near the monastery. San Geronimo is the patron saint of children and may also be invoked against lightning.

SAN IGNACIO DE LOYOLA/SAINT IGNATIUS OF LOYOLA: At one time a Spanish soldier, Saint Ignatius founded the Society of Jesus (the Jesuit Order). He is prayed to for repentance and return to the Sacraments, as well as against illness. Often depicted in a cassock, San Ignacio may wear a biretta or be shown as tonsured or bald. He usually holds a book inscribed with "IHS," an abbreviation of the Greek name for Jesus.

SAN JUAN BAUTISTA/SAINT JOHN THE BAPTIST: Saint John is the forerunner of Christ, the one who baptized Jesus and recognized him as the Messiah. John wears a hermit's garment and usually holds a staff with a banner. The lamb, in his arms or by his side, is an allusion to his recognition of Jesus as the "Lamb of God."

SAN LAZARO/SAINT LAZARUS: Lazarus was a beggar, whose sores were licked by dogs; he is turned away without receiving even crumbs from the table of the rich man.

SAN LORENZO/SAINT LAWRENCE: A protector against fire, San Lorenzo (said to be Spanish) was a deacon to the Pope; he was martyred by being burned on a gridiron for refusing to turn over the riches of the church to the prefect of Rome. The saint is shown wearing a wide-sleeved garment (dalmatic) worn by deacons, holding a palm and gridiron or sometimes a book or chalice.

[2] The material on the saints is largely based on two books: *Santos and Saints: The Religious Folk Art of Hispanic New Mexico* by Thomas J. Steele, S.J., and *New Kingdom of the Saints* by Larry Frank. Full publication information is provided in Selected Reading.

SAN PASCUAL BAILÓN/SAINT PASCAL BAYLON:
San Pascual (or Pasqual) was a shepherd who became a lay brother and worked in the dining room of the Franciscan Order. Initially, he was the patron saint of sheep and shepherds. Today, however, he generally appears as the patron saint of cooking, "the kitchen saint." He is one of the few saints occasionally shown in a humorous vein.

SAN PEDRO/SAINT PETER: Saint Peter, one of the apostles, was the first pope. He is the custodian of the keys of the kingdom of heaven. Thus, he is depicted in long robes, holding a key and sometimes a book. Peter is the patron of a happy death.

SAN RAMÓN NONATO/SAINT RAYMOND NONNATUS: This thirteenth-century saint, who ultimately became a cardinal, acquired his name Nonnatus ("unborn") because of his Cesarean birth from a dead mother. He is the patron saint of pregnant women, women in childbirth, and the unborn.

SAN ROQUE/SAINT ROCH: Saint Roque, a French saint, devoted his life to care of the sick, especially those with plague. He is ordinarily shown with boots and a traveler's hat; a dog licks his sores. He is prayed to for protection against disease and pardon for sins.

SAN SEBASTIAN/SAINT SEBASTIAN: A third-century Christian martyr in Rome, Saint Sebastian is usually depicted as a youth, sometimes nude, pierced by arrows.

SANTIAGO/SAINT JAMES THE GREATER: James was reputedly the apostle of Spain. Shown wearing a soldier's uniform, Santiago is mounted, usually on a small horse, and carries a sword or spear and a pennant.

SAN YSIDRO OR SAN ISIDRO LABRADOR/SAINT ISIDORE: The patron saint of farmers and crops, San Ysidro was very devout; God rewarded him by sending an angel to help with plowing so he would be free to pray. He is usually shown in farmer's garb and broad-brimmed hat, often with a plow pulled by oxen guided by an angel.

FEMALE SAINTS

SANTA ANA/SAINT ANN: Ann was the legendary name given the mother of Mary, the grandmother of Christ. She is ordinarily depicted holding or near a small girl. She is prayed to with regard to family needs and in connection with mother-child relationships.

SANTA CECILIA/SAINT CECILIA: A third-century Christian martyr, Saint Cecilia is traditionally regarded as the patron saint of music. She is ordinarily depicted with a musical instrument.

SANTA CLARA/SAINT CLARE: With help from Saint Francis of Assisi, Santa Clara founded the Franciscan nuns. She appears in the habit of a Franciscan nun holding a monstrance (the receptacle in which the host is held).

SANTA INÉS DEL CAMPO/SAINT AGNES OR SAINT INES: An Augustinian nun, Saint Agnes is shown in a long garment, holding a palm or staff, sometimes with a lamb. She is the patron of animals or people lost in the wilderness and of those who work outdoors. She is also the patron of flowers and crops.

SANTA LIBRADA/SAINT LIBERATA (LEGENDARY): Supposedly the daughter of a Portuguese king, Santa Librada made a vow of chastity. To avoid a forced marriage, she prayed for disfigurement, in response to which a beard appeared on her face. Her father had her crucified for witchcraft. Her intercession is sought concerning marriage, travel, and growth of children. She is considered a women's saint. Santa Librada is shown on the cross; in New Mexico, she is traditionally shown without a beard, although Nicholas Herrera has carved a bearded Librada.

SANTA LUCIA/SAINT LUCY: A young Sicilian girl, Saint Lucy was denounced as a Christian. Although her life was saved when she was thrown into a fire, she was eventually martyred—blinded in some accounts. A protector against eye disease, Saint Lucy is shown in long robes, carrying a palm and a pair of eyes on a dish.

SANTA MARIA MAGDALENA/SAINT MARY MAGDALEN (BIBLICAL): A woman of bad repute, Saint Mary Magdalen was converted by Christ and witnessed the Crucifixion and Resurrection. Saint Mary Magdalen is usually shown in a long dress and red cloak, praying. She is the patron saint for conversion from an evil life.

SANTA RITA DE CASIA/SAINT RITA OF CASCIA: An Italian peasant, Santa Rita reluctantly married a man who turned out to be a bad husband. After his death, she became a nun and, while meditating, a thorn from Christ's crown became embedded in her forehead. Shown in a nun's habit, sometimes with a wound on her forehead and a cross and skull in her hands, Saint Rita is the patron saint of difficult causes. She is also the patron of girls in need of husbands, as well as those in bad marriages.

Selected Reading

Books

Awalt, Barbe, and Paul Rhetts. *Charlie Carrillo: Tradition & Soul/Tradición y Alma*. Albuquerque: LPD Press, 1995.

————. *Our Saints Among Us: 400 Years of New Mexican Devotional Art*. Albuquerque: LPD Press, 1998.

Beardsley, John, and Jane Livingston. *Hispanic Art in the United States: Thirty Contemporary Painters and Sculptors*. New York: Abbeville Press, 1987.

Boyd, E. *Popular Arts of Colonial New Mexico*. Santa Fe: Museum of International Folk Art, 1959.

————. *Popular Arts of Spanish New Mexico*. Santa Fe: Museum of New Mexico Press, 1974.

Briggs, Charles L. *The Woodcarvers of Córdova, New Mexico: Social Dimensions of an Artistic "Revival."* Knoxville: University of Tennessee Press, 1980.

Butler, Rev. Alban. *Lives of the Saints*. New York: Kenedy, 1956.

Frank, Larry. *New Kingdom of the Saints: Religious Art of New Mexico 1780–1907*. Santa Fe: Red Crane Books, 1992.

Gavin, Robin Farwell. *Traditional Arts of Spanish New Mexico: The Hispanic Heritage Wing at the Museum of International Folk Art*. Santa Fe: Museum of New Mexico Press, 1994.

Jenkins, Myra Ellen, and Albert H. Schroeder. *A Brief History of New Mexico*. Albuquerque: University of New Mexico Press, 1974.

Kalb, Laurie Beth. *Santos, Statues, and Sculpture: Contemporary Woodcarving in New Mexico*. Los Angeles: Craft and Folk Art Museum, 1988.

————. *Crafting Devotions: Tradition in Contemporary New Mexico Santos*. Albuquerque: University of New Mexico Press and Los Angeles: Gene Autry Western Heritage Museum, 1994.

Oettinger Jr., Marion, ed. *Folk Art of Spain and the Americas: El Alma del Pueblo*. San Antonio, TX: San Antonio Museum of Art and New York: Abbeville Press, 1997.

One Space/Three Visions. Exhibition Catalog. Albuquerque, NM: Albuquerque Museum, 1979.

Pardue, Diana. *¡Chispas! Cultural Warriors of New Mexico*. Exhibition Catalog. Phoenix: The Heard Museum, 1992.

Pierce, Donna, and Marta Weigle, eds. *Spanish New Mexico: The Spanish Colonial Arts Society Collection*, 2 vols. Santa Fe: Museum of New Mexico Press, 1996.

Rosenak, Chuck, and Jan Rosenak. *Museum of American Folk Art Encyclopedia of Twentieth-Century American Folk Art and Artists*. New York: Abbeville Press, 1990.

————. *Contemporary American Folk Art: A Collector's Guide*. New York: Abbeville Press, 1996.

Salvador, Mari Lyn C. *Cuando Hablan Los Santos: Contemporary Santero Traditions from Northern New Mexico*. Exhibition Catalog. Albuquerque: Maxwell Museum of Anthropology, 1995.

Santos: Sacred Art of Colorado. Exhibition Catalog. Albuquerque: LPD Press, 1997.

Shalkop, Robert L. *Wooden Saints: The Santos of New Mexico*. Colorado Springs: The Taylor Museum for Southwestern Studies of the Colorado Springs Fine Arts Center, 1967.

Steele, Thomas J., S.J. *Santos and Saints: The Religious Folk Art of Hispanic New Mexico*. Santa Fe: Ancient City Press, 1982, 1994. Originally published as *Santos and Saints: Essays and Handbook*, Albuquerque: Calvin Horn, 1974.

Steele, Thomas J., S.J., Barbe Awalt, and Paul Rhetts. *The Regis Santos: Thirty Years of Collecting 1966–1996*. Albuquerque: LPD Press, 1997.

Weigle, Marta. *Brothers of Light, Brothers of Blood: The Penitentes of the Southwest*. Albuquerque: University of New Mexico Press, 1976.

Wroth, William. *Christian Images in Hispanic New Mexico*. Colorado Springs: The Taylor Museum of the Colorado Springs Fine Arts Center, 1982.

————. *Images of Penance, Images of Mercy: Southwestern Santos in the Late Nineteenth Century*. Norman and London: University of Oklahoma Press, 1991.

————, ed. *Hispanic Crafts of the Southwest*. Exhibition Catalog. Colorado Springs: The Taylor Museum of the Colorado Springs Fine Arts Center, 1977.

Periodicals

The following magazines provide information on contemporary santeros:

Spanish Market (annual). Santa Fe: Spanish Colonial Arts Society, Inc.

Tradición Revista (quarterly). Albuquerque: LPD Enterprises.

Sаптеras апd Sапteros

Frank Alarid
1710 Canyon Road
Santa Fe, NM 87501
(505) 988-1697

Fernando Bimonte
Calle del Arroyo 7
La Cienega, NM 87505
(505) 438-1830

Frank Brito Sr.
250 Irvine Street
Santa Fe, NM 87501
(505) 983-6638

Charlie Carrillo
2712 Paseo de Tularosa
Santa Fe, NM 87505
(505) 473-7941

Marie Romero Cash
295 Lomita
Santa Fe, NM 87501
(505) 988-2590

Gloria Lopez Cordova
P.O. Box 132
Córdova, NM 87523
(505) 351-4487

James Cordova
795 Avenida Primera
Santa Fe, NM 87505
(505) 988-1128 or
(505) 986-9934

José Raul Esquibel
6533 S. Yarrow Way
Littleton, CO 80123
(303) 979-5388

Cruzito Flores
612 S. Pacific Street
Las Vegas, NM
87701–3258
(505) 425-5880

Gustavo Victor Goler
P.O. Box 520
Taos, NM 87571
(505) 758-9538

Nicholas Herrera
P.O. Box 43
El Rito, NM 87530
(505) 581-4733

Rubel Jaramillo
7810 County Road E-5
Antonito, CO 81120
(719) 376-5364

Anita Romero Jones
8 Encantado Loop
Santa Fe, NM 87505
(505) 466-2089

Félix López
P.O. Box 3691
Fairview Station
Española, NM 87533
(505) 753-2785

José Benjamín López
63407 El Alamo Street
Española, NM 87532
(no phone)

Joseph A. López
P.O. Box 3691
Fairview Station
Española, NM 87533
(505) 753-2785

Krissa López
P.O. Box 3691
Fairview Station
Española, NM 87533
(505) 753-2785

Peter López
P.O. Box 183
Montezuma, NM 87731
(505) 425-8214

Ramón José López
P.O. Box 2495
Santa Fe, NM 87504
(505) 988-4976

Raymond (Ray) López
12 County Road 105
Santa Fe, NM 87501
(505) 455-3107

David Nabor Lucero
1924 Hopi Road
Santa Fe, NM 87501
(505) 983-1635

Frankie Nazario Lucero
128 Lorenzo Road
Santa Fe, NM 87501
(505) 820-2149

José Lucero
128 Lorenzo Road
Santa Fe, NM 87501
(505) 983-2401

Ernie Lujan
County Road 109
North, Box 52-A
Santa Fe, NM 87501
(505) 455-7417

Jerome Lujan
County Road 113
No. 161
Santa Fe, NM 87501
(505) 455-1123

Luisito Lujan
Route l, Box 147
Santa Fe, NM 87501
(505) 455-2471

Jacob Martinez
P.O. Box 579
Dixon, NM 87527
(505) 579-4530

Margarito R.
Mondragon
1414 Ninth Street
Las Vegas, NM 87701
(505) 454-0520

Eulogio and Zoraida
Ortega
Box 7
Velarde, NM 87582
(505) 852-2290

Sabinita López Ortiz
P.O. Box 152
Córdova, NM 87523
(505) 351-4572

Alcario Otero
246-A El Cerro Loop
Los Lunas, NM 87031
(505) 565-0047

Marco A. Oviedo
Route l, Box 23-A
Chimayó, NM 87522
(505) 351-2280

Bernadette Pino
(de Goler)
P.O. Box 1693
Ranchos de Taos, NM
87557
(505) 751-5531

Catherine Robles-Shaw
4025 Moorhead Avenue
Boulder, CO
80303–5511
(303) 494-9405

Carlos Santistevan
2560 Glenarm Place
Denver, CO 80205
(303) 297-1370

Arlene Cisneros Sena
Route 10, Box 141-A
Santa Fe, NM 87501
(505) 438-0163

Jacobo de la Serna
P.O. Box 481
Alcalde, NM 87511
(505) 852-0223

Luis Tapia
c/o Owings-Dewey
Fine Art
76 E. San Francisco
Santa Fe, NM 87501
(505) 982-6244

Leroy Trujillo
P.O. Box 248
Roy, NM 87743
(505) 485-2672

Malcolm Withers
2823 Ristra Plaza
Santa Fe, NM 87505
(505) 473-1782

ACKNOWLEDGMENTS

A great many people were excited by the prospect of seeing the santeras and santeros in this book get the national recognition they deserve. All the artists pitched in and helped us on a tight schedule; we are grateful for their help.

We also wish to thank the museums and the individual staff members who assisted us, especially James Nottage, Autry Museum of Western Heritage, Los Angeles; Tey Marianna Nunn, Museum of International Folk Art, Santa Fe; Marina Ochoa, Archdiocese Museum, Santa Fe; Diana Pardue, The Heard Museum, Phoenix; Mari Lyn Salvador, Maxwell Museum of Anthropology, Albuquerque; Ann Tennant, Denver Art Museum; and Cathy Wright, Taylor Museum for Southwestern Studies of the Colorado Springs Fine Arts Center.

Thanks are also due to the Smithsonian's National Museum of American Art, in particular to Lynda Hartigan, Deputy Chief Curator, who has supported our endeavors for more than twenty years, and to Andrew Connors and Helen Lucero.

Our friend Lynn Steuer, a teacher at the Folk Art Institute, Museum of American Folk Art in New York, has given graciously of her time to many museums; she is a patron of a number of the santeros.

Bud Redding, Director of the Spanish Colonial Arts Society, has been of help, as has John Berkenfield, Director of Development and Planning, El Rancho de las Golondrinas. Both provided very useful information. Both collections were made readily available to us for study.

Thanks also to those who allowed us to photograph their santos, particularly to Joseph L. and Reine Moure and Margot Linton, who gave up time during their short stays in Santa Fe so that various pieces of theirs could be included in this book.

We thank Thomas J. Steele, S.J., for his knowledge and insight, which he shared with us, and William Sutton of Regis University.

Barbe Awalt and Paul Rhetts are also due thanks for their assistance and for use of several of their photographs. Olivia Ortega deserves credit for her assistance with regard to the black and white photographic portraits of the artists.

Peter Vitale has gone out of his way to photograph a number of works on location, as well as in his studio. His photos are striking and add an extra dimension of beauty to the art.

Several galleries were also of assistance. Our thanks to John Isaac, John Isaac Antiques, Albuquerque; Rey Móntez,

Móntez Gallery, and Aaron Payne, Owings-Dewey Fine Art, both of Santa Fe; and to Phillip and Adele Cohen, Gallery 10, Scottsdale.

Thanks to Dave Jenney, the publisher at Northland, who suggested the project; to Erin Murphy, Northland's editor-in-chief, who kept us on schedule; to Heath Lynn Silberfeld, who copyedited the book; to Nancy Rice for the design and layout; to Jennifer Schaber, Northland's art director, for overseeing the design; and to Lisa Brownfield, Northland's production manager, who was responsible for coordinating the book's production and printing. As usual, there would be no book were it not for computer assistance from Robert Hake.

Last but not least, we would like to thank the late E. Boyd, without whose years of research we would know much less about the early santeros.

This project has been an eye-opener for us; we hope readers enjoy learning about the santeras and santeros as much as we enjoyed meeting them and collecting their art! Thanks again to all.

Index

CHUCK and JAN ROSENAK, successful attorneys, acclaimed authors, and recognized American folk art experts, have made collecting a second career and fashioned a New Mexico lifestyle devoted to finding and promoting the best folk artists working in the United States. While traveling the highways and backroads of the Southwest, they have fashioned relationships with hundreds of artists working in a variety of folk art traditions.

In addition to *The Saint Makers,* the Rosenaks are authors of *Navajo Folk Art: The People Speak* (Northland Publishing), a comprehensive and lavishly illustrated overview, and the authoritative *Museum of American Folk Art Encyclopedia of Twentieth-Century American Folk Art* (Abbeville Press).

The Rosenaks thrive on igniting the interests of everyone from art collectors and museum curators to casual buyers looking for unique adornments for their homes. Though the Smithsonian Institution recently purchased 250 pieces of their collection for a traveling exhibition, the Rosenaks' home remains filled with everything from Navajo pictorial rugs to whimsical metal and wood sculptures to the finest santos being fashioned today.